Hispanic New Mexican Pottery

Evidence of Craft Specialization
1790-1890

Charles M. Carrillo

Hispanic New Mexican Pottery

Evidence of Craft Specialization
1790-1890

Charles M. Carrillo

LPD Press
ALBUQUERQUE

Carrillo, Charles M.
Hispanic New Mexican Pottery:
Evidence of Craft Specialization 1790-1890

Includes bibliographical references and index.

Typesetting & Book Design by Paul Rhetts & Barbe Awalt
Photography by Paul Rhetts & Barbe Awalt

Historical Consultant & Copy Editor: Felipe R. Mirabal
Editorial Assistance: David Smoker and Thomas J. Steele, S.J.
Illustrations by Charles M. Carrillo and Paul Rhetts

Library of Congress Catalog Card Number: 97-70980
ISBN 0-9641542-3-4
First edition

10 9 8 7 6 5 4 3 2 1

For all the 18th and 19th century potters of Hispanic villages, your work is now remembered.

This work is dedicated to an earthly trinity that consists of six individuals: my parents, Dr. Rafael Abeyta and Loretta Juliana Rita Torres Carrillo; Thomas Lyons and Fr. Thomas Steele S.J.; and Jane and E. B. Hall, for their love, encouragement, and support.

Contents

Illustrations

Abbreviations

The following abbreviations represent archival sources listed in the text. The abbreviations are normally followed by a number, page, folio, frame, or other reference.

AASF Archives of the Archdiocese of Santa Fe: baptismal, marriage, and burial books

AFBN Archivo Franciscano Biblioteca San Augustín (Old Biblioteca Nacional), México, D.F.

AGN Archivo General de la Nación, Mexico City

MANM Mexican Archives of New Mexico, State Records Center and Archives, Santa Fe

SANM I Spanish Archives of New Mexico, Series I, land grant records, State Records Center and Archives, Santa Fe

SANM II Spanish Archives of New Mexico, Series II, provincial records, State Records Center and Archives, Santa Fe

TANM Territorial Archives of New Mexico, State Records Center and Archives, Santa Fe

Acknowledgments

There is an old New Mexican *dicho* or proverb that says *"Dime con quien andas, y te diré quien eres"* – "Tell me with whom you walk, and I will tell you who you are." While this book is about Hispanic New Mexican pottery, it is also in an allegorical sense the result of the people with whom I've walked.

My interest in archaeology, especially pottery, began when as seven-year-old boys my twin brother and I walked through the hills around Carnuel (Carnué), New Mexico, with a man we called *Tata*. I recall the anticipation of visits to Powell Boyd, so my brother and I could go out and look for pottery. On those walks with our *tata* I knew I would someday deal with pottery again. My *tata* has long since passed on, but my interest in archaeology was set. As I worked on this book, I often wished that he was still with us so that he could know what his pottery walks started.

In 1974, Dr. Marie Hughes, Professor Emeritus of the University of New Mexico, gave my twin brother and me a wonderful high school graduation present. She made arrangements for us to enroll in the 1974 Summer Archaeology Field School at New Mexico State University. Dr. Marie Hughes has also passed on; I wish she too could know that this opportunity set my feet in the proverbial concrete. In the fall of that same year I began taking classes at the University of New Mexico, with

intention of finishing a degree in anthropology. While there I was fortu-
nate to be a student and friend of many wonderful teachers. Over the
years many faculty members have provided invaluable instruction and
support. Linda Cordell has continued to be a constant friend and advi-
sor. Jeremy Sabloff, Robert Santley, Lawrence Straus, and Marta Weigle
were always there to lend advice and encouragement. My committee
challenged my work and provided informative critiques on the drafts. I
want to express my gratitude to each one.

When I first started taking classes at UNM, I was introduced to a
thinker who offered a new perspective in archaeology. Lewis Binford in
his "robust" manner was a model that I have always admired; he has also
been my friend, for this I am grateful. In a positive and helpful way Chip
Wills challenged my research, making the final product a more useful
research tool; for this I am also grateful. James Boone has always been
the quiet listener, ready to add positive input to my research; for this I
am also grateful. John Kessell is the other model, mentor, and friend
who has always added encouragement and support to my research. I
recall the first class that I took from John, and asking myself how New
Mexican history could be so vivid, so alive. John Kessell made it so, and
I have always tried to do the same for my students. I am grateful to John
for this.

While I was finishing my undergraduate degree in anthropology in
1977, Linda Cordell approached me and asked if I would be interested in
working in Abiquiú, New Mexico, at the historic site of Santa Rosa de
Lima de Abiquiú. She had been contacted by Ned Roberts at UNM;
apparently the local history association was seeking archaeologists to
work with the community in a summer program. I can almost say, "thanks
Ned, the rest is history." In Abiquiú I met many wonderful people who
have helped shape my life. I wish to thank the entire community; not
only is Abiquiú an important part of my research, it is my spiritual
home. There are too many people from Abiquiú to list; however, it is
important to name a handful.

This book would not be a reality if it were not for Gilberto Benito
Córdova – it is Benito who introduced me to Hispanic pottery. I also

wish to thank Juanita Gallegos, Aubrey and Vonnie Owens, Palmita Osegueda, Criselda Domínguez, and Dexter Trujillo of La Asociacíon de Santa Rosa de Lima de Abiquiú.

Perhaps the most significant guide I came to know, admire, and love in Abiquiú was Belén V. Trujillo. Although Belén did not have formal education beyond the third grade, the things she taught me will I hope be passed on to her great-grandchildren, for my wife Debbie is her grand-daughter. Debbie was blessed to be raised by her grandmother, who infused in her life the customs and more important the sentiment of her ancestors. Debbie's Uncle Floyd, whom she has always called "Daddy," is the salt of the earth. I could ask for no better a teacher than Floyd. He has been my spiritual model as I journeyed through the book years. His guidance and those of Los Hermanos of La Cofradía de Nuestro Padre Jesús Nazareno have provided prayer and friendship.

Belén and I did our share of walking; she would walk, I would talk, and she would teach. Grandma Belén is also no longer with us. Her memory is profoundly part of this book, and at home we now own her old "olla de barro" or clay pot. If pots could only talk!

In 1980, the first year I attended Spanish Market as a *santero*, or maker of holy images, I met an "Angel in Blue Jeans." Jane Hall and her husband E. B. Hall provided the scholarship that set this book in motion. In 1980, I applied and was accepted to the graduate school at UNM. I express my heartfelt gratitude for her willingness to provide the scholarship, and for her friendship. During this time I also became friends with Felipe R. Mirabal; we were both fascinated with New Mexico history. Felipe has remained a true and loyal friend, and has throughout the years provided me with a "pot" full of provocative thought, and has been my *nuevomexicano* mentor. He constantly has reminded me that since our first day at UNM we have been disturbed people. Thank you for your work on this book.

Felipe introduced me to a friend of my *tata*, Fr. Thomas Steele, S.J. No single person is more responsible for this book than Tom. Not only has he been my dear friend, he has been my mentor and my teacher, and he has gone to great lengths to conceal me away in clandestine locations to

finish this research. He has also read and edited every word that has been written at least seven times, and he is the most informed historian alive today concerning New Mexican Hispanic pottery. Everyone should be as blessed! Without Tom's careful mentorship and red pen, there would be no reason to write these words of acknowledgment. *Mil gracias, tio Steeo, qué Dios te bendiga siempre.*

Fr. Tom Steele and I had a friend in common; unfortunately he is no longer with us. On his deathbed, Thomas Lyons asked Thomas Steele to crack the whip and make sure that I finished this book. Thank you Tom Lyons for the request, and thank you Tom Steele for keeping the promise.

During the course of this research I was fortunate to become the subject of a book about my work as a New Mexican *santero* by Barbe Awalt and Paul Rhetts. They have continued to encourage me and provide "kudos" for finishing. Paul has been my computer guru. He has pulled me out of so many computer jams I've lost count. He has also provided the technical expertise for placing all of the photographs and graphics in the text. Thank you both for believing in this book and making it possible. For this and your loyal friendship I am grateful.

Felipe Ortega, fellow *hermano* and master Hispanic/Jicarilla potter, has pushed me throughout the past sixteen years, expecting that someday, someone would document the pottery traditions of his people. We have sat at many meals cooked in micaceous bean pots and discussed the progress and frustrations of this research. Felipe has been a mentor and friend throughout the process.

Michael Marshall, fellow archaeologist, was about the only one who believed me when I first began to conduct research for this book. The many hours of discussions over coffee helped make this book what it is. I am indebted to Mike for his mentorship.

Everyone should have a friend and editor as knowledgeable as Mary June-el Piper. I wish to acknowledge her insight and editorial skills for my dissertation which became the basis for this book. It is great to have a copy editor who is also an archaeologist.

Finally, who I am is evidenced by those that I learned to crawl and then walk with, and those with whom I travel each and every day. In

short, they are my family. My parents provided the home environment that was always conducive to learning, and in this allegorical sense taught me to walk. Their love and example paved the way for this book.

Many thanks to my brothers Andy, Tony, and David, my sister Cathy, and their families for their continued encouragement to see this research completed.

I have fond memories of the many discussions that took place at the anthropology lab at the University of New Mexico. Most especially I recall the serious discussions that I had with Helen Warren. Her serious approach concerning pot sherds is to be admired. She really understood tempering materials and her help will always be remembered. I hope she is sitting in Heaven with whole pots and having discussions with the makers of those pots.

Thank you Orcilia Zuniga Forbes for your friendship and support!

My wife and companion since 1978 has provided an unbending faith in everything that I have done. She has worried more about this book than I ever did; her unwavering support is an example of unselfish sacrifice. I love you for this. My *hijos* Estrellita de Atocha and Roán Miguel have always stood hand in hand with their mother and have provided the warmth and love so necessary in a family. For these precious gifts I am truly thankful.

"Dime con quien andas, y te diré quien eres" – These are the people with whom I walk; this is who I am.

Foreword

As beleaguered Spanish colonists under don Diego de Vargas fought to reestablish themselves in New Mexico, to survive battles with Pueblo Indian resisters, crowded living conditions in Santa Fe, privation, and sickness, an unusually prosaic event found its way into the record. On July 16, 1694, "a little after three in the afternoon, some Pecos Indians arrived loaded with glazed pottery to sell."

Although don Diego and his privileged circle ate on handsome *majólica* service from Puebla de los Angeles in New Spain or on Chinese porcelain unloaded at Acapulco from Manila galleons, most Hispanic New Mexicans made do with Pueblo Indian pottery. Its acquisition, interrupted by the Pueblo Revolt of 1680, resumed in the 1690s and continued for a century. With such a ready supply of affordable, good-quality, locally produced wares, there was no need during the 17th and most of the 18th century for the colonists themselves to manufacture ceramics. By 1790, however, conditions had begun to change.

Now there were twice as many Hispanos as Pueblos, twice as many consumers as producers, and the gap kept widening. Moreover, as a result of alliances achieved by Gov. Juan Bautista de Anza with Comanches and other former enemies, Hispanic New Mexicans started spreading out in all directions, away from their onetime

Pueblo neighbors and suppliers, who stayed put. Reforms decreed by Spain's Bourbon kings, meanwhile, stirred up economic activity all over the empire. Weaving for profit came to New Mexico. If wholesalers supplying distant markets to the south did indeed encourage Pueblo Indians to adapt the style of their pottery for export, the resulting drain may have reduced production for local trade and driven up prices. (Yet, curiously, no archaeological evidence from Mexico of this purported long-distance traffic in Pueblo pottery has yet come to light.)

Dispersed or not, Hispanic New Mexicans – everyone, regardless of origin or race but nominally Roman Catholic, Spanish-speaking, and not a member of an Indian community – still needed pots. During the century between 1790 and 1890, their population swelled steadily from some 20,000 to perhaps ten times that many. They laid out village after village, until they had expanded the area of their homeland tenfold. Many, in fact, after Congress cut New Mexico Territory down to size in the 1860s, found themselves in Colorado, Arizona, or Texas. No matter, in the face of such rapid increase, there never seemed to be enough good farming or grazing land for everybody.

Fierce competition, swindles, and shrinkage by successive inheritance to smaller than subsistence-sized parcels put a merciless pressure on the landless. How were families to feed themselves? What other ways, seasonally or full time, could land-poor but resourceful folks exploit their physical and human environment? Some, like the daring *comancheros* and *ciboleros*, carried trade goods to Indians or hunted buffalo for hides and meat. Others took up wood cutting or charcoal making, herb gathering, prospecting, trapping, and a variety of home-based crafts. Not a few, we can now say on good authority, turned to making pottery.

Charles M. Carrillo's study of Hispanic New Mexican pottery is first and foremost an invitation. Marshaling available data from the archaeological, documentary, and oral records, he invites archaeologists, historians, ethnographers, and others to recognize an earthy,

mundane enterprise that went largely unrecorded in contemporary written accounts. It can help us see into people's lives in 19th-century New Mexico. But since one compelling reason for this research was to complete his Ph.D. in archaeology, Carrillo presents here more material evidence than biographical.

Widely acclaimed as a *santero*, a maker of religious images, Charlie Carrillo undeniably prefers people to pots. He wants to know the potters by name and circumstances. How many were widows? How many were men down on their luck? Who taught them? Where did Tranquilina Ruybal learn how to make micaceous cooking pots that gave beans and stews such a heavenly taste? What stories do sherds of convex-molded bowls at the Trujillo House or of huge wine vats at Casa Colorada have to tell? If making pottery implied such a low social status, are there not disparaging remarks in folk plays, songs, or dichos?

That Hispanic potters, dispersed far and wide, produced their wares mainly of local materials for local consumption may explain in part why their ceramic tradition has gone unnoticed by outsiders for so long. More significant, in studying and selling the Southwest, scholars and boosters for generations have favored Indians over Hispanic New Mexicans. Village churches and Penitente rituals do not tell the whole story. Henceforth, thanks to Charles M. Carrillo's invitation, which he admits is preliminary but suggestive, no historical archaeologist excavating a New Mexican Hispanic domestic site from this period will dare assume that Indians manufactured all the pottery that lies scattered about. To do so will only invite a visit from the ghost of Tranquilina Ruybal.

John L. Kessell
Professor of History (retired)
University of New Mexico
Albuquerque, New Mexico

Preface

People nowadays can hardly imagine how many different ways the nineteenth-century Hispanic population of New Mexico used pottery. A thorough recounting of the various daily uses of pottery would go a long way toward telling the whole story of village life. Some New Mexicans even today repeat a colonial *dicho*: *"Aunque son del mismo barro, no es lo mismo el basín que el jarro!* – Although the clay is the same, a chamber pot is not the same as a food jar!"* This proverb reminds us of the immense variety of ceramic use among Hispanics.

Historians in general and archaeologists in particular have regularly assumed that each and every piece of pottery associated with New Mexican Hispanic village life was a trade item introduced from the Orient, México, or the nearest Indian Pueblo. This book challenges that unproven, persistent assumption. It offers a model for understanding the manufacture of pottery during the late Spanish Colonial, Mexican Republic, and U.S. Territorial periods in New Mexico. More important, it provides proof through archaeological excavations, laboratory analysis, documentary records, and oral history that New Mexican Hispanics of the period 1790-1890 verified the model in actual practice sustained over a century.

The data presented in this book will make it impossible to subscribe any longer to the perspectives offered by earlier scholars. These

perspectives suffered from unwarranted and untested presupposi-
tions. One such presupposition claimed that pottery-making among
New Mexican Hispanics could not have existed because the tasks
associated with pottery-making were low-status and hence attribut-
able only to Native Americans. This view failed to understand the
role pottery manufacture played in the cultural, economic, and physi-
cal environments of various village populations throughout the world.
Dean Arnold's model as presented in *Ceramic Theory & Cultural Process*,
1985, which this present book subscribes to, has synthesized infor-
mation from several parts of the world, and it now offers an extraor-
dinarily illuminating context for interpreting pottery production
among New Mexican Hispanics.

Practically all the pottery that New Mexican Hispanics made
was utilitarian. It was designed either for the storage, transportation,
preparation, and serving of food or for personal hygiene. Much more
rarely, it served for rituals. Conservative in shape and downright drab
in decoration or lack of decoration, such pottery typically took the
form of jars, pots, pitchers, bowls, soup plates, *comales* (griddles), cham-
ber-pots, and pinch-pots for cosmetics.

Many historic wares show evidence of recycling. Many times a
large cooking pot might become a chamber pot, a chimney flue, a
large broken jar might be used as an animal feeding trough, and
pottery sherds were used as they broke or with a little reshaping as
scoops, pot lids, drop spindles, scrapers, or other handy household
devices. A number of turn-of-the-century photographs of Hispanic
village life depict Hispanic wool spinners using old or slightly dam-
aged bowls as *telpacates* or spindle guides. Spinners would spin the
bottom end of drop spindles or *malacates* in the concave base of shal-
low bowls which they rested on the floor or in their laps (cf. Plate 1).

Some Hispanic families had access to imported wares of special-
ized shapes, such as Mexican *majólica* and Oriental wares. Yet in the
typical Hispanic village of the eighteenth and nineteenth centuries,
Hispanic families normally used some pottery traded or bartered from
near-by Puebloan or Apachean potters and some pottery made by

Hispanic potters. The research presented in this book suggests that during the late-eighteenth and nineteenth centuries some Hispanic villagers became ceramic craft specialists. Every archaeological investigation of a Hispanic village or *hacienda* site in New Mexico and southern Colorado has uncovered the results of the manifold dynamics of cultural, economic, and natural environments, and so the ceramic traditions represented in the archaeological and ethnographic record of these Hispanic settlements vary considerably. Thus at some Hispanic villages and archaeological sites, only Pueblo pottery is

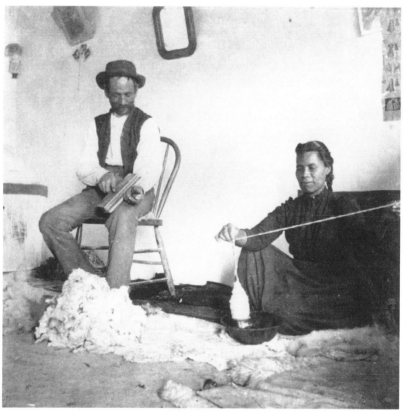

PLATE 1: CHIMAYÓ, NEW MEXICO, CIRCA 1909.
Hispanic family carding and spinning wool. Note burnished black bowl used as telapacate. Prudence Clark Collection, Menaul Historical Library. 1975.001.049.

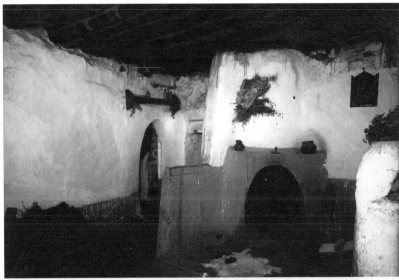

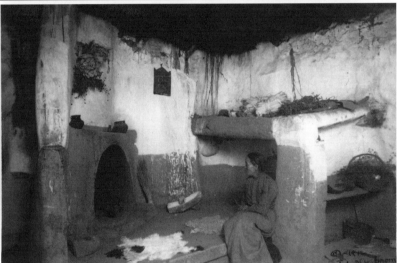

PLATE 2 AND PLATE 3: INTERIOR DE LA PEÑA RESIDENCE, SANTA FE, NM 1912. Although it cannot be determined if the pots are Hispanic, this is typical of homes/ haciendas in 19th century Hispanic New Mexico. Note the pots on the mantle, in the fireplace as well as broken pottery pieces on the shelf. Photos by Jesse L. Nusbaum. Courtesy Museum of New Mexico, neg. no. 29030 (top) and neg. no. 15335 (bottom).

found; other sites offer Pueblo pottery, Mexican *majólicas*, and Hispanic pottery; at still other locations, Hispanic-made pottery abounds while Puebloan and Apachean pottery is uncommon.

Hispanic potters and Puebloan and Apachean potters made pottery in nearly identical manners. Hispanics and Indians from the southern part of New Spain (today's Republic of México) probably introduced molding techniques, but most Hispanic potters and all the Native Americans did most of their work by using the coiling and scraping technique. Examination of sherds and whole pieces from the archaeological record and of extant heirloom pieces suggests that the potters started the vessel in a base and then progressively added coils of clay and scraped them together in such a manner as to bond them and obliterate the coil marks. When the vessel reached the desired height, the potters shaped and thinned the vessels with additional scraping, then finished the rim and added any necessary handles, spouts, and fluting. The Hispanic artisans often used an alternate method for forming smaller bowls, that of pressing a pancake-like disk of moist clay onto a convex mold specifically constructed for that purpose. Potters may have also used the bottoms of existing pots on which they molded small bowls. When the bowls had partially dried, the potters then removed them from the mold and finished their work.

Decoration on Hispanic wares was minimal. The surface of micaceous wares was most often left unpolished. Potters tended to rag-slip these wares with a thin micaceous slip. Some Hispanic micaceous wares show corncob scraping marks beneath the slipped surface. This tradition is most often associated with Apachean micaceous wares, as many Apache people were absorbed into the Hispanic population. The surface of other wares was slipped and polished smooth with a stone. At times, a rag-applied border was added to the interior and rims of bowls, and sometimes to the rims of jars. The red-colored bordered pottery is often mistaken for Tewa ware. The archaeological record for some Hispanic villages located along the Río Grande in southern New Mexico indicates that pottery was

decorated with simple floral motifs. Some wares were smudged black, while other wares exhibit little or no surface preparation. There is little ethnographic or archaeological evidence that clearly delineates the firing practices employed by Hispanic potters. However, evidence gleaned from sherds collected from archaeological sites, as well as from extant ceramics from Hispanic villages, indicates that the Hispanic population relied on firing practices akin to those used by local Native Americans. Therefore it is hypothesized that Hispanic pottery was typically fired in open, shallow depressions.

The history of land grant settlement may provide a clue for understanding access to fuel and may explain the difference in firing techniques noted for Hispanic pottery. The historic use of dung for firing pottery among Pueblo potters has never before been satisfactorily elucidated. This research offers possible insights for explaining why Pueblo potters switched to dung fuel in the eighteenth century. Hispanic access to wood fuel may explain technological differences noted for Hispanic pottery; however, in general, Hispanic pottery was fired like Pueblo pottery.

Pottery Uses

Hispanic culinary practices of the eighteenth and nineteenth centuries generally assimilated those of the native population. The obvious exceptions were Mexican culinary practices brought by the early resettlers after 1694 and the European tradition of baking and frying. In the typical Hispanic ceramic repertoire, ceramic form was directly related to ceramic function, unless the ceramic was recycled.

Bean pots and stew pots were the most common forms of cooking vessel. Legumes, meats, and grain products such as *posole* and *atole* were prepared in flaring-lipped pots. Some of these pots had double or single handles, others had no handle. The handle facilitated removal from corner fireplaces or outdoor fires and pouring. There were few pot lids or covers. Ethnographic evidence suggests that cooks probably used a plate, a bowl, or even a sherd as a pot

cover when necessary. However, some lids were likely made by the potters in Hispanic villages.

Molded or hand-coiled and -shaped hemispherical bowls were used for many purposes, such as drinking, food preparation, serving, and even storage. Small bowls were used also for the preparation of medicines, for personal hygiene, for pigments used for dyeing wool, and for pigments and dyes used in painting *santos* (images of holy personages) and furniture. Soup plates and bowls were mainly used for food serving, although these forms could have served as lids to cover pots.

Jars functioned as multipurpose containers. Some jars were made to transport and hold water, others were used for storage of liquids or

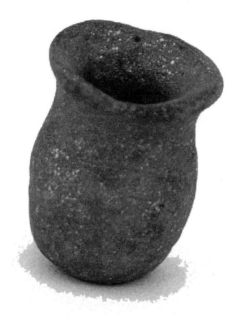

PLATE 4: PINCH POT. ABIQUIÚ, NEW MEXICO, 19TH CENTURY.
1 ¾" tall, 1 ¼" rim diameter. Used for holding Tierra Blanca, a white facial powder. Collection of Charles Carrillo family. Photograph by Paul Rhetts.

dry foodstuffs like grains, cornmeal, flour, or beans. Wine and brandy production in eighteenth- and nineteenth-century New Mexico has been noted by numerous historians. In areas where wine and brandy were produced, very large jars with burnished polished interiors were produced by specialists. The archaeological evidence from southern New Mexico, specifically the ceramic assemblages at Casa Colorada, suggests such production.

While the main function of ceramic *comales* (griddles) (see pages 75-77, Orlando Romero comal) was for cooking *tortillas*, these griddles were used also to sear meat and to warm food. Although frying is now a common element of traditional New Mexican cuisine, there are very few extant examples of either imported ceramics or Puebloan, Apachean, or Hispanic pottery that were used like modern frying

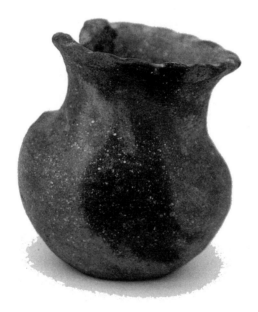

Plate 5: El Rito Micaceous Slip Candleholder, Abiquiú, New Mexico, 19th Century.
3" tall, 2 ½" rim diameter. Handle missing. Collection of Charles Carrillo family. Photograph by Paul Rhetts.

pans. The introduction of fried foods is inextricably linked to the introduction of European domesticated livestock. The fat from beef and pork yielded lard which was used in frying. It is likely that deep fat frying was accomplished in wide-mouth bowls or pots before imported copper or other metal caldrons were available.

Ceramic longevity has been addressed by numerous scholars who note that pottery which is used and moved on a regular basis has a shorter life than pottery which is rarely moved or infrequently used (Arnold 1974:153-54). In the 1950s in the Mexican village of Tzintzuntzán, Foster noted that the vessels with the shortest lives were cooking vessels, bean pots, and griddles. Serving wares fared somewhat better. More stationary pots – which tended to be larger – had the greatest longevity (Foster 1960a:608). Research concerning the principles of ceramic longevity include the work by Arnold (1985:153-158), Longacre (1981:63-64), Deboer (1974), Pastron (1974:109), and David and Hennig (1972:19). The same longevity patterns are hypothesized for pottery used in New Mexican Hispanic households during the seventeenth, eighteenth, and nineteenth centuries.

There is no documentation – either ethnographic or archaeological – for forms such as handled cups, baking or casserole dishes, or serving platters. Sound historical and ethnographic research suggests that early Hispanics probably found these forms unnecessary for food preparation and serving.

In addition to ceramics manufactured for food preparation, serving, and storage, other ceramics were made for household utilitarian use. These included candle holders, cosmetic containers, inkwells, and chamber pots. Some pots were even used as chimney flues. Limited numbers of pots were likely used in rituals and for devotional purposes. Rituals of a non-devotional kind included the preparation and storage of love potions and medicines in ceramic containers.

In short, ceramics played an important role in the daily needs of the Hispanic population throughout the eighteenth and nineteenth centuries. Pottery shapes most often associated with Puebloan manufacture prevailed throughout this time. Since potters were most often

marginal members of society, the more successful townspeople did not look to them for innovations, and so Hispanic potters naturally adhered to traditional shape categories favored by consumers. Resistance to change was strong; however, Hispanic potters did introduce new shapes such as pitchers.

When the railroad arrived in New Mexico in 1879-1880, ceramic traditions among Hispanic potters declined dramatically, while the tourist curio trade in Pueblo pottery exploded. Moreover, metal containers, cooking pots and pans, and American-made crockery slowly replaced Hispanic-made ceramics in most Hispanic villages and settlements. Despite this trend, some Hispanic potters continued to make bean pots or other cooking pots. They were responding to

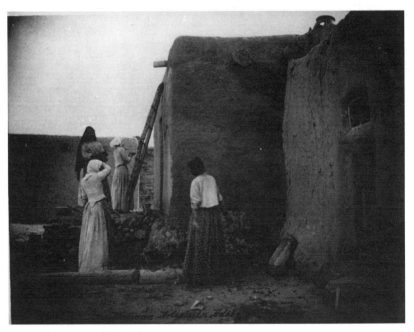

PLATE 6: ABIQUIÚ, NEW MEXICO. CA. 1897.
Of particular interest is the broken, reused pot in the upper right used as a chimney flue. From this photograph, it cannot be determined if this is a Hispanic-made pot; however, it is used to illustrate pottery reuse. Photo by Philip E. Harroun. Courtesy Museum of New Mexico, neg. no. 12534.

the demand by Hispanic villagers who preferred to eat food cooked in a traditional manner. Following the model proposed in this book, the potters continued to manufacture pottery to supplement subsistence activities and thus earn a living. As late as the early 1940s there were still a few potters making Hispanic pottery (see data on Abiquiú and La Madera). Unfortunately, no one documented pottery manufacturing techniques in Hispanic villages at this time; however, a few scholars and writers made cursory remarks about this tradition. Hispanic pottery is an important craft item of the late Spanish Colonial, Mexican Republic, and Territorial periods. This book will contextualize its importance and provide a more robust view of Hispanic life of the period from 1790 to 1890.

Introduction

For the past century, archaeological, ethnographic, and ethnohistoric research in the American Southwest, and more specifically in New Mexico, has largely concentrated on Native Americans. Among the myriad of data collected, perhaps the largest body of data concerns ceramics and ceramic analysis. Because of their widespread distribution in the Southwest, ceramics are still the most widely used determinants for chronology. Increasingly, however, archaeological ceramics are being used to improve our understanding of the social dynamics, especially the economic and political manifestations, in different areas around the world.

In the archaeological context of Hispanic sites from the Spanish Colonial Period (1692–1821), the Mexican Republic Period (1821–1846), and the Territorial Period (1846–1912) in New Mexico, the ceramics or pottery recovered through archaeological excavation or survey are often assumed to be of either Puebloan or Athabascan (Navajo and Apache) origin. This assumption has not been fully tested.

Previous research on Hispanic pottery production is rare. Only a few scholars have seriously addressed the problem of the identification of Hispanic ceramics in the archaeological record of New Mexico and southern Colorado. They include Hurt and Dick (1946), Dick

(1968), Carrillo (1987), and Levine (1990). No research has explored the causes that might have led to the development of a Hispanic ceramic tradition, but such causes might be found in the social, economic, and especially ecological and environmental influences operating in the New Mexican landscape during the colonial period.

More commonly, ceramic assemblages from Hispanic sites have been lumped with assemblages of Native American ceramics on the assumption that with few exceptions all historic ceramics derive from trade or from Indian servants using Indian pottery manufacturing skills in Hispanic households. A brief review of previous research will provide a better understanding of the manner in which Hispanic ceramics have been viewed.

The earliest archaeological work in the Southwest noted that the Río Grande Pueblos manufactured a variety of ceramics, which included red, brown, black, polychrome, and micaceous wares (Kidder and Shepard 1936; Mera 1939; Toulouse 1949). In contrast to the attention that has been lavished on prehistoric and historic ceramics manufactured by Pueblos, relatively little research has been carried out on the plain and utilitarian wares of the historic period, and none has been conducted for Hispanic utilitarian wares.

Most of the historic archaeology that has been conducted has again concentrated on abandoned pueblos and mission sites. Few Hispanic archaeological sites, villages, or individual homes have been surveyed extensively; fewer still have been tested or excavated. The few material culture studies that have been carried out always focus on "Spanish Colonial crafts" – more specifically architecture, textiles, ironwork, furniture, and religious images. The term "Spanish Colonial" has been widely used for seventy years, primarily by Anglo writers, in reference to the arts and crafts of Hispanic New Mexico. Since the inauguration of the Spanish Colonial Arts Society in the 1920s, the term has grown in popularity and given precedence to the arts and crafts of colonial New Mexico. The result has been a one-sided view of "Spanish" in New Mexico, established by both popular and scholarly writers who often forgot that all aspects of

Hispanic culture in New Mexico were filtered through the colony of New Spain and to a greater or lesser degree modified by this historical process. The notion of "culture bearers" bringing European culture directly to New Mexico, presented along with the notion that occupations involved in ceramic manufacture are "backwards and poorly remunerated," led to an early dismissal of the possibility of Hispanic New Mexican ceramic manufacture. Little has changed since the 1920s, and the attitude still current among many respected archaeologists is articulated below:

> While the Spanish imposed new shapes on native potters such as the "soup plate," handled mug and footed bases on dishes for table use, they seem to have left technical matters such as firing methods to their wards who continued to use their ancient methods. Thus fired bricks and terra cotta were never introduced into New Mexico (Boyd 1974:9).

and

> Archaeological evidence offered in support of Hispano pottery manufacture in New Mexico is inferential. The claim itself is neither historically nor ethnographically convincing. Because pottery manufacture is traditionally a low status, low income occupation throughout Latin America, historically associated with Indian behavior, it is neither a "Hispano" tradition nor activity considered commensurate with Hispanic values (Snow 1984:105).

Numerous archaeologists working in the Southwest have followed traditional typologies set forth by Kidder and Shepard in 1936, Mera in 1939, Shepard in 1956, and Harlow in 1973. Unlike Meso-American scholars who have remained alert to the possibility of specialization, few Southwestern scholars have seriously attempted to identify craft specialization in the American Southwest. More recently Bronitsky (1983), S. Plog (1980), Cordell and Plog (1979), and

Ford et al. (1972) have examined craft specialization among the Southwest's ancient inhabitants. The origins of pottery production in the Southwest have only recently been discussed, relating pottery production to increased sedentism and a greater dependence on cultivated foods, adding to a growing body of data concerning changing social and economic conditions that favored pottery production (Crown and Wills 1995).

The indifference to Hispanic site archaeology and material culture has a historical dimension. To Southwestern archaeologists, the study of Hispanic village, home, and ranch sites did not seem to offer the potential for rich and useful information, leading those scholars to turn to the native peoples and their seemingly more alluring and exotic material culture. But processual perspectives have brought about changes in attitudes that have led to studies of craft specialization.

Almost all the studies of Hispanic material culture have concentrated on the identification of formal classes of objects thought to be Spanish or Mexican in origin. Ceramics have traditionally been characterized in terms of formal properties related to Puebloan and Athabascan typologies. Ethnographic studies concerning ceramic material culture and the use of pottery among Hispanic New Mexicans are extremely rare.

This book examines the notion of Hispanic ceramic manufacture as a specific instance of craft specialization in New Mexico from the last decade of the eighteenth century until the coming of the railroad to New Mexico (1790–1890).

Many types of specialization have been described in anthropological literature. Robert Evans (1978) was perhaps the first to encourage archaeologists to operationalize these definitions. Since then archaeologists have differentiated between specialization and production. They recognize that raw materials are manufactured into useful objects – this process is production – while specialization is the process that systematizes and standardizes production.

Rice describes specialization as "the practice of a particular economic activity by a relatively small number of skilled individuals who engage in it for their primary livelihood," while standardization is "the lack of variation in attributes of composition, form and style within a particular category such as pottery" that often accompany specialization (Rice 1987:482). The numerous views of specialization include those of Rice (1981:220, 1987:482), Tosi (1984:23), and Costin (1986:238, 1991:4).

This research examines specialization in which individuals or families derive their subsistence by participating in a specialized activity, in this case, pottery manufacture.

> A more useful definition connotes a specific set of social — as well as economic — relationships, where sociopolitical integration is in no small part dependent on the fact that people are economically dependent on one another ... specialization is a differentiated, regularized, permanent, and perhaps institutionalized production system in which producers depend on extra-household exchange relationships at least in part for their livelihood, and consumers depend on them for acquisition of goods they do not produce themselves (Costin 1991:4).

Earle (1981) has discussed the difference between what he terms attached and independent production in craft specialization. More recently Costin (1991) has proposed an eight-part typology for the organization of specialist production. The data presented in this research for the development of Hispanic pottery as evidence of craft specialization in late colonial New Mexico dovetail with the first two specialization typologies tendered by Costin:

1. Individual specialization: autonomous individuals or households producing for unrestricted local consumption;
2. Dispersed workshop: larger workshops producing for unrestricted local consumption (Costin 1991:8).

This research, then, seeks to shed light on craft specialization in which the Hispanic potters are working in either individual or dispersed workshop situations.

> Items manufactured by independent specialists tend to be utilitarian. They are obtained and/or used by most – if not all – households on a frequent basis. Examples include food preparation tools, cooking and some serving vessels, clothing, tools used in basic households maintenance and subsistence activities, and basic household furniture. No restrictions are placed on the distribution of the products of independent specialists; in the most extreme cases all members of a society may be viewed as potential customers (Costin 1991:11).

The notion of specialization as it is presented in the ethnographic research (Longacre, Kvamme, and Kobayashi 1988) and theoretical treatments in the archaeological literature (Feinman 1986; Plog 1987; Upham 1982) typically associate specialization with standardized materials and/or manufacturing techniques.

Craft specialization for purposes of this discussion is considered to be an adaptive process in the dynamic interrelationship between people and the environment in which they live. In a more general sense, the concept of specialization refers to "a labor regime in which subsistence is obtained primarily through the performance of a delimited series of tasks, the output of which is used to procure other required goods or services" (Santley n.d.:10).

Ethnographic and archaeological evidence of Hispanic pottery from the southern region of New Mexico to the southern region of Colorado implies broad acceptance of certain stylistic criteria in the manufacture of pottery. This adherence to certain stylistic criteria in a large geographic area implies consensus on the part of both those manufacturing this pottery and those who use it. However, the differences in the availability of raw material, specifically clay, result in

a situation in which the generally accepted notion of "Ceramic Type," or even "Ceramic Type Site," becomes useless. In short, Hispanic pottery production in late-eighteenth- and nineteenth-century New Mexico resulted in a manufacturing procedure that used a variety of locally available sand-tempered clays and produced ceramic vessels which followed certain stylistic criteria. This resulted in a ceramic population that exhibits a tremendous amount of regional variation; nevertheless, this heterogeneous population of ceramics can be understood in the context of land disenfranchisement.

No broad scholarly research has hitherto examined the possibility of craft specialization within New Mexican Hispanic material culture, nor has much of this work been done on Southwestern Pueblo material culture (Cordell and Plog 1979; Plog 1980). The two notable exceptions in the literature on the Pueblo Indians, both of them closely focused on a single sort of craft product, are Shepard's (1942) study of Río Grande glazewares and Montgomery's (1963) study of fibrolite axes.

In general, archaeological research aimed at understanding and identifying craft specialization for complex civilizations and/or states has provided an enormous body of data, from which much has been learned. Examples from Teotihuacán and Uruk demonstrate socioeconomic differentiation in the form of shops, occupational barrios, and wards, all of which point to craft specialization (Rice 1981). However, attempts to understand craft specialization among non-industrialized peoples or societies are almost nonexistent. In ceramic studies, the work of Rice (1981) and Shepard (1942) stand out.

This research provides an operative study of how the manufacture of ceramics among the Hispanic population in the late eighteenth and nineteenth centuries evolved from what may have been a typical activity performed by self-sufficient households in Hispanic villages into a specialized economic pursuit by a number of Hispanic villagers who used this specialized craft to earn a living. It will also provide a basis for modeling the past and aid in the development of inferences about social, political, and economic structures

independent of direct historical records apart from the ethnographic analogy.

To address the question of Hispanic ceramic production and specialization, this research will build upon a model of ceramic specialization proposed by Dean Arnold (1985). Currently there is no available hypothesis for explaining either the reason that Hispanic ceramic traditions developed or the role that ceramics played in shaping the socioeconomic structure of New Mexico during the period under consideration.

In order to study the craft specialization of pottery a theoretical structure is needed for inferring the existence of specialists. Until Dean Arnold's study appeared in 1985, no comprehensive theoretical or methodological model was available. Arnold's model has, since then, shaped the research interests in ceramic specialization. The research presented here espouses the theoretical scheme proposed by Arnold and provides a framework for examining the ceramics produced by Hispanic villagers in New Mexico in the eighteenth and nineteenth centuries.

A data base consisting of archival (documentary), ethnographic (oral history), and archaeological records will be interpreted using Arnold's model, and once interpreted this data base will lead to an improved understanding of the origins, distribution, and time sequences of Hispanic ceramics made and used in New Mexico in the late eighteenth and nineteenth centuries. This same model will also be used to explore the social, economic, and cultural meanings and implications of ceramic specialization among relatively landless Hispanic New Mexicans.

This model will put Hispanic ceramic specialization into relation with the environmental, social, and economic factors that operated in the frontier colony of New Mexico. These factors can be considered "forcing" or "limiting" conditions which shaped the nature of Hispanic pottery traditions. Increasing population pressures and the economic shifts that occurred in the 1780s as part of the Bourbon reforms[1] of New Spain were the primary causal factors that led to

craft specialization among some Hispanics in villages and settlements throughout colonial New Mexico. Hispanics of that era found that craft specialization in pottery was an efficient economic strategy to improve the chances of survival in difficult times.

The term "Hispanic" as used in this research refers to those people who were culturally, though not necessarily biologically, Spanish. From the time of the recolonization of New Mexico in 1693 and well beyond the American occupation in 1846, the Hispanic population can be characterized as a population in transition. The social and political dynamics operating in this frontier colony perpetuated change. A unique Hispanic New Mexican identity developed, re-plete with a distinctive language, religious values, and notable folk art. In short, the Hispanic population of eighteenth- and nineteenth-century New Mexico was a menagerie of frontier peoples. The separate New Mexican identity was caused in part by a geographical and cultural-psychological separation from New Spain (later from México), and especially from Spain, and in part by the cultural separation from the local Native Americans.

An operational definition may prove helpful: A traditional New Mexican Hispanic was a person who chose to live in a Hispanic manner by residing in a Hispanic village or settlement. This included *genízaro* villages that are now Hispanic villages. It also included the homesites occupied by Hispanic settlers that were not attached to larger planned plazas such as scattered ranch sites or extended family *placitas*. These individuals chose to live in New Mexico rather than in Spain or New Spain (México), and they chose to live in a Hispanic village or extended family residence or *placita* rather than in a pueblo or nomadic encampment. They also chose or were forced to speak Spanish rather than an Indian language as their primary language, and to believe in and practice Catholicism rather than a Native American religion. Biologically many of the people who made this choice were totally or predominantly Native American.

Numerous studies have examined ethnic labeling in New Mexcio, from the time of the first colonization efforts until the present.

To date the most comprehensive study is that done by Bustamante
(Bustamante 1983). He concludes:

> Hispano is used here in a cultural sense, that is, it
> identifies those individuals who participate in the
> Mexican-Spanish elements of the culture to a greater
> or lesser degree. Though much cultural change and
> cultural accretion have occurred, the basic cultural
> elements of the Spanish language, Catholicism as the
> primary religion and rites of passage of the social
> system are of Spanish origin. Also hispano is the most
> neutral of all the ethnic terms used by the group.
> However, the present author recognizes that no one
> term is satisfactory to all at all times which is, in-
> deed, the reason for this study (Bustamante 1982:6).

For purposes of this book, the same strategy will be adapted. Nu-
merous other ethnic labels have been used by New Mexican
Hispanos to describe themselves including *español, castizo, mestizo,
genízaro, mexicano, vecino, hispano, chicano,* Spanish-American, Mexican-
American, Hispano-Americano, *latino, neo-mexicano,* and more recently,
Hispanic.

Outline

Chapter 1 contains a historical overview of New Mexico from
the time of the first Spanish colonization in 1598 until the end of the
territorial period in 1912. This overview provides the context for Span-
ish Colonial and Mexican Republic policies of land acquisition, settle-
ment, and land tenure.

The New Mexican evidence for a Hispanic ceramic tradition is
the focus of Chapter 2. It begins with a discussion of the assumptions
that inhibit recognition of a Hispanic pottery tradition. Archival data
drawn mainly from the Spanish and Mexican Archives of New
Mexico; oral histories collected mostly from older Hispanic village
residents; and the record of numerous Hispanic site excavations in

the past thirty or so years join to form a quite adequate historical record, rich and unified though admittedly not as complete as we might wish it were.

The reorientation of long-distance trade during the last decades of Spanish rule profoundly affected the Hispanic populace in New Mexico. Descriptions of the late colonial economy clearly show that Pueblo pottery was a substantial part of the goods exported to México. The impact of this new trade in Puebloan pottery, its effects on the Hispanic population, and changing Hispanic demographics are explored in Chapter 2 as part of the New Mexican evidence for a Hispanic ceramic tradition.

Next, specific cases from the Hispanic villages throughout New Mexico are examined, from the Mesilla Valley in southern New Mexico to settlements in southern Colorado. Some of the Hispanic communities are located along the Río Grande and its tributaries; others are located in mountainous areas. All the villages or archaeological sites examined in this research were established after the recolonization of New Mexico in 1693, and the evidence drawn from excavation dates from the 1730s to the 1860s. They include small villages or settlements such as Las Huertas near Placitas and larger settlements like Córdova, New Mexico.

Chapter 3 examines a test case from the Hispanic village of Abiquiú, New Mexico.[2] The Abiquiú case study provides the archival and ethnohistoric documentation and the archaeological data necessary for understanding pottery production and craft specialization at one Hispanic village in New Mexico. This information does not exist for any other Hispanic village; therefore Abiquiú is a unique test case. The role of clay, temper, and fuel in the production of Hispanic pottery will also be considered in this test case. Selection of different tempering materials by Hispanic and Pueblo potters in this region will be addressed to provide data for the long-standing debate on the possibility of Hispanic manufacture. This information will provide the pivotal argument in this research for inferring the existence of a Hispanic pottery manufacturing tradition in late-eighteenth- and nineteenth-century New Mexico.

It is interesting to note that don Pedro Bautista Pino commented
in 1812:
> In addition to the usual kinds of soil and clay, there
> are others worthy of attention, owing to their quality
> and fineness. In the pueblo of Ácoma there is one
> called 'rock clay,' of black color which could be worked
> on a wheel to produce all manner of ceramics for
> common household use.

The original Spanish reads:
> Hai ademas de los comunes, otros dignos de atencion
> por su calidad y finura. En el pueblo de Ácoma se
> encuentra uno llamado barro piedra, de color negro,
> del que se pueden trabajar a torno toda especie de
> vasijas para el uso comun de las casas. don Pedro
> Bautista Pino, 1812 (taken from Bustamante 1995:14,
> facsimile 11) [page 27]

Chapter 4 examines Arnold's 1985 model, which provides a set
of generalizations described as feedback mechanisms that stimulate
or diminish ceramic production. The fundamental suppositions are
that certain universal processes that involve the manufacture of ce-
ramics are ultimately tied to ecological, cultural, and chemical fac-
tors. An understanding of these factors provides the basis for exam-
ining colonial Hispanic craft specializations in general and ceramic
specialization in particular.

Chapter 5 examines the assumptions of Arnold's model of craft
specialization. Arnold suggests that the pattern of pottery specializa-
tion, a widespread phenomenon, is a solution to insufficient land or
agricultural resources. In this research specialization is addressed from
a broad ethnographic perspective using non-Southwestern peoples
who are comparable on many points to the New Mexican Hispan-
ics. Comparative ethnographic data indicate that ceramic specializa-

tion is common worldwide. The resultant parallels between particulars of Arnold's model and the New Mexican evidence will demonstrate the inevitable emergence of craft specialization in New Mexico.

The second part of Chapter 5 will examine the hypothesis that, because some Hispanics were disenfranchised (that is they had poor, insufficient, or no land), they turned away from agricultural pursuits and toward craft specialization. Specialized manufacture of pottery was one such possibility among Hispanic New Mexicans. The production of craft items such as pottery provides non-agricultural options in densely populated regions where agrarian subsistence is the prime source of nutrients (Netting 1990:43).

Within the framework of this overview, the socio-political and socioeconomic structure of colonial New Mexican demographics will be examined. The population data provide a synchronic overview that helps to demonstrate how many Hispanic people became disenfranchised. This chapter will examine the notion that specialized pottery production is an occupation of last resort, conferring a low status on the specialist (D. Arnold 1985; Berns 1986; David and Hennig 1972; Foster 1965; Matson 1965). The notion that craft specialization among disenfranchised Hispanics can be understood as a strategy which allowed households access to a more diverse economic base in colonial New Mexico will also be examined. The situation of landlessness and land debasing that was partially responsible for the emergence of craft specialization will be detailed in the application of the Arnold model for the Hispanic populace in eighteenth- and nineteenth-century New Mexico.

Finally, this book examines the implications of its findings about Hispanic New Mexican ceramic specialization for historical research on and interpretation of New Mexican material culture, and it will rectify the lack of attention devoted to Hispanic ceramics of eighteenth- and nineteenth-century New Mexico. This section of the study will reveal the nature of craft specialization in general and ceramic specialization in particular, and it will provide an alternative explanation for the presence of certain pottery assemblages found at his-

toric Hispanic sites. The application of Dean Arnold's 1985 model to the archaeology of Hispanic New Mexico has significant potential for archaeological studies in the Southwest and for ceramic studies in general.

Chapter One
Spanish Colonial New Mexico

The northernmost frontier area of New Spain, known as New Mexico, was first colonized by Juan de Oñate in 1598. Oñate located his headquarters at the confluence of the Río Grande and the Río Chama, naming it San Gabriel de Yunqueouinge. This initial colony consisted of some 130 soldiers, their families, and their servants. The colony grew in size and by 1608 boasted the settlement of Santa Fe, which came to include the Barrio de Analco, a Mexican Indian *placita*. Franciscans established missions at nearly all the Río Grande pueblos as well as in the Salinas district of eastern New Mexico, including Gran Quivira, Abó, and Quaraí. Missions also were established among the western pueblos of the Zunis, Ácomas, and Hopis.

The early Hispanic settlers introduced the *encomienda* system to New Mexico. This system, already in vogue in México, was originally intended to extract tribute from the native population in the form of produce or goods from the adjacent Pueblo lands. In some cases the tribute was actually paid in the form of personal service. Records of the early *encomiendas* were destroyed during the Pueblo Revolt of 1680.

Hardships and drought led to the abandonment of the Salinas district pueblos by the 1670s. Hostilities with nomadic Indians, drought, disease, and environmental depredations added to the difficulty experienced by Pueblo peoples, whose leaders cooperatively planned and successfully executed the great Pueblo Revolt of 1680. The general Hispanic population and ecclesiastical leaders reluctantly abandoned the frontier colony of New Mexico in August of 1680. The colonial outpost of New Mexico remained in the control of its native peoples, who removed nearly all vestiges of Spanish domination during the revolt. The frontier area north of the present-day cities of Cuidad Juárez, México, and El Paso, Texas, remained unoccupied by Hispanic settlers until 1692–1693, when Don Diego de Vargas successfully reestablished the colony of New Mexico. The recolonization efforts of 1693 found most of New Mexico's native population occupying the best agricultural land along the Río Grande, lower Río Chama, and upper Pecos drainages and their tributaries. Within two years, soldiers, equipment, and settlers were arriving in the reestablished colony. The settlers included not only a few of the former settlers from the previous colony but many new recruits from the Valley of México and the Zacatecas area in northcentral México.

For the first three decades of the new colony, the population grew somewhat unsteadily. The most complete research on colonial New Mexican population records can be found in the recent dissertation by Ross Frank (1992) and the work by Tjarks (1978:45–88).

The first reliable and complete population statistics of New Mexico were compiled in 1748 by Don José Antonio de Villaseñor y Sánchez[3] (Tjarks 1978:49). The population of New Mexico continued to increase despite numerous factors that would normally tend to limit growth. These included infectious diseases, death due to warfare, and an economy that never allowed more than mere subsistence-level survival.

Vecino[4] [resident Hispanic New Mexican] population growth did not proceed entirely from natural increase. The period between 1760 and about 1785 saw the

highest levels of intermarriage between Indians and
Vecinos during the colonial period, as a result of close
cooperation and proximity encouraged by their com-
mon defense of the province against marauding
Plains Indians (Frank 1992:193).

While the majority of the population was concentrated along
the Río Grande, especially at or near Santa Cruz de la Cañada, a
hierarchy of core or mother villages began to develop by the middle
of the eighteenth century. It is from these core villages that other
villages "budded off" as the Hispanic population grew. Villages like
Abiquiú in the northwest (1743) and La Plaza de Nuestra Señora de
los Dolores de los Genízaros in Belén in the southern part of the

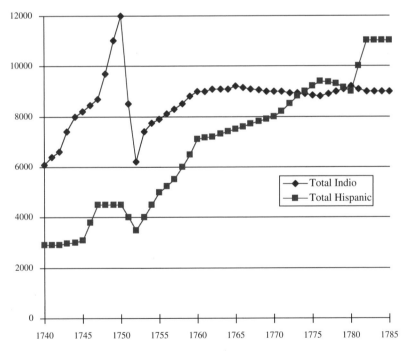

FIGURE 1: POPULATION OF NEW MEXICO, 1740-1785
(adapted from Frank 1992:54)

colony (1740) acted as *genízaro* buffer villages at two of the colony's many frontiers (Córdova 1979; Horvath 1979).

Generally *genízaros* came from nomadic tribal ancestry, although work by Swadesh in 1974 and Córdova in 1978 shows that a significant minority of the *genízaro* population was of Pueblo ancestry. *Genízaros* were detribalized, hispanicized Native peoples who lived in Spanish-style villages. Bustamante states:

> As had already begun to happen during the Spanish Colonial period, multi-ethnic groups continued to mix during the Mexican period. Legally at least, the social barriers caused by the *casta* system with its concomitant social stigma had been removed by the fact that México achieved its independence from Spain. During this period those still being distinguished as ethnically different were the *criados*, the *genízaros* and the Pueblo Indians. The Pueblo Indians had persisted in maintaining the cultural identity and independence even though there was some intermarriage between them and the Mexicans. The *criados* and the *genízaros* were being rapidly assimilated as they and especially their children became more accepted into the Mexican society since there is no evidence of endogamy being practiced by the Mexicans. In the main, the social differentiation during this time was now between the *ricos*, and a small middle class of professionals and the *pobres* who ranged from the self sufficient small land holding villagers to the vagabonds who roamed the province (Bustamante 1982:93).

Before 1779, the year of the Spanish victory over the principal band of Comanches, years of warfare had taken their toll on New Mexico's Hispanic population. From the 1750s until the end of the 1770s Apache, Ute, Navajo, and Comanche hostilities checked the

population growth of New Mexico, cutting off agricultural lands and slowing commercial activities. Military campaigns against nomadic Indians, especially Comanches and Apaches, had led to some degree of peace in the relations between Hispanics and the Indians (Jones 1962:93–107; Moorhead 1968:277–284; Weber 1982).

In 1780 and 1781 a smallpox epidemic also ravaged the population of the remote New Mexican frontier province, but the Hispanic population bounced back quickly and saw a tremendous growth that lasted for at least the next five decades (R. Frank 1992:6-74).

In increasing numbers New Mexican Hispanics were moving into uninhabited areas. The strategy employed by the New Mexican Hispanic population resembles the general model proposed by Boserup (1965), which argues that population growth forms an independent variable and thus represents a major factor in determining agricultural development. In this model the expanding population can turn to three alternative strategies to increase available supplies of food. These strategies are to: 1) intensify production, 2) change or intensify production technology, or 3) bring new land under cultivation. Groups under pressure may select combinations of these methods or use only one strategy (Boserup 1965). During the late colonial period New Mexican Hispanics most often chose the third option. With the lessening of the threat of Indian hostilities in the 1780s, Hispanics began a process of expansion that radiated out from the established population centers. As Frank points out:

> Colonial New Mexico represents an example of growth related primarily to change in population. A very high statistical correlation between population and tithe rentals from 1730 to 1821 underscores the close relationship between population and economic production. The commercial expansion during the late colonial period served as an important factor in encouraging and sustaining the growth of the population. The population of New Mexico rose dramatically during the last half-century of Spanish rule,

driven by growth in the *Vecino* (Hispanic) popula-
tion. By 1821, the *Vecino* (Hispanic) population num-
bered over 25,000 persons, compared to around 4,500
in the 1740s (Frank 1989:6).

Census data of the 1790s indicate that the Hispanic population
was growing extremely rapidly and that new villages were estab-
lished when groups of families broke away and settled in previously
unsecured secondary drainage basins. This splinter process was par-
tially due to the relative peace that had been established by Gover-
nor Juan Baptista de Anza, who was in charge of the colony of New
Mexico from 1778 to 1788. While peaceful relationships between
Hispanics and native peoples surely provided ideal conditions for
the expansion process, the present writer will argue that population
pressure was the cause that pushed Hispanic settlers into new areas.

In many cases, because of the age of the individuals, the inability
to move, or other cultural or political factors, many families and indi-
viduals remained on lands settled by their ancestors. In areas along
the Río Grande and Río Chama the carrying capacity of the agricul-
tural land likely decreased relative to the increased population size.
This reduction of the productivity per capita may have forced His-
panic families either to seek alternative living sites in areas of mar-
ginal agricultural output or, if they could not or would not move, to
develop alternative subsistence strategies to supplement their income
or to produce the entirety of it. The manufacture of pottery is exam-
ined as a possible craft specialization resulting from this strategy shift.

In many of the areas occupied by Hispanic settlers after the mid-
1700s, such as the mountainous regions of northern New Mexico
and southern Colorado, the soils were poor and land was marginal.
The vast majority of land in New Mexico is not arable. Since colo-
nial times, arable land has been considered an immensely valuable
possession.

Apparently, over the years, numerous landlords oc-
cupied the arable land on the [Cañones Grant] and

established usufruct grazing rights on its *ejidos* [common land]. For example in the Cañones microbasin there are presently (1981) 120 individual plots of arable land within the confines of the northwestern section of the grant, totaling only 168 acres of land. These tracts are situated in intermittent natural pockets, which would indicate that they did not become numerous through subdivision among heirs. Indeed, the majority of them have been in the hands of Cañones community residents for generations (Westphall 1988:140).

Few scholarly writers have examined the fact that population pressures in the existing communities were agents in this splinter process.

As the population of Hispanics increased after the mid 1700s, the notable expansion of Hispanic villages into small tributary drainages from the late 1790s until the early 1860s parallels the shift by Hispanics to specific kinds of non-agricultural work, namely craft specialization. In New Mexican Hispanic villages the cottage-industry mode of production of woolen textiles for household use and export is the most obvious example of craft specialization. The specialists included carders, spinners, and weavers. Significant research is available on the textile industry of colonial New Mexico. Literature addressing issues related to the development and maintenance of the Hispanic weaving traditions has added to our understanding of the tradition (Burroughs 1977; Ehly 1973; Fisher 1979; Jaramillo-Lavadie 1977; Lucero 1986; Stoller 1979; Wheat 1979). However, the research has failed to provide any evidence as to the feedback mechanisms that favored the development of this type of craft specialization. In developing and maintaining non-agricultural subsistence activities, Hispanics solved the critical problem of how to use lands that are marginal or poor in respect to agricultural production but rich in the raw materials necessary for pottery making:

With the progressive elimination of primary subsis-
tence activities like agriculture because of popula-
tion pressure, marketing strategies must develop in
order to turn pots into food if ceramics production is
to serve as an alternative to direct food production.
Thus a potter may utilize extensive networks of ex-
change, trade and distribution to exchange pots for
food (Arnold 1985:227).

By the 1770s the power structure of the government of King Car-
los III[5] underwent significant changes. In 1772, the defense system of
northern New Spain was reorganized and the defensive fortifica-
tions known as *presidios* were realigned. Coupled with the sweeping
economic changes that were affecting New Spain, the Bourbon re-
forms had a profound effect on the frontier colony of New Mexico
(Frank 1992). Late colonial economic growth spurred by the Bour-
bon reforms in México and strengthened by an increasing popula-
tion base in New Mexico provided the impetus for a cultural self-
definition of New Mexican Hispanics. This self-definition hardened
the cultural boundaries between the Hispanic population and the
Pueblo Indians. The social and economic position of the Pueblo Indi-
ans suffered after 1785, declining relative to that of the Hispanic popu-
lation. Hispanics increasingly participated in the long-distance trade
to southern markets in México. The archival evidence shows that by
the early 1790s a large-scale coercive mechanism existed for the ex-
traction of goods for export (Frank 1992). Evidence for the exporta-
tion of New Mexican goods to southern markets will be examined
in Chapter 5.

Population increases in Hispanic villages resulted in a vigorous
centrifugal movement from the core area into new areas, such that
by the time of the American occupation Hispanics had settled and
were using almost all the irrigable land in the Río Grande, Río Chama,
and Pecos River valleys, along the eastern and western slopes of the

Sangre de Cristo mountain range, and in nearly all mountainous watersheds in central and northern New Mexico.

> By the end of Mexican rule little Hispano ranches and villages – crude clusters of adobe and stone houses in a labyrinth of pole and brush corrals – were found in every irrigable valley for seventy miles along this eastern flank of the high mountains (Meinig 1970:30).

The relationships of pottery manufacture to the environment and Hispanic culture can be understood as a series of feedback mechanisms. Population pressure in late colonial New Mexico was one such feedback process that favored and maintained the production of pottery by disenfranchised Hispanics. Concerning population pressure Arnold offers this insight:

> The social position of potters in the household industry is related to population pressure and the sexual division of labor. When women are potters, the craft may be valued because a woman can supplement her husband's income from subsistence activities. When male subsistence activities are eliminated, however, and the amount of agricultural land diminishes, scarce land is highly valued and land ownership becomes a source of power and prestige. Population pressure forces men into the craft and the social position of the potters thus decreases because of their limited access to or ownership of agricultural land (Arnold 1985:226).

In late colonial New Mexico the progressive elimination of agricultural lands, the primary subsistence base for Hispanic settlers, forced individuals to develop new strategies that could turn crafts into food. More specifically, some disenfranchised Hispanics turned to the craft

of pottery to make a living. Pottery production by individuals or even households in some Hispanic villages in late colonial New Mexico is thus an adaptation of the population to a specific kind of non-agricultural resource; it is a strategy of using land which has available ceramic resources like clay and temper but which has little or no unexploited agricultural potential.

Land Tenure

Understanding the conditions that favored Hispanic pottery production requires a brief review of land tenure practices that evolved in colonial New Mexico. Land tenure is the combination of custom and law by which groups, families, and individuals occupy, own, use, and transfer land. The characteristic Hispanic land-tenure practice in the earliest period of the colony (1598–1680) was a combination of *encomienda* and *repartimiento,* the granting of land and of the services of the indigenous persons living on the land. Instead of taking the land away from the indigenous people (as with Anglo plantations on the eastern seaboard) or taking the indigenous people away from other lands (as with African slavery), the Spanish took both the indigenous people *and* their land. The Pueblos may still have "owned" the land, but much of the benefit of the land and the people's lives and labor on it ended up in Spanish pockets, mainly because of the combination of *encomienda* and *repartimiento.*

In this manner Juan de Oñate and the early Spaniards attempted to integrate the pueblos and the Indians who lived in them into the feudal system of the Spanish Empire: the military officers and their families would be the aristocratic lords, and the Pueblo Indians would be the serfs. The lord owed his serfs leadership, protection, generosity, and Christianization, and the serfs owed their lord honor, obedience, and tribute in the form of labor or the products of labor. This seemed to the Spanish colonizers a fine way of getting some use out of the Pueblo peoples, who conveniently were sedentary agriculturists who lived in towns, not nomads who needed to be gathered into *reducciones* and "reduced" to a settled serfdom. As Ortiz puts it:

Settlements were formed through a variety of feu-
dalistic manorial tenure by families which settled
along the [Río Grande] River from Socorro to Taos.
Feudalistic estates may have developed as large ha-
ciendas surrounded by irrigated farm and grazing
lands, for it is clear from existing documents that set-
tlers tended to be isolated from one another and to
depend on Pueblo labor (Ortiz 1980:33).

In parallel with the *encomienda*, the settlers and missionaries used
a related system of conscript labor called *repartimiento* which had a
profound negative impact on the social system of the Pueblo peoples
especially because of the way it damaged their agricultural tradition.
The Spanish had founded only one town, Santa Fe, for the majority
of the colonizers lived close to the people who were bound to them
by the twin feudal ties of *encomienda* and *repartimiento* so that they
might supervise the work the people performed for the Spaniards'
benefit.

These colonial systems of oppression, based on Medieval Euro-
pean land tenure practices, brought on the 1680 Pueblo Rebellion:

The culture and land tenure of the seventeenth cen-
tury was Pueblo, not Spanish, with colonial rule and
oppressive superstructure unintegrated with the
[Pueblo] society at any level (Ortiz 1980:39).

The *encomienda* and the *repartimiento* were exactly that "oppressive su-
perstructure."

Under Diego de Vargas, the Spanish returned in 1692–1693 to
recolonize New Mexico. The occupants of various pueblos resisted
from time to time during the first several years, either rising in revolt
or running away to the Great Plains or to the Hopi mesas in north-
eastern Arizona. But they finally realized that the Spanish had learned
the lesson of 1680 and that they intended to abide by the "New

Deal" they had offered to the Pueblo peoples. There would be no more encomiendas; indeed, even the *encomienda* promised to De Vargas was never activated (Kessell 1989). Instead, the Spanish would reestablish Santa Fe and then found their own communities, like Santa Cruz in 1695 and Albuquerque in 1706, and innumerable other villages and settlements, such as Abiquiú in 1734, Ojo Caliente in 1735, Tomé in 1739, Valencia in 1740, Ranchos de Taos in 1744, Belén in 1740, and Las Trampas in 1751, and the Pueblos would live by themselves and for the most part govern themselves (Ebright 1994:26). They needed only to accept a Franciscan missionary and cooperate with their Spanish neighbors in matters of mutual advantage, such as irrigation systems and defense against the nomadic marauders.

Through the governors, the Spanish crown gave the Hispanic *vecinos* various grants of land, most of them not occupied by the Pueblo Indians; the gift of the inhabited Santa Cruz area occasioned one of the early rebellions, and the governors thereafter tried not to give to the Hispanics land that the Pueblos owned. At first many of these gifts were individual and family grants, often for grazing, but as the Hispanic population increased the majority of grants were community land grants to which groups of families would migrate and erect a new village; they no longer moved to an existing settlement of Indians and colonized them by *encomienda* (Ortiz 1980). Malcomb Ebright adds:

> Land grants in New Mexico fell into two main categories, which were determined more by custom than by written law. A private grant was made to an individual who would own the entire grant and could sell it after the possession requirement was met. In the eighteenth century, more land grants in New Mexico tended to be private grants, probably an outgrowth of the seventeenth-century *encomienda* practice. Community grants became more prevalent in the nineteenth century.

In the case of a community grant, individuals in a
group of settlers would each receive an allotment of
land for a house (*solar de casa*), an irrigable plot (*suerte*),
and the right to use the remaining unallotted land
on the grant in common with the other settlers for
pasture, watering places, firewood, and logs for build-
ing, as well as for hunting, fishing, gathering herbs,
and rock quarrying, among other uses. Depending
on the lay of the land, these allotments were often
combined into one plot – usually a strip of land run-
ning from the river to the foothills. A settler would
own his allotment free and clear after four years, and
could sell it as private property. But the common lands
were owned by the community and could not be
sold (Ebright 1994:24–25).

The grant documents were invariably written in such a way as to
require the grantees to reside on their land permanently. Absentee
ownership was completely alien to the legal requirements and to
the essential purpose of these community grants.

Community grants were given in large numbers because the His-
panic population was growing quite rapidly. *Vecinos* who found that
they were "surplus population" approached the governors and claimed
that they needed land to pursue the farming and stock raising that
made up the vast majority of the eighteenth-century New Mexican
economy. In such an agrarian-ranching world, a town can get only
so big because there is no more land where people can farm and run
animals (Fergusson 1931:285).

One reason the Hispanic population boomed was the addition
to the reconquest settlers of a remarkable large number of *genízaros*,
detribalized hispanicized Indians from Puebloan, Plains, Basin, or
Athabascan peoples. By the late eighteenth century, they may have
composed as much as a third of the Hispanic population of New
Mexico (Schroeder 1972:62).

If they had come into Hispanic families as *criados* (servants by capture or purchase, an unhappy late survival of feudalism), they gained their freedom on marrying or on reaching age twenty-one. As early as the 1740s, colonial authorities actively recruited them, offering them land grants and providing them with the means to get a new start in life if they would settle on the periphery of the New Mexico colony (Belén, San Miguel del Vado) or in the vulnerable gaps (Las Trampas). One such peripheral community was Santo Tomás Apostal de Abiquiú, where the number of detribalized Puebloans was so large that they were a clear majority of the *genízaro* population of the Santo Tomás Plaza. Adult males in such villages were so often involved in frontier skirmishes that their mortality rate was quite high (Swadesh 1974:41–42).

In some cases *genízaro* populations were forced to relocate. In 1780, Governor Juan Baptista de Anza tried to move the *genízaros* of the Santa Fe Barrio de Analco, but they successfully appealed to the commandant-general of the northern region on the grounds that they were a long-established community (Thomas 1932:92). But other groups of *genízaros* were not so lucky, and even the Analco people may have suffered forced relocation to the San Miguel del Vado area, when Pecos Pueblo's disastrous decline created a defensive emergency in the upper Pecos Valley.

Whether given to *vecinos* or to *genízaros*, the community land grants of the eighteenth and nineteenth centuries went quite a way – though not by any means all the way – toward satisfying the Hispanics' life-or-death need for new lands for ranching and farming.

Farming was the principal subsistence resource in colonial New Mexico, although pastoral activities added greatly to the local economy. Farming was practiced in plots irrigated by a system of irrigation canals called *acequias* that derived water from the Río Grande, Río Chama, Pecos River, as well as mountain watersheds in areas like Chimayó, Truchas, and Mora. It is therefore not unusual to find that the most complete census of the Spanish colonial period, that of 1790, enumerated most males as farmers (Tjarks 1978:45). Small land-

owners who farmed the land typically acquired it in three ways. Many became owners through the land grant system allotting them a *suerte* or lot drawn from irrigable land; others purchased it; and still others inherited it.

Relatively little has been done to account for the distribution of the types of agrarian sociopolitical systems that were operating and emerging in the wake of a growing New Mexican Hispanic population. The problem lies in translating statistics on Hispanic and Native American population densities and distributions along with information on agricultural techniques and carrying capacity into meaningful data that reflect both the demographic conditions and the gradual shift by both populations into alternative subsistence strategies.

Frank relates that the bulk of growth during the late colonial period was a result of increasing fertility of the Hispanic population and attributes this trend to the fact that first marriages of Hispanic females occurred at a relatively young age. In theory, earlier marriage should increase fertility and thus family size (Frank 1992). In most documented cases from colonial New Mexico, land was acquired through inheritance. This practice ensured that succeeding generations would have land to farm and was accomplished by the feudal system of dividing lands into narrow strips which ran from the river at the bottom to the *acequia madre* (the main canal) at the top. Eventually families became disenfranchised from their lands when the land was too poor in quality or too small in quantity and when there was no one left to work the land for aged or widowed individuals. The continuing lack of an adequate supply of good (and new) land will play a key role in the cause-and-effect argument of this thesis.

Before presenting the archival, ethnographic, and archaeological evidence for a Hispanic pottery tradition in Chapter 2, it is necessary to examine the changing pottery traditions operative among the Pueblos, and to understand these changes as part of a dynamic frontier economy that was evolving. During the late eighteenth century, His-

panic households began to make their own ceramic vessels; this
gradual switch from the dependence on Puebloan pottery to pottery
produced at numerous Hispanic villages is examined in the section
that follows.

Shifting Pottery Production: The Switch from Pueblo-Produced Pottery to Pottery Made by Hispanic Craft Specialists

The cultural and ecological processes which favored the appear-
ance of a Hispanic pottery tradition in the mid- to late-eighteenth
century can be related to population dynamics. Some individuals or
families, having become disenfranchised from their land base, sought
alternative subsistence strategies. Making pottery to supplement their
income or as an entire source of living was one such option.

During this time period many changes were taking place both
within the local economy of New Mexico and within the greater
economy of New Spain. Coupled with the effects of disenfranchise-
ment from a land base and the changes within the colony and in
New Spain, numerous mechanisms evolved that encouraged His-
panics to begin producing pottery. One such mechanism or "push"
will be explored below.

This section will examine the shift of Hispanic peoples from a
nearly total dependence on Pueblo-made pottery to the use and
manufacture of Hispanic pottery by individuals or families who, for
purposes of this discussion, are identified as craft specialists. The
changeover is linked to the late colonial economy of New Mexico in
which a dramatic change in the economic status of Pueblo pottery
manufacturers ultimately led to social change not only among the
Pueblo Indians but also among the Hispanic population.

The dependence of Hispanic settlers on Pueblo-made goods, in-
cluding pottery and textiles, began with their arrival in New Mexico
in the summer of 1598. Throughout the early colonial period from
1598 to 1680 and again from the time of recolonization in 1693
throughout much of the next century, occupants of Tewa, Tiwa, Towa,

and Keres pueblos manufactured a variety of pottery types which they regularly traded or bartered with their Hispanic neighbors. This information has generally been cited as adequate evidence for denying that a tradition of Hispanic pottery-making ever existed in New Mexico (Hackett 1937; Schroeder 1964; Snow 1984).

In his 1993 article Ross Frank provides insight on the development of a Hispanic pottery tradition in New Mexico. The late 1780s surge in New Mexico's economic activity and the increased long-distance trade to northern New Spain can provide important clues for interpreting the rapid shift in material culture of both Pueblo Indians and Hispanic villagers. Frank tells us:

> A reading of late-eighteenth-century Pueblo pottery reveals Indian potters under pressure to change pottery-making traditions in order to produce for a non-Indian market, and suggests the need for a reexamination of relations between Spanish settlers and Pueblo Indians at the end of the colonial era (Frank 1992:283).

Frank (1992) relates that the eighteenth-century long-distance trade system lasted until the 1770s and typically supplied the external markets to the south with goods obtained from Plains Indians. These goods were acquired by barter during the annual trade fairs. By 1786 the Spanish and Comanche treaty alliance had been secured, and a new economy began to emerge. The expanding economy was fueled by an ever enlarging exportation of New Mexican–made goods to the southern markets.

In the last two decades of the eighteenth century, as the Bourbon reforms invigorated the commerce of New Spain, more New Mexican Pueblo pottery was shipped south. This opening into a cash economy led to greatly increased production, which changed the economic interrelationships of Pueblos and New Mexican Hispanics and altered the form and quality of the large *tinajas;* these jars assumed shapes that were both more spherical and more attuned to

the Hispanic traditions and needs of the viceroyalty, but the quality
of construction, slip, and decoration generally dropped off. Frank com-
ments:

> The economic boom after 1780 accounts for the rapid
> evolution of pottery-making traditions, along remark-
> ably similar lines that took place at approximately
> the same time in most of the pottery-making pueb-
> los. The sea change in the development of Pueblo
> pottery styles between 1780 and 1820 represents an
> important manifestation of the social effect of the
> contemporary economic boom on the Pueblo Indi-
> ans. In contrast to the Pueblo weaving tradition left
> largely alone by burgeoning *Vecino* production, the
> stylistic and technical changes in the late eighteenth
> century Pueblo pottery suggests Indian crafts people
> under pressure to change pottery-making traditions
> in order to produce for a non-Indian market (Frank
> 1992:265).

While there is evidence to suggest a large-scale cohesive mecha-
nism operating in the early 1790s for the extraction of goods for ex-
port, it is not clear whether the system encompassed disenfranchised
Hispanics as well as Pueblo Indians.

The financial infrastructure that developed in late colonial New
Mexico provided the capital and credit for engaging in long-distance
trade. Connected with commercial houses in New Spain, this trade
brought about a demand for certain products that were transported
from New Mexico into areas like Nueva Viscaya. The demand for
pottery made by Pueblo Indians may have created a vacuum in His-
panic New Mexico and in essence enticed Hispanics to engage in
their own pottery-making. The demand for pottery by Hispanic house-
holds was ultimately tied to the socioeconomic reforms taking place
in late colonial New Mexico. Population pressure and this external
demand were the catalysts that conditioned the emergence of a His-

panic pottery tradition after the mid 1780s. The possibility that Hispanics may have been engaged in occasional pottery production before this time does not alter this discussion.

When the Pueblos began concentrating a lot of their energy on producing small wares and perhaps even the large spherical *tinajas* that were carried to the south, the Hispanics, who had been accustomed to trading for these wares, could no longer afford the pottery. To fill the vacuum created by the shortfall of Pueblo pottery, the Hispanic *vecinos* began to make many of the wares they needed for domestic use, especially cooking vessels and the smaller, utilitarian wares that were used on a day-to-day basis. Thus it was that disenfranchised Hispanics, either individuals or families, turned to potterymaking to "fill the niche."

Hispanic villagers who used ceramic specialization as a means to offset their declining economic position within the community provided a viable means of support for their families and thus "buffered" themselves against failure. Rice notes:

> It has been difficult to understand how the manufacture of pottery evolved from what may have been a typical activity performed by self-sufficient households along with a variety of other tasks into a specialized economic pursuit carried out by a small number of skilled practitioners who did little if anything else to earn a living (1981:219).

Mention of pottery in colonial documents is uncommon. One of the earliest historical records that mentions pottery was drafted by Fray Pedro Serrano, who wrote that Hispanic *alcaldes* (local officials appointed by the Governor as the district magistrate) "do not visit pueblos except to gather pots, plates, jars, etc." (Hackett 1937:486). This 1761 account points to a growing demand on Pueblo potters. The items these *alcaldes* sought were commonly extracted for tithe – the church income which the Spanish Empire collected and distributed – and used for trade.

Prior to the 1770s, the long-distance trade system supplied items obtained from the Pueblo Indians as well as nomadic Indians, principally animal hides, both deer and buffalo skins, as well as *piñón* nuts, salt, and Pueblo textiles. There is little or no mention of pottery as a trade item.

The Pueblos began producing pottery for export from New Mexico to flourishing regions to the south, especially the mining areas of Chihuahua, Parral, Guanajuato, and Durango and the newly founded *presidios* (military fortifications) of Nueva Viscaya, all of which brought about rapid population increases. These areas began to purchase commercial goods from New Mexico and other surrounding provinces. New Mexico provided Hispanic blanketry and Pueblo pottery, and each of these crafts doubtless experienced an increase in production and in specialization in order to meet the growing demand from the south.

Numerous scholars have noted that the Pueblo pottery changed suddenly around 1750 and that the output of some pueblos indicates a general trend in which the production and design execution are much less careful than before (Frank and Harlow 1974; Harlow 1973; Kidder and Amsden 1931; Kidder and Shepard 1936; Mera 1939). Frank comments that the expanded trade in Pueblo pottery explains both the stylistic changes in size, shape, and decoration and the general sacrifice of quality in favor of quantity:

> One can discern three major trends in the southern Tewa and northeastern Keres late-eighteenth-century pottery transition. The shape of pottery vessels evolved from the low Ogapoge bulge to Powhoge and Kiua types which have large, almost spherical mid-bodies, sometimes ending in a shoulder that met the now thin neck. The pueblos replaced clouds, feathers, and other formal design elements with complex abstractions, less formally organized decorative spaces, and new active, stylized shapes. Finally, in a number of pueblos the new types exhibited a marked

degradation in the quality of their output consistent
with increased production for trade (Frank 1992:293).

It could be argued that the less desirable wares, sloppier in execu-
tion, were made by the pueblos for trade to nearby Hispanics; how-
ever, because Hispanic villagers were aware of the finer quality wares
also produced by the Pueblos, it is unlikely that the Hispanics would
accept the inferior wares. It may well be that the sloppier, inferior
wares were made for the southern market, for the purchasers in the
southern markets may have been unaware of (or unwilling to pay
for) the finer pottery produced by the Pueblos.

While most of these ceramic wares were made for cooking, serv-
ing, and storing food, other uses may have conditioned the quality of
production:

> Ignoring the example of the missionaries, the Indian
> until recent times continued to remove human waste
> in the *tinajas* on a daily basis, in effect a more hy-
> gienic system. A similar practice seems to have been
> followed by much of the Hispanic population. ...
> The widespread use of chamber pots in New Mexi-
> can homes has to be inferred from a few casual ref-
> erences and from what is known generally about
> Hispanic customs of waste disposal. ... While some
> of the finely made Mexican chamber pots are known
> to have reached the northern borderlands, the aver-
> age citizen on the frontier depended upon cheap
> vessels, locally produced. The New Mexican, frag-
> mentary evidence would suggest, relied chiefly upon
> Pueblo pottery for the chamber pots (Simmons
> 1992:221–223).

This statement that even chamber pots were manufactured by
Pueblo potters is based in part on the traditional assumption that

ceramics were solely the product of Indian manufacture. If during the late eighteenth and early nineteenth centuries Pueblo pottery production was focused on economic profit, and the majority of Pueblo-made pottery was exported to southern markets or used in the same pueblo in which it was produced, a situation may have emerged in which *vecinos* accustomed to trading for Pueblo pottery began to turn to other Hispanics for utilitarian household pottery, which included service wares and even chamber pots. The production of ceremonial pottery in the pueblos, sacred vessels which were not produced for utilitarian or commercial purposes, would constitute an exception to the generalization that most Indian-made pottery was sent south.

Frank points out that two related developments in a commercial system determined the role of Pueblo participation in the Hispanic economy of New Mexico, beginning as early as the 1780s. Hispanic weavers began producing large quantities of textiles different from those produced by the Pueblo weavers; Pueblo weavers produced *mantas* (*serapes* or ponchos) while Hispanics produced blankets. At the same time, Hispanic merchants became the so-called middlemen as Pueblo Indians were no longer included in the trading expeditions to Chihuahua and beyond. As Hispanic merchants marketed larger quantities of Hispanic-made textiles to the southern markets, they also began to export greater quantities of Pueblo pottery. A clear parallel example of craft specialization among Hispanic villagers appears in late-eighteenth-century weaving as a cottage industry. For several decades prior to the 1780s, tithing records indicate that Pueblo weaving, especially in the form of *mantas* produced from cotton or from wool, made up the majority of the textiles. These *mantas* were woven on vertical looms, thus restricting the length of each piece. Hispanic weavers used a European treadle loom that positioned the work horizontally and enabled them to produce much longer pieces that could be cut to any length as needed. They also produced quantities of blankets and *sabanilla*, a plain weave homespun fabric used for clothing. From the 1780s to the end of the eighteenth century,

Hispanic weavers exported large quantities of woolen items to southern markets. Numerous writers comment on the sudden rise of a Hispanic weaving tradition in New Mexico, illustrating the shift from part-time to full-time specialization brought about by the growing demand from the markets to the south, but also because these same Hispanic peoples turned to alternative strategies to supplement their income. The centers of Hispanic weaving were located in the Río Abajo area near Belén and in the Río Arriba area of the Chimayó Valley, running as far as the mountain town of Truchas. Each of these areas has a relatively restricted land base that the local population had outgrown, thus providing the conditions that fostered full-time weaving and other craft specializations.

Perhaps merchants in Chihuahua were becoming increasingly interested in Pueblo ceramics because of the "small quantities of pottery" taken south by New Mexican Hispanics and mentioned by Fray Juan Agustín Morfí in 1778 (Frank 1992:264). Zebulon Montgomery Pike, captured by Spanish soldiers in 1807 while he was an officer in the U.S. Army, commented that New Mexican Hispanics exported "a vast variety and quantity of pottery ware" manufactured "by the civilized Indians, as the Spanish think it more honorable to be agriculturists than mechanics" (Pike 1966[1]:51).

The common practice of barter or trade in pottery between the Pueblos and their Hispanic neighbors is evidenced by archaeological and documentary evidence. The following chapter supplies data from southern to northern New Mexico, including sites where Hispanic pottery appears. At the archaeological sites of El Paso, Fort Fillmore in the Mesilla Valley, the Paraje de Fray Cristóval, Belén, Los Poblanos, San José de los Ranchos (Albuquerque area), the central New Mexican village of Manzano, and in the Abiquiú district, Pueblo pottery formed a common part of typical Hispanic households during the eighteenth century. In 1794, the Franciscan custodian Fray Cayetano José Bernal wrote of the Mission of San Diego de Tesuque:

These women, particularly of [the] Tegua Nation, the female Indians are more laborious than the men and

their common work is to make things of pottery by
hand [and] without any instrument whatsoever, such
as large earthen jars, or narrow-mouthed pitchers for
water, pots, bowls, tubs, dishes, etc., but all very suffi-
cient and of little consistency, and they sell them or
barter for vegetables as provisions.

The Spanish reads as follows:
Estas[,] particularmente de Nacion Tegua[,] las indias
son mas laboriosas, que los hombres, y su comun
trabajo es hazer cosas de alfereria a mano sin
instrumento alguno, como tinajas, ó canteros para
agua, ollas, caxetes, Lebrillos, Platos, E[ceter]ª[s] pero
todo mui basto y de poca consistencia, y lo benden ó
Truecan por bastirato Legumbres[,] E[ceter]ª
(AFBN:1IX1794; AFBN 31: 635.5L 5R-10V.; and AASF
LD 1794 #13; microfilm roll 53, frames 109 and 117).

The rejuvenation of long-distance trade in the 1780s changed
what may have been almost a century of trade relations. As Hispan-
ics began to make pottery because of the demand for such wares (see
discussion on micaceous wares in Chapter 3), social factors related to
population pressure also conditioned the nature of subsistence prac-
tices in the colony. People with poor quality, insufficient, or no land
resorted to craft production. In addition to the changing role of Pueblo
pottery and the demand by Hispanic households for pottery that
was eventually filled by Hispanic potters, the circumscription of land
and a population explosion among Hispanic households also favored
the creation of a Hispanic ceramic tradition.

Beginning as early as the 1750s, nomadic Indians increased their
hostilities toward the settled peoples of New Mexico. The intensifi-
cation of hostilities in the 1770s made it impossible for the Hispanic
populace to expand beyond the areas that had already been settled

and brought under cultivation. These troubles coincided with a small-pox epidemic in 1780–1781 (Simmons 1966:319–326) that killed twenty percent of the population. But estimates of birth rates for New Mexico in 1782 indicate that the Hispanic population rebounded and grew even greater while the native population during the nineteenth century never reached the level it had attained before the epidemic (Frank 1992:303).

The breath of change in the late 1780s can be attributed to the combination of these three influences on the people of New Mexico. Arnold's model (1985) describes, analyzes, and explains the universal processes which relate ceramics to the environment and the culture and identifies the factors that stimulate the production of pottery or other crafts. According to Arnold's model, increased Hispanic population, unavailability of land for farming and grazing, and the focusing of Pueblo attention on making pottery for export (due to the effects of the Bourbon reforms in New Spain) combined to maximize the causes and conditions that brought about Hispanic craft specialization and the emergence of a Hispanic pottery tradition.

The emphasis of Hispanic potters seems to have been on the production of utilitarian goods; most of the ceramics were intended for food preparation and serving, although some pottery may have served other needs, like chamber pots. In contrast, the emphasis of Pueblo potters of the same period seems to have been on the large rounded or globular polychrome vessels that have been referred to by archaeologists, museum curators, and gallery agents as storage vessels. These *tinajas* were common trade items brought into Hispanic villages; the archaeological record bears witness to this fact.

This information, then, provides another means of understanding the social, political, and environmental conditions that prevailed in colonial New Mexico and drew the Hispanic population into alternative subsistence strategies. It should be noted, however, that because of the widespread availability of ceramic resources and the insecure nature of pottery production, the Hispanic potters who engaged in pottery production in the late colonial period did so be-

cause they had no other means of support for themselves and their families (D. Arnold 1975a, 1978b, 1980, 1985; Peacock 1981). The following chapter presents the archival, ethnographic, and archaeological evidence for a Hispanic pottery tradition operating in the late eighteenth and nineteenth centuries in New Mexico.

Chapter Two
The New Mexican Evidence

This chapter assembles data from Hispanic archaeological sites, oral histories from Hispanic villagers, and information from archival and other documentary sources in order to provide clear and persuasive evidence of Hispanic ceramic traditions and the economic motives that led New Mexican Hispanics to become engaged in pottery production as craft specialists.

The paucity of archaeological data concerning Hispanic sites and villages must be understood as a consequence of the nature and history of anthropological and historical research in New Mexico. As early as the 1890s Fred Harvey and Company actively collected traditional craft items from both Hispanics and Native Americans. The frequency of barter and trade that had existed for almost three centuries in New Mexico resulted in the Company's finding items of Native American manufacture in Hispanic villages and items of Hispanic manufacture in pueblos; consequently, by the turn of the century early collectors had easy access to material culture from throughout New Mexico but often had no clear idea what they were collecting.

Between the world wars, Hispanic site archaeology and Hispanic ethnographic studies were greatly influenced by a developing interest on the part of museum collectors, art historians, and anthropologists formerly interested only in Native American arts and crafts and native material culture. As scholars began to piece together the history of the Hispanic arts in New Mexico, it was common for them to identify the material culture as either "fine art" or "folk art" and to classify them according to the places they had been collected from. It was still common at this time to find ethnographers, archaeologists, and historians avidly studying the Native American culture while practically ignoring the Hispanic.

The first concerted body of scholarly work on Spanish colonial material culture came from the eminent scholar E. Boyd. Boyd is credited with defining the paradigm of Spanish colonial studies in New Mexico, and her work (especially Boyd 1974) has been a kind of "bible" for all subsequent scholars. Boyd's primary interest focused on the art of the *santeros* or saint-makers, but she also included work on architecture, furniture, textiles, and other "minor arts." Her background as an artist and art historian shaped her conceptual analysis of traditional Hispanic arts and crafts of New Mexico (Weigle, Larcombe, and Larcombe 1983). Many scholars continue to use her research framework for examining Hispanic craft production.

One of the prominent scholars of Southwestern pottery research was H. P. Mera, whose work with historical pottery established the field of research. He was also interested in certain areas of Hispanic material culture. About this work McIntyre writes:

> Mera, who was certainly aware of Boyd's research because the two had worked closely together at the School of American Research (SAR) and the Museum of New Mexico in Santa Fe, applied Boyd's paradigm to his own research on the Río Grande blanket (McIntyre 1990:49).

Through his work Mera established a firm background for under-
standing the larger items of New Mexican Hispanic weaving, such
as blankets, *serapes*, and carpets that were produced neither by Pueblo
nor by Navajo weavers – textiles that were not derivative of local
Native American traditions. Unfortunately, Mera paid little atten-
tion to domestic goods such as clothing, footwear, and pottery.

The first article suggesting the possibility that Hispanics created
pottery was by Herb Dick and Wesley Hurt. In an ethnographic study

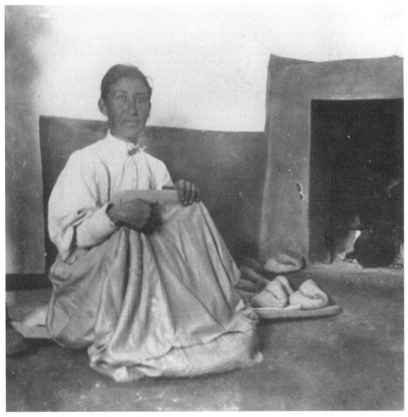

PLATE 7: CHIMAYÓ, NEW MEXICO, CIRCA 1900.
*Hispanic woman with freshly baked bread. Note the single-handled micaceous
bean pot in the fireplace resting next to a tinamaiste or metal trivet. Prudence Clark
Collection, Menaul Historical Library. 1975.001.044.*

of the central New Mexican mountain village of Manzano, these authors discussed the likelihood that Hispanic craftpersons were engaged in pottery production. Since their research indicated that these wares did not have antecedents in New Mexico, they suggested that these "new" styles were the result of influences introduced by missionaries or by Mexican Indian auxiliaries. They even suggested that these wares most closely resembled wares from Río Balsas in México (Hurt and Dick 1946:309).

Roland Dickey's detailed treatise about Hispanic "folk arts" and life style provided the next peek into the world of Hispanic pottery: "In isolated instances, Spanish villagers made pottery of their own, but this was probably learned from Indian neighbors" (Dickey 1949:91). For the next three decades there are few mentions of Hispanic pottery and even fewer about the archaeology of Hispanic sites. The notable exceptions are the comments by Wendorf and Reed in 1955, when they also postulated that the plain red and black wares of the eighteenth and nineteenth centuries were introduced from southern México (Wendorf and Reed 1955:131–173). The excavation and analysis of Hispanic material culture, specifically the pottery sherds of a Hispanic homesite on the mesa east of Albuquerque's North Valley, caused Brody and Colberg to write in 1966: "It may be Spanish pottery, but we simply do not know enough as yet about the pottery making habits of the nineteenth century, both Indian and Spanish, to draw firm conclusions" (Brody and Colberg 1966:17).

The attitudes of early scholars have not fostered an examination of the social and natural environmental context of utilitarian objects or even of sacred art. As a consequence, pottery found at Hispanic sites throughout New Mexico was almost invariably presumed to be the product of Indian manufacture. Archaeological excavation of Hispanic sites is still rare, and as previously noted, the attitude of most researchers concerning Hispanic sites and their culture material, especially pottery, still reflects the belief that

> Ceramic assemblages at Spanish households are identical with those of Pueblo origin in terms of decora-

tion traditions (late glaze and matte-paint wares, for example), methods and techniques of manufacture, and materials used. Such traditions show little or no significant change from pre-Hispanic times in the region (Thomas, Bower, Kantner, Stoller, and Snow 1992:25).

But this chapter will present the evidence that will prove the existence of a truly New Mexican Hispanic tradition of making Hispanic pottery.

Ethnohistory/Oral History

The integration of archival data in this study will provide a bridge between (on the one hand) the archaeological data from numerous sites that indicate that a Hispanic pottery tradition was active in colonial New Mexico, as evidenced from sites scattered from the Mesilla Valley all the way to southern Colorado, and (on the other hand) the oral record of *vecinos* from numerous Hispanic villages who report living memory of Hispanic potters producing pottery for local consumption. These data have been gathered from a variety of sources, including archives, oral histories, and other ethnographic field work.

The archival data for the most part derive from the Spanish Archives of New Mexico (SANM), the Mexican Archives of New Mexico (MANM), the Territorial Archives of New Mexico (TANM), and the Archives of the Archdiocese of Santa Fe (AASF). The ethnographic data presented in this research also come from numerous sources, which include Hispanic oral histories transcribed and filed among the WPA[6] files, oral accounts reported by various writers, and oral history data derived from ethnographic field work by numerous anthropologists.

Information concerning potters in general, and more specifically Hispanic potters, rarely appears in colonial New Mexican documents. The paucity of textual sources concerning pottery illustrates the nature of colonial New Mexican ceramic production, which was of

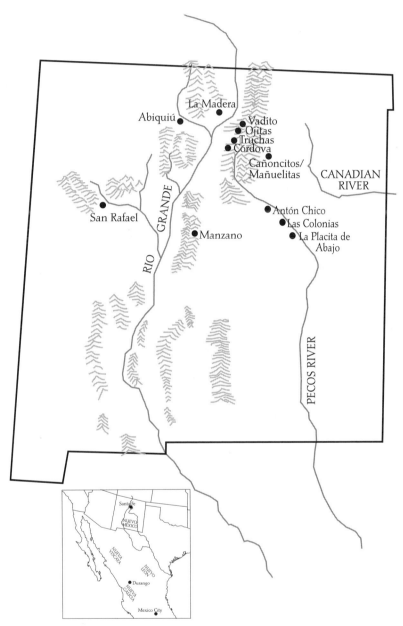

MAP 1: HISTORIC HISPANIC VILLAGES
Map illustration by Paul Rhetts.

little or no concern for colonial authorities or chroniclers; however, this does not diminish the importance of pottery as an indicator of social change in New Mexico. As noted earlier, New Mexican colonial authorities did not write about pottery because it was economically unimportant beyond the communities in which it was produced and used.

The following examples are derived from a variety of sources. This information documents a Hispanic pottery tradition from southern New Mexican villages to villages in southern Colorado. All but one of the sites or villages mentioned in the following discussion either were or still are Hispanic; the single exception is Fort Fillmore, a territorial period U.S. military site in southern New Mexico.

The New Mexican Evidence

The section that follows contains ethnographic data derived from Hispanic villages or settlements that are still occupied. With the exceptions of the village of Manzano, which is located in the Manzano Mountains in central New Mexico, and the settlement of San Rafael, which is located near Grants in western New Mexico, the remainder of the Hispanic settlements described in this section are in northern New Mexico. In each settlement the tradition of Hispanic pottery manufacture has been documented. This tradition is said to have existed in many more villages; however, ethnographic documentation is unavailable. Although numerous pottery types were once made in many of these villages, and these pottery types form the basis for the archaeological documentation of a Hispanic pottery tradition examined in the second part of this chapter, it is the presence of micaceous pottery that is most commonly associated with Hispanic pottery manufacture. Micaceous wares have come to be associated with Hispanic villages. In her discussion about the thin-walled micaceous wares commonly associated with Hispanic settlements, Warren (1981:162) writes:

> The possibility that mica was an intentional ceramic
> tradition and not merely a geographic expedience

... is suggested by the discovery of prepared mica-
ceous clay specimens some distance from clay de-
posits, and by the importation of mica schist to sites
for possible use in preparation of micaceous clays.

The presence of this tradition in Hispanic villages of the late eigh-
teenth and nineteenth centuries will be explored in the third part of
this chapter.

Manzano

The history of the settlement of the Manzano[7] area by Hispanic
settlers is sketchy, but some families already resided in the area by
1830. It was not until the early 1930s that Wesley Hurt began his
work in the area. At Manzano he noted that ceramic traditions were
extant in the early 1900s.

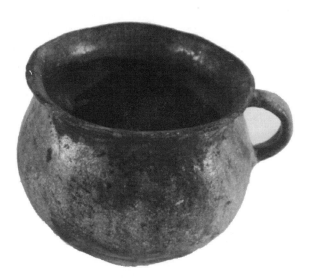

PLATE 8: SILVER/BROWN MICACEOUS BEAN POT, CÓRDOVA/TRUCHAS, NEW MEXICO,
19TH CENTURY.
5 ¼" tall, 5" rim diameter. Collection of Troy Fernández. Photograph by Paul
Rhetts.

Hurt indicates that in the 1930s Manzano was still based on subsistence farming:

> During the early years of the nineteenth century at Manzano locally made pottery was common although porcelain wares from México were present, judging by the sherds types found in the refuse heaps of the torreon and associated fortress building. ... The local pottery was not only obtained from friendly Pueblo Indians but some of it was fabricated in Manzano and Chato, a small farming community a short distance to the south (Hurt 1989:38).

Hurt's informants described two different pottery manufacturing techniques. One informant described the *tortilla* mold-and-shape technique, while another described the coil-and-scrape technique. Archaeological excavations in other areas indicate that soup bowls and dishes were mainly molded while the larger cooking pots and jars were made by coil-and-scrape techniques. Polished red-on-tan wares known as Casitas Red-on-brown, a polished blackware known as Manzano Black, plainwares, and micaceous wares were noted at Manzano.

Informants also stated that pottery-making was introduced by a Navajo woman by the name of Guadalupe Romero. While the origins are important, for purposes of this discussion of cultural practices, if a large number of individuals live in Hispanic communities and share a common practice, both the individuals and the practice should be considered Hispanic.

Antón Chico and the Antón Chico Land Grant

The village of Antón Chico[8] lies within the Antón Chico Land Grant, which was established in 1822. The Hispanic settlements within the grant were abandoned in the late 1820s and reestablished in the 1830s. The village itself was settled before the 1830s. One of the first descriptions of Antón Chico was made in 1841 by George

Kendall, a member of the 1841-1842 Texas-Santa Fe Expedition. Kendall describes the Hispanic village as

> seated upon a little hill overlooking the Pecos, and probably containing two or three hundred inhabitants. The little village of Antón Chico is built in a square, the houses fronting on the inner side, although there are entrances, protected by strong doors, on the outer. The houses are of one story only, built of adobes, a species of large sun-dried bricks, while the tops are flat. They have neither windows nor floors, and in point of comfort and convenience are only one degree removed from the modest wigwam of the Indian (Kendall 1939:536).

In comparison with other colonial communities in New Mexico, the Hispanic villages on the Antón Chico Land Grant are somewhat different. While the community was built around a central plaza, a *casa-corral* design was also employed to add protection. The compound walls extended from the rear of the structures and provided space for livestock, stores, gardens, and a host of subsistence activities.

This Guadalupe County village is located on the east bank of the Pecos River some forty miles southeast of the Hispanic town of Pecos and thirty-seven miles southeast of Pecos Pueblo. It was one of the first Hispanic towns built outside the geographical limits of the Pueblo world; the Hispanic population of Antón Chico made their own space rather than piggybacking on that of the Pueblos. Antón Chico has been occupied continuously since the 1830s; however, it has undergone several periods of decline since the turn of the century.

In 1984 the Antón Chico Land Grant and the villages located within the grant boundaries were surveyed for the New Mexico Historic Preservation Division as part of the National Register of Historic Places district nomination process. Both standing and ruined buildings in the village of Antón Chico were mapped. Pueblo Indian and Hispanic pottery sherds abound at the archaeological ruins within

the town boundaries, especially within the *casa-corral* units. These walled compounds are usually rectangular with a residential unit along one margin and outbuildings along the other walls. Cisterns, *hornos*, and other activity areas were recorded in both the functioning *casa-corral* units in Antón Chico and in the *casa-corral* compounds recognized in the archaeological record.

While much of the pottery is of Native American manufacture, the majority exhibit traits that suggest local manufacture. Even more important, it matches the description of Spanish pottery published by Dick in 1968. The majority of the sherds seen during the survey are Casitas Red-on-brown, Hispanic Blackware, Carnué Plainware, and micaceous wares. Some residents recalled the manufacture of micaceous wares directly across the Pecos in the Hispanic community of Tecolotito (Carrillo and O'Hara 1985).[9] The same assemblage was noted for the Antón Chico Land Grant villages of Las Colonias de San José, a territorial period settlement located down river from Antón Chico, and La Placita de Abajo, located one mile downstream from Las Colonias de San José. The pottery assemblages at San José and La Placita de Abajo contained higher percentages of Hispanic wares, but like those at Antón Chico they also contained a mixture of Tewa trade wares such as Ogapoge Polychrome, San Juan Red-on-brown, and Kapo Black.

Las Colonias de San José

The Hispanic village of Las Colonias de San José was settled between 1860 and 1865, mostly by settlers from the nearby village of Antón Chico. This village is distinctive because of the well-executed gridded units that form the *casa-corral* compound architecture of elongated single-file residences. The survey team recorded Hispanic and Pueblo pottery scattered throughout the complex. Most notable was the presence of both Hispanic and Jicarilla Apache micaceous wares. Numerous residents recalled the manufacture of pottery in San José as late as the 1940s and even pointed to a location up the Pecos River where clay was obtained. (For details of the presence of Hispanic pottery see Carrillo and O'Hara 1985.)

La Placita de Abajo

The village of La Placita de Abajo was established on the Antón Chico Land Grant in the 1880s as a result of the continuing Hispanic population expansion. The entire village complex is now in ruins. It is located along the Pecos River approximately one mile south of Las Colonias de San José and fourteen miles north of Santa

PLATE 9: SHERD, MICACEOUS, LAS COLONIAS DE SAN JOSÉ, NEW MEXICO, 19TH CENTURY.
This sherd, from a large vessel wall, is extremely thick. It measures ¾" thick. Photograph by Paul Rhetts

Rosa, New Mexico. The village ruins are defined in the National Register nomination as a complex of seventeen archaeological proveniences; most are *casa-corral* residential units. Throughout the village complex, survey records indicate a scattering of modern glass and iron crockery as well as micaceous and Casitas Red-on-brown pottery. La Placita was totally abandoned after major floods on the Pecos River in the 1920s, 1930s, and 1940s destroyed the irrigation system and washed away major portions of the community's arable land. Among the many turn-of-the-century items documented in the archaeological survey were large numbers of Hispanic sherds and fewer Pueblo sherds. as was noted in the other Hispanic communities on the Antón Chico Land Grant.

Córdova (San Antonio del Llano Quemado)

The exact date of the original settlement of the village of Córdova is unknown, but it is likely that Hispanic settlers first settled the area between 1725 and 1749. Until 1900 it was named San Antonio del

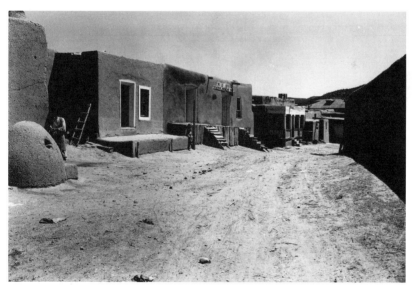

PLATE 10: CÓRDOVA, NEW MEXICO, CA. 1935.
Photo by T. Harmon Parkhurst. Courtesy Museum of New Mexico, neg. no. 2757.

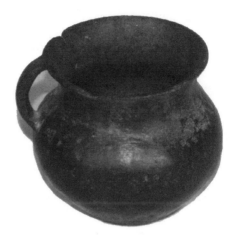

PLATE 11: MICACEOUS BLACK POT/OLLITA, CÓRDOVA, NEW MEXICO, 19TH CENTURY.
6" tall, 4 ¼" rim diameter. This pot has blackened because of carbon soot deposits.
Collection of José Floyd Lucero and María Padilla. Photograph by Paul Rhetts.

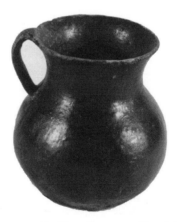

PLATE 12: SMALL MICACEOUS POT/JAR, CÓRDOVA, NEW MEXICO, 19TH CENTURY.
6" tall, 4 ¼" rim diameter. The surface of this jar has carbonized rendering it a
black lustrous color. The original color was a micaceous brown. Pots similar in
shape were used in Mexico and Latin America for preparation of coffee or choco-
late. Collection of Troy Fernández. Photograph by Paul Rhetts.

Llano Quemado from a nearby Tano Indian ruin. Córdova was listed as the northern boundary of the Santo Domingo de Cundiyó Grant in 1743 (SANM I #211, SRCA). The village was abandoned in 1748, along with Ojo Caliente and other outlying villages, as a result of continuing attacks by nomadic Indians. In 1749 Governor Joaquín Codallos y Rabal decreed that certain families return to the lands they had abandoned (SANM I #718, NMSRCA), and so it was that Córdova was finally settled permanently.

Lorin Brown and his colleagues describe Hispanic pottery making in the early years of Córdova:

> The early inhabitants of Córdova did not have far to seek for material for making dishes, cups, and cooking utensils. Close to the village there were substantial deposits of a micaceous clay that is good for pottery. Certain women made pottery as a means of acquiring those necessities of life that they lacked because they had no land on which to raise these necessary goods (Brown et al. 1978).

Brown and his coauthors continue with a description of pottery manufacture and add that the "certain women" to whom they refer were widows. They also state that pots were traded for the amount of corn, flour, or beans they would hold. Dean Arnold's hypothesis for craft specialization specifically states that ceramic specialists make pottery not only for their own use but for trade since they are economically dependent on the craft because of their lack of adequate land (D. Arnold 1985:168), and Brown's account of the Córdova widows' motivation fits exactly into the theoretical model:

> Pottery trade was followed by widows and women who had no land from which to expect to stock their larder. Because their neighbors needed pots and jars as well as the flat griddles called *comales*, on which *tortillas* were baked, this craft supplied a need in the community and gave a livelihood to women who

otherwise would have suffered privation and who
would have had to accept charity (Brown et al. 1978).

Brown and colleagues also note that the same clay deposits were
known and used with permission of the grant residents by the Jicarilla
Apaches who came to the area in the summer and who also made
pottery. They also made willow basketry which they traded with
villagers for food. The writers do mention that the Apache people
traded pottery to the villagers.

Any archaeologist who works at Córdova should be alert to the
possibility that in addition to Hispanic and nearby Tewa pottery, Ji-
carilla pottery is likely to be found. It is possible that potters in Córdova
learned manufacturing techniques from the Jicarilla; but further re-
search regarding Córdova should look for evidence of such influ-

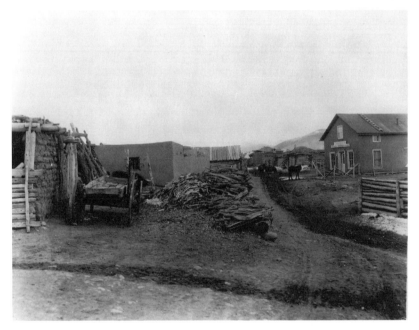

PLATE 13: TRUCHAS, NEW MEXICO, CA. 1930.
Courtesy Museum of New Mexico, neg. no. 53620.

ence, and a document search might help trace other influences on the pottery of Hispanic Córdova. Despite the lack of these major research initiatives, Lorin Brown's information clearly supports the existence of pottery specialization among the landless Hispanic women of Córdova in the past fifty years.

Truchas

Recent data compiled by Dr. William Wroth, the former director of the Taylor Museum of the Colorado Fine Art Center, reveal that much like the Hispanics of Córdova, the Hispanics of Truchas also made pottery. Wroth states that, while cleaning out a very old house belonging to Prisciliano Sandoval, he found two undecorated utilitarian pots made of micaceous clay. When he showed these pots to several older residents, two informants indicated that pots like these had been made in Truchas until the 1930s, when the potter died.

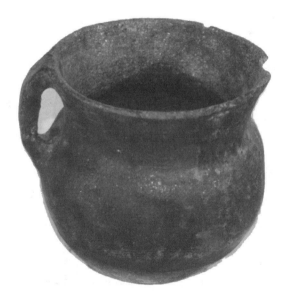

PLATE 14: MICACEOUS POT/OLLITA, TRUCHAS, NEW MEXICO, 19TH CENTURY. 5" tall, 5 ½" rim diameter. This pot has blackened because of carbon deposits. Collection of Troy Fernández. Photograph by Paul Rhetts.

One of the informants showed Wroth where the micaceous clay was dug (Wroth 1973).

Ojitas

Wroth also reported micaceous pottery manufacture in the Hispanic village of Ojitas,[10] near Chamisal (personal communication, letter to the author dated 1990). After interviewing Amadeo López, formerly of Chamisal but residing in Denver in 1981, Wroth reported that the informant's foster-mother, Tomásita García de López, made pottery in Ojitas in the early 1900s. The informant stated that his father brought his wife the clay from the village of Truchas. Miguel and his nephew Amadeo López carried the clay home in cloth bags. Amadeo López, 83 years old at the time of the interview in 1981, said that Tomásita made *ollas de barro* [pots of clay] which were used for cooking beans and *chicos* and for making coffee. Mr. López claimed

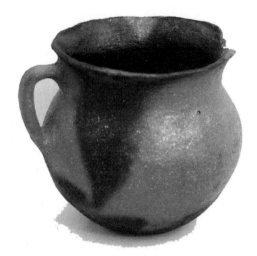

PLATE 15: MICACEOUS BEAN POT, TRUCHAS, NEW MEXICO, 19TH CENTURY. 5 ½" tall, 5 ⅛" rim diameter. Note this pot has not been used for cooking as it is not carbonized on the outside. Collection of Troy Fernández. Photograph by Paul Rhetts.

that his foster-mother Tomásita was not Indian and was in fact *pura mexicana.*

Vadito

The small Hispanic settlement of Vadito is located five miles northeast of Peñasco, New Mexico. In 1995, Filomena Romero Mascareñas of Vadito donated a micaceous clay *comal* or griddle to the Museum of New Mexico, Palace of the Governors (Plate 17). She gave the following account of *El Comal de Barro* (The Clay Griddle) to her nephew, Orlando A. Romero, Director of the History Library:

> In 1914 I came to live with my brother Enrique Romero. I cooked for him and his hired help. I made *tortillas* on this *comal* over an open fire on a metal stand (*tinamaiste*). When my brother got married in 1916 I went to live with my parents. My brother later rented the house for a few years. Somehow, this *comal*

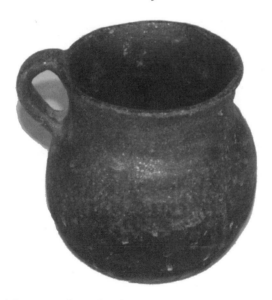

PLATE 16: MICACEOUS BEAN POT, VADITO, NEW MEXICO, 19TH CENTURY. 6" tall, 4 ¼" rim diameter. Collection of Charlie Carrillo family. Photograph by Paul Rhetts.

was left untouched or unbroken by the renters. In 1933 my husband and I bought the same house and I found the *comal* intact. I was surprised! I have kept it as a family relic (files of the Palace of the Governors, Santa Fe, New Mexico).

PLATE 17: MICACEOUS COMAL, VADITO, NEW MEXICO, EARLY 20TH CENTURY. 12" rim diameter. Photograph by Blair Clark. Courtesy Palace of Governors, Museum of New Mexico.

Orlando Romero (personal communication, 1995) commented that his aunt, who was born in 1906, was merely seven years old when she first recalled using the griddle and that she was sure it was of Hispanic manufacture, made of local clay (Romero, personal communication, 1995). The *comal* is 30.5 centimeters in diameter and .5 centimeters thick, the raised lip being 2.5 centimeters thick.

Abiquiú

In the late 1970s and early 1980s, the author performed field work in Abiquiú and several nearby villages on the Chama River in Río Arriba County. Numerous villagers recalled a pottery tradition that remained quite active as late as the 1930s and did not end entirely until the early 1940s.

Earlier, Gilberto Benito Córdova[11] had performed some ethnographic field work in connection with the historic site of Santa Rosa

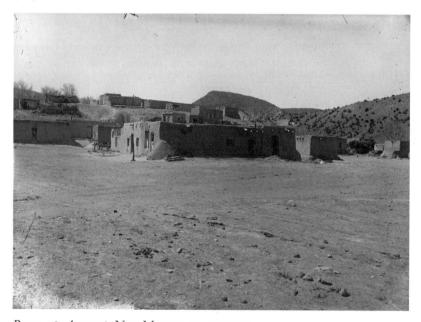

PLATE 18: ABIQUIÚ, NEW MEXICO. CA 1915-20.
Photograph by T. Harmon Parkhurst. Courtesy Museum of New Mexico, neg. no. 13697.

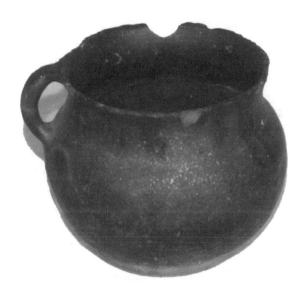

PLATE 19: EL RITO MICACEOUS SLIP BEAN POT, ABIQUIÚ, NEW MEXICO, 19TH CENTURY.
6 ½" tall, 6" rim diameter. Formerly owned by Belén Veronis Trujillo of Abiquiú. Made in Abiquiú by Cleofas García. Photograph by Paul Rhetts.

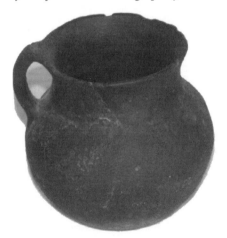

PLATE 20: MICACEOUS POT/OLLITA, ABIQUIÚ, NEW MEXICO, 19TH CENTURY. 6" tall, 5 ¾" rim diameter. Collection of Floyd and Virginia Trujillo. Photograph by Paul Rhetts.

de Lima de Abiquiú, which indicated that pottery manufacture was once practiced as a resource buffering strategy by widows who found themselves without other means of adequate support. Following Córdova's lead, the author interviewed numerous elderly residents of the Abiquiú areas and found that all of them recalled a pottery-making tradition (Carrillo, field notes from Abiquiú, 1978–1985).

In 1980 and 1984, Belén Trujillo recalled that Cleofas García made pottery, and she even pointed out the spot where the pottery was fired. She used the pot pictured below by Cleofas García until the 1940s. Her son Floyd Trujillo (age 64 in 1995) also recalled that, as a young boy, he hauled *sabina* or juniper and *cuipas* or juniper bark shavings for Cleofas García to use in the firing. She also remembered the names of Josephina and Dela as makers of pottery, however she could not recall their last names.

Mrs. Trujillo used a micaceous bean pot that she had inherited from her mother until the bottom wore through in the 1940s. Unable to acquire a new pot, she began using a metal pot for her cooking.

Benjamín Archuleta, who lived to be 98, recalled in 1980 (when he was in his early nineties) that during his youth numerous families in Abiquiú had engaged in pottery manufacture. He specifically recalled that the pottery was made specifically to be traded for food: the buyer filled a vessel with corn or wheat, then the potter kept the grain and the buyer took the vessel home.

None of the informants could recall exactly where the potters obtained their clay. Mr. Archuleta recalled seeing clay being collected from a vein when he was a young man. This was someplace near the *camposanto* – the local Catholic cemetery. From this clay, the Casitas variety of Hispanic pottery was made. Both Mrs. Trujillo and Mr. Archuleta recalled that micaceous clay was purchased from other Hispanics who traded the clay, yet neither could recall where this micaceous clay came from (field notes from Abiquiú, 1978–1985).

Schroeder (1964:46) noted that potters in San Juan used three types of slips; the most common one was purchased from Hispanics in Abiquiú. This red ochre was collected by Hispanics from Abiquiú

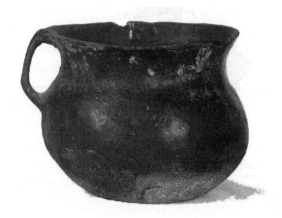

*PLATE 21: ABIQUIÚ MICACEOUS BEAN POT, ABIQUIÚ, NEW MEXICO, 19TH CEN-
TURY.
4 ½" tall, 5 ½" rim diameter. This small ollita is typical of the micaceous ware
made in Abiquiú in the late 19th century. It has a flat base which like facilitated
use on a wood buring stove. There are corncob striations on this vessel. Collection of
Charlie Carrillo family. Photograph by Paul Rhetts.*

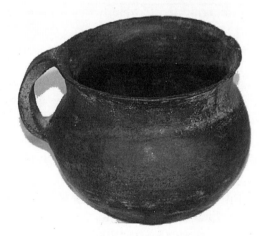

*PLATE 22: ABIQUIÚ MICACEOUS BEAN POT, ABIQUIÚ, NEW MEXICO, 19TH CEN-
TURY.
5 ¼" tall, 3 ¾" rim diameter. Note the thick handle and flat bottom. Collection of
Floyd and Virginia Trujillo. Photograph by Paul Rhetts.*

from a location that is now covered by the waters behind Abiquiú Dam on the Chama River. Floyd Trujillo recalled this information from his childhood.

Numerous families in the village of Abiquiú and the surrounding communities of Cañones, Barranco, and Medanales have heirloom pots. Some of these pots are clearly of Native American manufacture, while others are of Hispanic origin. The owners of these pots stated that they were made locally by Hispanic potters. The most distinctive form of non-Hispanic origin are the flat-rimmed Jicarilla Apache micaceous wares. Abiquiú was the location of the first Jicarilla Indian agency, established in 1852, and therefore the presence of Jicarilla pottery in the Abiquiú region is understandable (see discussion on micaceous wares in this chapter). The distinctive flat rims identify the pottery and clearly separate it from pieces of Hispanic origin. The pots that are of Hispanic origin and still in the possession of Hispanic families are, for the most part, micaceous wares. In all cases these micaceous wares have turned black from carbonization, which resulted from using these vessels for cooking.

All the interviewees suggested that the availability of imported stoneware and metal cooking pots changed the demand for locally produced pottery and that the potters finally passed away, leaving no one to take their place. The gradual decline in demand for these wares led to the loss of ceramic craft specialization by World War II (field notes from Abiquiú, 1978–1985).

San Rafael

San Rafael[12] is located three miles south of Grants, New Mexico, in Cibola County. This Hispanic settlement was first settled in the late 1800s. While no ethnographic data has ever been collected in this settlement, the present writer has interviewed a few families who once lived there. Pantaleón and Cirilia Cabrera have in their possession a cooking pot collected in San Rafael. What makes this pot interesting is that the lower half appears to have been thrown on a rudimentary wheel while the upper portion appears to be hand-

coiled. The entire pot is blackened by carbonization, and in shape it resembles other bean pots made in Hispanic villages in northern New Mexico. Mr. and Mrs. Cabrera believe this is a Hispanic-made cooking pot and that similar pots were once used by Hispanic residents in San Rafael.

La Madera/La Petaca Area

Approximately four miles north of Ojo Caliente, in northcentral New Mexico, is the small village of La Madera. This area has been used since the mid 1700s by settlers from Ojo Caliente and later from El Rito. The village of La Madera was settled sometime in the first quarter of the nineteenth century. Nearby is the village of La Petaca. This area was one of the traditional sources for micaceous clay used by Jicarilla Apaches. The rich clay deposits have been used by the Jicarilla, Tewa, and Hispanic villagers for the past two hundred and fifty years.

In 1969 Felipe Ortega apprenticed with Jesusita Martínez, who at age 90 still remembered how to make micaceous clay bean pots. Felipe recalled that Jesusita was blind at the time she taught him to make the clay pots and that she had learned the art of making micaceous pottery from her mother, who was Jicarilla Apache. Apparently Jesusita's family settled in La Petaca and adopted a Hispanic lifestyle. Jesusita was born in 1879 and learned the craft from her mother when she was twelve years old.

Felipe Ortega began to study the tradition of Hispanic pottery in 1976 and applied for admission as an exhibitor at the traditional Spanish Market that year. He was rejected by Alan Vedder with a letter stating that "Spanish" people never made pottery. Since then he has mastered this art form and is considered a master potter. Felipe Ortega recognizes his Hispanic ancestry even while he is keenly aware of his Jicarilla roots. Numerous Jicarilla people apparently settled in this area, close to their traditional source of micaceous clay. In his research he was able to document a long-standing tradition of Hispanic-made micaceous wares in La Madera and in nearby vil-

lages. He also was able to document the fact that these potters were disenfranchised from traditional subsistence economies and that they often made pottery upon demand (Felipe Ortega, personal communication 1995).

Cañoncito/Manuelitas

The settlement of Cañoncito is located approximately 18 miles northwest of Las Vegas, New Mexico, near the larger village of Sapelló. This area was settled in the last quarter of the nineteenth century by Hispanic families.[13] Historically, bands of Jicarilla Apache peoples used the area for hunting and trading, and were known to have occasionally intermarried with Hispanic settlers in the area.

Lloyd Herrera, who was raised in this settlement, is the owner of numerous micaceous pots. He was told that these pots were manufactured by local Hispanic residents at the turn of the century. These heirloom *ollitas* or little pots do not have the characteristic flattened

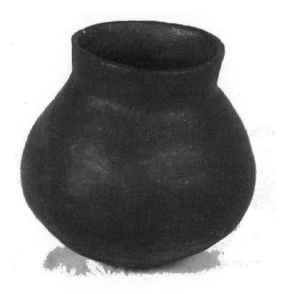

PLATE 23: MANUELITAS OLLA, MANUELITAS, NEW MEXICO, 19TH CENTURY.
7 ¼" tall, 4 ¾" rim diameter. Of particular interest is the unusual shape. This pot has no handle. Collection of Lloyd Herrera. Photograph by Paul Rhetts.

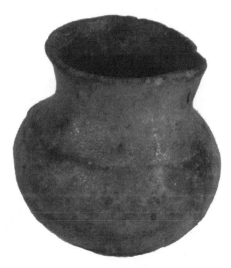

*PLATE 24: MANUELITAS PITCHER, MANUELITAS, NEW MEXICO, 19TH CENTURY.
5 ½" tall, 3 ½" rim diameter. Handle missing. Collection of Lloyd Herrera. Photograph by Paul Rhetts.*

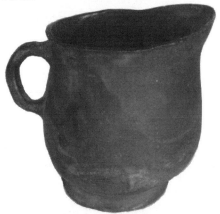

*PLATE 25: BURNISHED RED/BROWN-PASTE PITCHER, COLLECTED IN LAS VEGAS, NEW MEXICO, 19TH CENTURY.
7 ½" tall, 7" rim diameter of opening. Tiny golden flecks of intrusive mica can be seen in the paste. This pitcher has a ringed base which was fashioned from a separate clay ring and attached to the rounded pitcher bottom. Collection of the Charlie Carrillo family. Photograph by Paul Rhetts.*

rim associated with Jicarilla manufacture, although the local potters may have been Apache *criadas*. These *criadas* were often incorporated into the Hispanic households, and their children normally understood themselves to be culturally Hispanic. Concerning *criados*, Bustamante writes:

> The baptismal records indicate that some 1,300 *criados* were baptized between 1760 and the mid-1870s with the highest number, 742, occurring during the 1860s at the height of hostilities with the Navajos. ... The *criado* system then became ingrained in the culture of the Hispano. Having *criados* was not only a practical source of labor but it also became fashionable. ... The children born to *criados* were free citizens and entered Hispano society (Bustamante 1982:87).

Summary

The Hispanic settlements examined in this section were settled or established between 1740 and 1850, with the possible exception of San Rafael. In each case it is clear that a pottery tradition was practiced by people who resided in these communities and considered themselves to be Hispanic. In many of these villages the people who now call themselves Hispanics, *hispanos, mexicanos,* Spanish-Americans, or even *chicanos* have ancestory that is clearly Native American. This is not disputed; however, to be told by art historians and anthropologists that their people did not engage in craft traditions that are part of living memory is an insult to their cultural patrimony. Equally important, to be told that pottery traditions are not Hispanic denies its clear visibility in the ethnographic record and blurs its visibility in the archaeological record. The section that follows compiles an overview of villages in New Mexico that lack a documentary or oral history record of pottery-making but contain archaeological remains that point to a heterogeneous ceramic tradition operating in eighteenth- and nineteenth-century New Mexico.

Map 2: Archaeological sites
Map illustration by Paul Rhetts.

Sites with Archaeological Evidence Only

The following section contains an overview of Hispanic village sites that have been excavated or at least surveyed by archaeologists (Map 2). These sites have been included in this overview because the archaeologists working with the material culture from these sites have noted the presence of a ceramic tradition that is not Native American and is therefore suspected to be of local Hispanic character. Starting in southern New Mexico and proceeding northward to southern Colorado, these sites document a Hispanic pottery tradition. Some of the sites are located in the valley bottoms, while many are located in the mountains of northern New Mexico. The only site listed in this overview that was not a Hispanic village site is Fort Fillmore in the Mesilla Valley of southern New Mexico. It is included here because of the presence of Hispanic pottery throughout the site. This locally produced pottery was likely manufactured at nearby Hispanic settlements in the lower Río Grande valley.

All the sites date from 1740 to the late 1870s. Las Majadas does have a seventeenth-century component; however, like most seventeenth-century sites, it is overlain with eighteenth- and nineteenth-century components.

El Paso District

San Elizario and the Old Socorro Mission

The results of the analysis of local earthenware ceramics recovered from San Elizario and the Old Socorro Mission were being finalized at the time of the publication of this book. In two separate unpublished reports Michael Marshall reports the analysis of a school of Brownware ceramics manufactured historically in the El Paso district. He names the ware "Valle Bajo Brownware." Concerning the ceramics from San Elizario Marshall notes:

> The Valle Bajo Brownware industry is quite similar to the New Mexican Carnué-Casitas industry and both are probably regional expressions of a northern

Mexican native-mestizo tradition which developed
in the northern frontier during the late seventeenth-
early eighteenth centuries. Most of these vessels in
both wares are plain and sand-tempered. Many are
quite large with thick walls. The vessels were fired in
an uncontrolled atmosphere and have variable sur-
face and paste colors. Decoration is infrequent and
confined to red rim bands and crude broad-line de-
signs. The plainwares are crude, but well made and
quite serviceable (Marshall 1996A)

Concerning the ceramics from the Old Socorro Mission, Marshall
notes that these Brownwares are part of the Valle Brownware tradi-
tion that existed roughly from 1750 to 1920. The Valle Bajo Brownware
ceramics are included in this study because the makers of these ce-
ramics represent the Hispanic traditions of the El Paso district, and as
Marshall has suggested, they were part of a general northern Mexi-
can native-mestizo ceramic industry and are separate from an earlier
ceramic tradition that shows influence of local Manso, Suma, Tiwa,
and Piro ceramic traditions.

Las Cruces–Fort Fillmore

Fort Fillmore was a Civil War period military outpost located in
southern New Mexico near Las Cruces. It was first occupied in 1851
and was abandoned by 1862. Confederate troops took possession of
the fort in 1861 and used it for one year (Frazer 1983).

Archaeological work at Fort Fillmore consisted of the excavation
of six refuse deposits and one area designated by the archaeologists
as a privy. Frazer noted in 1983 that while many of the supplies
needed at the fort were army issue, food and other goods were pro-
cured from the local populace. King and Staski (1984) conclude that
this also included the "locally produced ceramics." They list the ce-
ramic material as "brownwares manufactured by Hispanic residents."
Although these ceramics are not discussed further, it is clear from

the report that they are of local manufacture and were likely pro-
cured by Army officers for use by troops stationed at the fort.

Paraje de Fray Cristóval

This Hispanic village[14] was established sometime between 1854
and 1860. In 1854 W. W. H. Davis described this location as follows:

> Fray Cristóval is a simple camping ground and not,
> as the young traveler would most likely imagine be-
> fore he arrived there, a respectable-sized village, where
> he could find entertainment for man and beast (Davis
> 1938).

Four years later Judge Davis would enumerate a village of 195
individuals complete with a hotel (U.S. census records of 1860). The
1860 census lists the village as "Fra Cristóbal." By 1870 the village is
listed in the census records as Paraje and boasts a population of 517
inhabitants, most of whom are listed as farmers, laborers, and house-
keepers (Marshall 1979).

Douglas Boyd (1986:235) describes a piece of coarse, sand-tem-
pered pottery dug up at the territorial site of Paraje de Fray Cristóval,
a Hispanic way station located in the Río Abajo south of the city of
Socorro. He comments that it resembles Carnué Plain, a Hispanic
ware discussed by Dick in 1968. This type of pottery has been found
in sites extending from the area of Belén south to that of El Paso,
Texas.

While there is only a brief discussion of this pottery type in the
archaeological literature, Boyd suggests that Pueblo Indian–manu-
factured pottery may have been difficult for the residents at Paraje de
Fray Cristóval to obtain, since they lived at such distances from pot-
tery-making pueblos, and that Hispanic people therefore began to
make their own pottery.

Río Abajo District

La Joyita

The archaeological remains of La Joyita are located south of the present day village of La Joya on the southeast bank of the confluence of Arroyo de Castillo and the Río Grande. Marshall and Walt (1984:275) indicate that this Hispanic settlement was short lived. The earliest reference to the settlement appears in 1846 (Wislizenus 1969:58). It is listed in the 1850 census as "El Jollital" with a population of 186 persons. The 1860 census lists settlements as "La Hollita de Valencia" having a population of 248 persons, whereas the 1870 census lists the settlement as "La Joyita" with a population of 460 persons (Marshall and Walt 1984:275). A great flood devastated the entire area of La Joyita in 1884 (Carter 1953:17), and it is likely that this village was destroyed in that episode as it does not appear on the 1885 census records. Two near-by newly established Hispanic settlements appear for the first time in the 1885 census records, suggesting that the population of La Joyita resettled in the immediate area after the flood (Marshall and Walt 1984:275).

The site of La Joyita, LA31738,[15] consists of low earthen mounds of scattered room blocks and a *casa-corral* structure. Metal and glass artifacts were noted at the site along with Hispanic pottery. Marshall and Walt note:

> Earthenware ceramics of the Carnué class are quite abundant. … There is considerable variety in the Carnué material which is present. Both thin and thick vessels appear; many have thin red or red-and-white slipped washes, whereas numerous others have a red band slipped about the neck (Marshall and Walt 1984:300).

The red-banded pottery is referred to elsewhere as Casitas-red-on-brown, whereas the other material is called Carnué plain. This is one of the few references to a white-slipped Carnué ware.

El Tajo

Much like the Hispanic settlement of La Joyita, the Hispanic settlement of El Tajo came into existence after the Mexican Republic and was likely destroyed by the great flood of 1884. The census records of 1860 list the settlement as " El Tago" with a population of 129 people. By 1870 the population of "Tajo" had dwindled to 70 persons (Marshall and Walt 1984:270).

The rather extensive remains of El Tajo thus appear to be the result of an occupation which extended

PLATE 26: CASITAS RED-ON-TAN RIM SHERDS, EL TAJO, NEW MEXICO, 19TH CENTURY.
Photograph by Paul Rhetts.

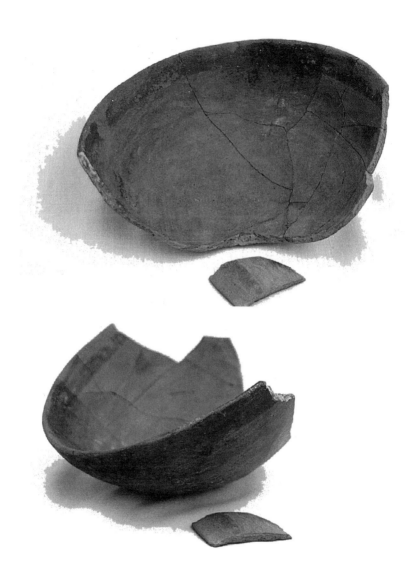

PLATE 27: CASITAS RED-ON-TAN BOWL, EL TAJO, NEW MEXICO, 19TH CENTURY. 3 ½" tall, 6 ½" rim diameter. Two views of the reconstructed fragments. Photograph by Paul Rhetts.

PLATE 28: TINAJA SHERDS, EL TAJO, NEW MEXICO, 19TH CENTURY.
These thick sherds are the local variant of Carnué Plain and are likely fragments
of wine vessels/vats. Photograph by Paul Rhetts.

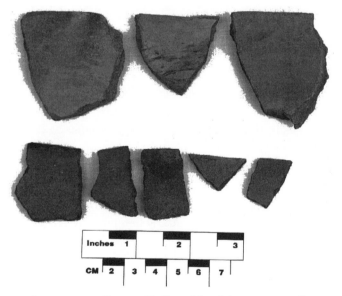

PLATE 29: CASITAS PLAIN SHERDS, EL TAJO, NEW MEXICO, 19TH CENTURY.
Photograph by Paul Rhetts.

from ca. 1855-1875, and the establishment of El Tajo
would appear to correspond with the abandonment
of La Parida, which is 6 kilometers to the north
(Marshall and Walt 1984:271).

The archaeological remains of El Tajo consist of a series of large
adobe rooms arranged in a linear fashion around a small plaza, with
house remains to the south of the plaza. Large quantities of historic
ceramics are scattered about the surface of this looted site.

The majority of ceramics noted at this site are Hispanic pottery
types known as Carnué Plain and Casitas red-on-brown. Puebloan
ceramics seem to be limited to some Ácoma and Zuní style trade
ceramics. Of particular note are the very thick Carnué style ceramics
that appear to be fragments of what were likely wine vats. Many
pieces measure up to $1\frac{1}{4}$ inch [3.1 mm] thick. These *tinajas* have
burnished/polished interiors which have all been smudged, while
the exterior surfaces appear to be scraped smooth, yet unpolished. It
is my speculation that the interior surfaces of these wares were pol-
ished and smudged in preparation for using the containers for wine
making. This preparation would seal the porous interior surface, thus
providing a container that did not "sweat" or evaporate its contents.

The historic Hispanic communities of the Río Grande valley near
Socorro were often noted for their wine making; it is logical to as-
sume that within this area local pottery specialists provided large
wine making *tinajas* for that purpose.

In 1869, Lt. James Bourke while assigned to Fort Craig described
the lifestyles of the Hispanic population noting that:

> In person, they were, so far as my observations ex-
> tended, neat and clean, bathing frequently in the large
> *acequias* or irrigating canals which conducted the
> waters of the Río Grande to the barley fields and
> vineyards. … Grapes and peaches were the princi-
> pal fruits and wine in some quantity was made in
> the valley (Bloom 1934:41-42).

The Casitas Red-on-brown ceramics typically exhibit an unpolished red band applied to either the polished or unpolished exterior and interior lip surfaces of soup plates, small bowls and some jars. Less frequently found at this site are the unbanded Casitas ceramics, some are stone polished while others are unpolished. Evidence from El Tajo ceramics also suggest molding, although the majority of the Hispanic ceramics appears to be coil-made. The Hispanic ceramics of El Tajo are sand tempered and made from local clays.

Casa Colorada del Sur

Numerous archaeological surveys in the past ten years have documented many Hispanic settlements along the *camino real* between Belén and Socorro, New Mexico. Of particular interest is the site of Casa Colorada del Sur, of which Michael Marshall states: "This is probably the best description of the Carnué (Hispanic) assemblage that I have made in survey notes" (Marshall, letter to author, 1994).

The nineteenth-century Hispanic site of LA779 is located on the eastern edge of the Río Grande valley, 1.8 km north of Veguita, New Mexico, near the confluence of Abó Arroyo and the Río Grande. The site consists of a series of adobe roomblocks arranged around a central plaza. Marshall estimates that the settlement contained approximately one hundred rooms. He also estimates that the village was established "sometime during the early nineteenth century, probably during the Mexican period" (Marshall and Marshall 1992:68). He postulates that Casa Colorada was named for a *rancho* built of red adobe earth in the 1740s. By 1760 Bishop don Pedro de Tamarón y Romeral[16] described the original Casa Colorada as ruins (Adams 1954:43).

Although the Casa Colorada Grant was made as early as 1813, Hispanic settlers were likely to have been living in the area before that time. Archival records indicated that families were living there in 1823 (Pearce 1965:28). By 1833 Casa Colorada was listed as a plaza (Bloom 1913:14) and by 1840 it was listed as a principal village in the Río Medio. The village is plotted on an 1850s map, and in that same year 553 people were listed as residents. The population expe-

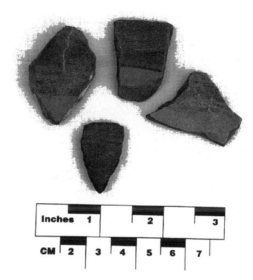

PLATE 30: CASITAS RED-ON-BROWN RIM SHERDS, CASA COLORADA DEL SUR, NEW MEXICO, 19TH CENTURY.
Photograph by Paul Rhetts.

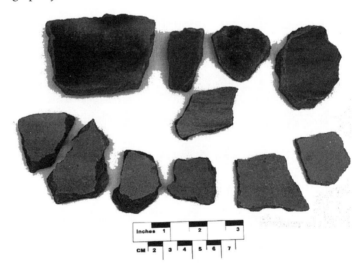

PLATE 31: CARNUÉ PLAIN SHERDS, CASA COLORADA DEL SUR, NEW MEXICO, 19TH CENTURY.
Photograph by Paul Rhetts.

PLATE 32: CASITAS WHITE-SLIPPED SHERD, CASA COLORADA DEL SUR, NEW MEXICO, 19TH CENTURY.
Photograph by Paul Rhetts.

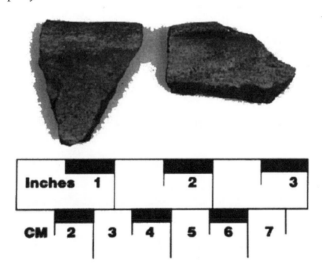

PLATE 33: CASITAS WHITE-BANDED WARE RIM SHERDS, CASA COLORADA DEL SUR, NEW MEXICO, 19TH CENTURY.
Photograph by Paul Rhetts.

rienced a steady decline during most of the following four decades. The 1860 census listed 300 inhabitants, the 1870 census listed 226, the 1890 census listed 214, and the 1900 census listed 219 persons.

While the economy of this village is not yet clear from historical research, its location along the Río Grande suggests a village farming complex. The presence of an extensive Hispanic pottery tradition marks this site as a key for understanding pottery specialization. Marshall writes:

> The earthenware assemblage from this site mainly represents a native Hispanic industry dating from the Mexican and early territorial periods. Native American ceramics appear to be limited to a few vessels of Ácoma, Zuni and Athabascan types (Marshall and Marshall 1992:72).

Marshall adds that while the most common embellishment found in the assemblage is the application of a single red band around the lips of vessels, broad curved lines were also observed on sherd fragments, these lines forming part of large floral designs. This is the only documented case of Hispanic wares in the literature that describes the application of painted floral designs on vessel walls. The red-banded wares relate to the Casitas Red-on-brown described by Dick (1968).

Concerning the Hispanic ceramics from Casa Colorada, Marshall writes:

> The variation in the Hispanic earthenware vessels from LA779 is to a large degree simply stylistic and represents expressions of a single industry known as the Carnué tradition. All exhibit a similar iron-laden clay, and all are sand-tempered. Variations in paste and temper are a result of the degree of processing: that is, large utility vessels have a thick wall, poorly sorted paste, and coarse temper, in contrast to finer paste and fine temper in the thin walls of ser-

vice vessels. Treatment by polishing and the application of broad red-striped rim bands are the principal means of embellishment, but occasional use of broad line decoration, applications of red and white slips and the production of polished orange-red and black wares are noted (Marshall and Marshall 1992:74).

Marshall notes the presence of red slipped wares, Carnué Plain/ gray, Carnué Tan-bronze, Carnué Red-on-buff, Polished tan-orange ware, Gray-black polished wares, and a white slipped/polished Carnué-like ware.

The presence of a Hispanic pottery tradition in this nineteenth-century village along the Río Grande suggests craft specialization. It is hypothesized that the area around Casa Colorada was a wine producing area and that the presence of sizable quantities of large ceramic vessels was related to the production and distribution of wine. Apparently wines were produced in the area of present-day El Paso. Governor Fernando de Chacón's report to Commandant General Nemesio Salcido, dated August 28, 1803, refers to the production of wine and brandy in New Mexico (Simmons 1991).

Belén

The modern city of Belén, on the west side of the Río Grande in Valencia County, once consisted of six separate plazas. None of these plazas have remained intact; all have been overwhelmed by modern construction and the changing land-use strategies of the area.

One plaza was known as Nuestra Señora de los Dolores de los Genízaros de Belén. Horvath's research concerning the *genízaro* plaza in Belén, New Mexico, helped the present writer locate the site (Horvath 1979). Although the configuration of the plaza is lost, archaeological remains in the form of pottery and lithic debris can be found along the eastern edge of the railroad yards near the roundhouse in Belén.

The pottery assemblage is mixed, containing both Native American wares and wares that most closely resemble Carnué Plain and Hispanic utility ware. Additionally, Casitas Red-on-brown wares and Smudge Blackwares are present nearby.

San Antonio de los Poblanos (LA46355)

In 1986 the Research Section of the Laboratory of Anthropology excavated portions of LA46355, a site better known as San Antonio de los Poblanos, in the north valley of Albuquerque between Montaño and Chávez roads. Archival research shows that the first reference to San Antonio was made in 1783 by the Franciscan Fray Gabriel de Lago; Los Poblanos was likely named for its settlers, many of whom came from Puebla de los Angeles (México).

Excavations unearthed 1,003 sherds from trash deposits. The question of Hispanic vs. Pueblo derivation also arose during the investigation at Los Poblanos, but the archaeologists were able to determine that 74.8% of the ceramics from the trash pit were locally made by Hispanic potters (Rudecoff and Carrillo 1987:49–50). Although ceramics from nearby Santa Ana Pueblo, the Punamé area, and the Ácoma-Laguna area were present on the site, their percentages were low. Higher percentages were recorded for Tewa wares. The predominant ware was Carnué Plain, a Hispanic utility ware. Of the Carnué sherds, 89.7% were from cooking pots, which accounted for 99.3% of all the cooking sherds in the assemblage. The settlement of Los Poblanos was far enough from villages that produced micaceous wares that Carnué Plain was the predominant utility ware. This plaza was located only ½ mile south of San José de los Ranchos.

San José de los Ranchos (LA46638)

By the end of the eighteenth century small Hispanic settlements had nucleated around dispersed farmlands in the valley north of the Alburquerque (Albuquerque) plaza. The increasing population in the valley north of Alburquerque was likely in response to land disenfranchisement and overcrowding at the main plaza of Alburquerque.

The same situation eventually effected the settlers that occupied the settlement that came to be known as Los Ranchos. Although the census of 1750 lists 192 families in the valley, which included both San Antonio de los Poblanos and San José de los Ranchos, individual plazas are not listed. In 1790 the plazas are numbered yet remain unnamed in the census records. Davis (1985) matched the names of the inhabitants listed in the 1790 census and the names listed in the 1802 records of the Cofradía de las Benditas Almas/Animas del Purgatorio (AASF, Loose Documents, 1802, no.30) verified the names of the plazas north of Alburquerque. The same names remain in use today and are part of the greater Alburquerque area. It was established that the site of LA46638 was the plaza known as La Plaza del Señor San José de los Ranchos. This plaza was the third plaza north of the main Alburquerque plaza. The 1790 census lists the plaza as a settlement of 176 residents in 40 households, making it one of the largest plazas in the valley north of Alburquerque.

Craft specialization is indicated by a propensity of occupations relating to textile production by 40% of the households. By 1814 the population includes 65 households with a population of 331 persons (Davis 1985). The original settlement was located near the present day intersection of Río Grande Boulevard and Chávez Road.

This settlement was built in the flood plain and was repeatedly flooded. In 1874 a major flood inundated the plaza. At Los Ranchos the houses are submerged and the people are living on the foothills (Carter 1953:74)

A flood in 1904 finally destroyed what remained of the original plaza. Most families relocated a short distance north of this site and established new households. Archaeological survey of the area in the early 1980s documented all the plazas listed in the 1802 Confraternity document. In the summer of 1996, test excavations of portions of the site of La Plaza del Señor San José de los Ranchos were

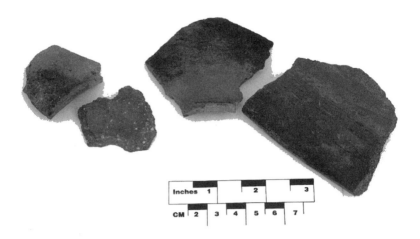

PLATE 34: CARNUÉ PLAIN SHERDS, SAN JOSÉ DE LOS RANCHOS, NEW MEXICO, 19TH CENTURY.
Note the groglike temper in the sherd (second from left). These Carnué wares exhibit a tremendous variety of tempers. Photograph by Paul Rhetts.

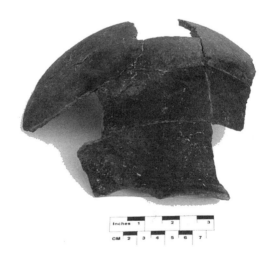

PLATE 35: CARNUÉ PLAINWARE OLLA FRAGMENT, SAN JOSÉ DE LOS RANCHOS, NEW MEXICO, 19TH CENTURY.
Reconstructed from fragments. Photograph by Paul Rhetts.

begun by volunteers under the direction of Kathryn Sergeant of Los Ranchos.

Historic pottery recorded during the archaeological survey of the site area included Hispanic manufactured wares and Pueblo pottery from Cochití/Santo Domingo, Zía and Ácoma, as well as Tewa wares and Hopi wares. A few micaceous wares of unknown origin as well as Mexican-made ceramics were also noted. In short, San José de los Ranchos seems to have been a hub for ceramic trade and exchange. The wide diversity of ceramics at this site may have come about because the area was also known as a textile production center. This localized specialization may have encouraged the trade and exchange of ceramics for woolen products.

The Hispanic made wares recorded at the site include: Casitas Red-on-buff (brown), Casitas Red-on white, Carnué Plain, and Manzano Black. Manzano Black (Dick 1968) is the predominate plainware at the site. This polished black ware differs from Kapo Black (Harlow 1973) which has a vitric tuff temper. Kapo Black is indigenous to the Tewa area. Manzano Black ware is referred to as Hispanic Blackware in other sections of this research. This ware is tempered with sand or crushed sandstone. Numerous vessel forms were recorded at the site including wide-mouthed jars, hemispherical bowls, flange plates, and flange bowls. The Carnué wares at this site are sand tempered. Some of the sand temper is very coarse. These wares are usually thick-walled and exhibit interior polishing. The exterior surfaces usually appear to be wiped yet unpolished. Most forms are wide-mouthed jars.

Many of the thin-walled bowls at the site appear to have been mold-made (see discussion on this technique on page 145 ff). Casitas Red-on-buff are common at the site; most forms are hemispherical bowls and flange plates; however, Casitas jar forms were also noted at the site (Warren 1985).

The plaza site of Señor San José de los Ranchos is the richest archaeological site of the Spanish Colonial period in the Albuquerque vicinity. The ceramic assemblage at this site records a complex

economic structure that suggest craft specialization. The ceramic assemblage also suggests an evolution from dependence on Pueblo-manufactured pottery by the inhabitants of Los Ranchos to the manufacture and use of Hispanic pottery types.

San Antonio de las Huertas

Near the present town of Placitas in Sandoval County is the Spanish colonial site of Las Huertas. One of the first references to Las Huertas was made on September 20, 1765, when Governor Tomás Vélez de Cachupín received a petition for a "tract of land at the place commonly called Las Huertas." Juan Gutiérrez of Bernalillo asked the governor for a land grant for his family and nine other families. Before the grant was formalized Cachupín died. However the petitioners apparently moved there or were already in residence before they drafted the petition. Governor Pedro Fermín de Mendinueta completed the process and on December 31, 1767, issued the grant to twenty-one families. (The settlement had grown in one year from nine families to twenty-one.) The village of Las Huertas was inhabited from the mid 1700s until at least the late 1800s. It is not clear when the site was finally abandoned, but in 1881 the Las Huertas Land Grant was still home to an estimated 500 people (Brody and Colberg 1966:11).

In 1980 the site of Las Huertas was partially excavated prior to the construction of the MAPCO[17] pipeline. The ceramic material recovered from the site was described:

> Some 1644 sherds of indigenous pottery types were recovered from the excavated area at Las Huertas. Most are of Pueblo Indian origin, while some may be of Spanish manufacture (Ferg 1984:32).

The ceramic assemblage at Las Huertas is interesting because historical accounts imply that the residents at Las Huertas traded almost exclusively with San Felipe Pueblo; however, excavated ceramics reveal that the primary source for pottery was Santa Ana

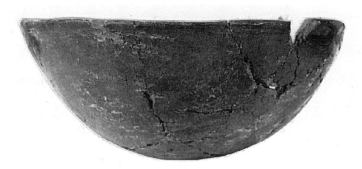

PLATE 36: CARNUÉ PLAIN BOWL, SAN ANTONIO DE LAS HUERTAS, NEW MEXICO, 19TH CENTURY.
15.3 cm. body diameter. Photograph courtesy Complete Archaeological Service Associates, Cortez, CO.

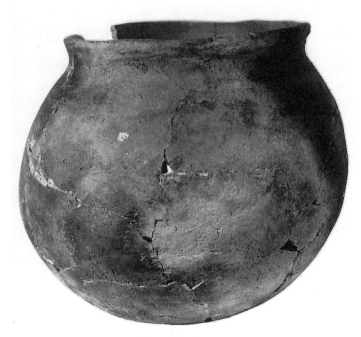

PLATE 37: CARNUÉ PLAIN JAR, SAN ANTONIO DE LAS HUERTAS, NEW MEXICO, 19TH CENTURY.
20 cm. body diameter. Photograph courtesy Complete Archaeological Service Associates, Cortez, CO.

PLATE 38: CARNUÉ PLAIN JAR BASE, SAN ANTONIO DE LAS HUERTAS, NEW MEXICO, 19TH CENTURY.
21.8 cm. body diameter. Photograph courtesy Complete Archaeological Service Associates, Cortez, CO.

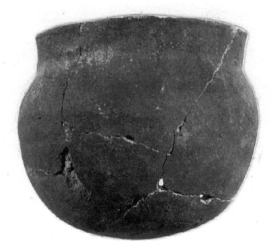

PLATE 39: CARNUÉ PLAIN JAR, SAN ANTONIO DE LAS HUERTAS, NEW MEXICO, 19TH CENTURY.
9.2 cm. body diameter. Photograph courtesy Complete Archaeological Service Associates, Cortez, CO.

Pueblo. Ferg explains the Santa Ana connection and goes on to re-mark: "The second problem of interest here is the question of whether or not Spanish settlers in New Mexico made any of their own pot-tery, or whether all was obtained from the nearest pueblo" (1984:34). Analysis of the excavated ceramics revealed that almost half of the black ware used sand temper, had rather thick walls, and was poorly polished. Ferg states, "the source of this material is uncertain, but it is certainly not Tewa in origin, as temper, thickness, and finish are all in marked contrast to the Kapo Gray and Kapo Black at the site" (Ferg 1984:38). Of all the ceramics recovered during the excava-tion, 54.9% were deemed to be of uncertain — that is to say, non-Pueblo — origin. Of these, 48.0% were Carnué Plain, while 2.0% were Casitas Red-on-brown and 2.6% were polished blackwares made in the Hispanic tradition with sand temper. Therefore more than half of the Las Huertas assemblage appears to be Hispanic in origin.

PLATE 40: CASITAS RED-ON-BROWN BOWL RIMS, SAN ANTONIO DE LAS HUERTAS, NEW MEXICO, 19TH CENTURY.
Bottom rim is 15.6 cm. wide. Photograph courtesy Complete Archaeological Ser-vice Associates, Cortez, CO.

Ferg also noted that Casitas Red-on-brown was present at the site
and that he was convinced that this too was of Hispanic origin (Ferg
1984:38).

Las Majadas (Cañón de Cochití)

Excavations at seventeenth-, eighteenth-, and nineteenth-century
sites in the Cochití area performed during the 1960s and early 1970s
revealed innovations in ceramic forms. Warren (1979:235) argues
that these innovations included pottery *comales* (griddles), soup plates,
ring-base vessels, mold-made vessels, fiber temper, and such new
decorative styles as mica-slipped utility ware. She attributes many of
these changes to a Meso-American influence, pointing out that Mexi-
can Indians were often members of Spanish colonial households.

Warren believes that Hispanic settlers moved into the area after
the Oñate conquest of 1598 and began producing their own ceram-
ics. Changes in tempering materials as well as changes in shapes
first appear at sites like the seventeenth-century Spanish colonial
site of Las Majadas.[18]

While there are no historical diaries or other early written ac-
counts concerning Las Huertas in particular or Hispanic activity in
general on the Las Huertas Land Grant, the fictional account by
Minton (1973) is based on historical fact as related by informants
interviewed by the WPA Writers' Program. In his novel, Minton
(1973:3, 83–84) describes Spanish women and men making pottery
jars by the coil-and-scrape method. This method of pottery construc-
tion may have been learned from the potters of the nearby pueblos
of Sandía, Santa Ana, or San Felipe or from some other Keres or Tiwa
source. Minton does not describe pottery manufacture any further.

Aurupa

The nineteenth-century Hispanic settlement of Aurupa is located
in northeastern New Mexico on Tecolote Creek. Concerning the ce-
ramics found at this Hispanic village, Warren writes:

> All of the micaceous culinary sherds appear to have
> been of local origin … as fragments of possible tem-

per were present at the site. ... Three pieces of gold colored mica schist with quartz and dark minerals were found. The mica wares from Aurupa are similar to Cimarrón Micaceous but have no slip or float and have no thickening of rims. Polished red and blackwares also containing fragments of the mica schist were found at Aurupa (Warren 1981:161).

Warren's discussion of the unslipped micaceous wares that did not have thickened rims is insightful. Typically the slipped micaceous wares exhibiting thickened rims relate to Jicarilla Apache manufacture of the mid-eighteenth century. By 1750 Jicarilla Apaches living in northeastern New Mexico were producing micaceous wares named Cimarrón Micaceous. Gunnerson named these wares in 1969

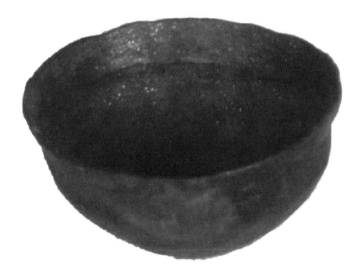

PLATE 41: BOWL WITH MICA INTRUSIONS, PECOS VALLEY NEAR TECOLOTE, NEW MEXICO, 19TH CENTURY.
2 ¾" tall, 5 ½" rim diameter. Note the thin uneven rim. Collection of Charlie Carrillo family. Photograph by Paul Rhetts.

and described the wares as having a flaky, laminated appearance, covered in a fine textured clay slip or float (Gunnerson 1969:33).

The micaceous wares recovered from Aurupa more closely resemble Hispanic micaceous wares than Jicarilla wares. The association with polished red and black wares containing fragments of the same mica is a clear indication of a Hispanic ceramic tradition (Warren 1981:157).

Casitas Ruin (El Rito Creek)

The archaeological site of Casitas, an eighteenth- and nineteenth-century Hispanic village along El Rito Creek in Río Arriba County, is the type site for Casitas Red-on-brown. Dick (1968) notes that this Hispanic pottery type is known to occur from Mesilla, New Mexico, northward to Las Sauces in the San Luis Valley of Southern Colorado, and along the foothill Hispanic villages from Trinidad, Colorado, south paralleling the Río Grande to Manzano, New Mexico. The site of Casitas Ruin is located 7.3 miles south of the town of El Rito, New Mexico. This site was described by Harrington (1916:145) as Casita Vieja (Little Old House). The burial notices for 1820 in the

PLATE 42: CASITAS RED-ON-BROWN RIM SHERDS, CASITAS RUIN, NEW MEXICO, 19TH CENTURY.
Photograph by Paul Rhetts.

PLATE 43: HISPANIC BLACKWARE RIM SHERDS, CASITAS RUIN, NEW MEXICO, 19TH CENTURY.
Photograph by Paul Rhetts.

PLATE 44: HISPANIC POLISHED BLACKWARE AND GRAYWARE SHERDS, CASITAS RUIN, NEW MEXICO, 19TH CENTURY.
Photograph by Paul Rhetts.

Archives of the Archdiocese of Santa Fe list the settlement as Casitas (AASF; L.D. 1830, No. 36). This colonial village was occupied sometime before 1820 and abandoned in the 1890s (Harrington 1916:145). The Casitas ruins consist of four house blocks arranged around a plaza. A small chapel with a walled *camposanto* was located along the east side of the plaza. The site of Casitas was excavated by Herb Dick in the 1960s. No excavation report has been published.

This small eighteenth-century village ruin is a key site for the archaeological interpretation of Hispanic ceramics. In a random sample of 100 sherds from surface collections, 89.7% of the sherds were tempered with local sand, while 10.3% were tempered with tuff (Dick 1968:78). In other words, almost 90% of these wares were probably manufactured at the Casitas site, while 10% likely were traded from the Tewa pueblos some thirty miles south.

In 1987 the author located clay mines that may have been the source for the Hispanic population at Casitas and even for potters at Santa Rosa de Lima de Abiquiú. These clay mines are located approximately three-quarters of a mile southwest of the Casitas ruins, at the base of a hill that is locally known as "Darst Hill" (Carrillo 1987).

No contemporary Indian pueblos existed in the vicinity of the Casitas Ruin, and most of its inhabitants came from the Hispanic village of Santa Rosa de Lima de Abiquiú in the Chama Valley.

Santa Rosa de Lima de Abiquiú (LA6602)

The Hispanic village of Santa Rosa de Lima de Abiquiú has a history that spans from the early 1700's to the early 1900's. Starting on August 23, 1734, ten settlers petitioned the Governor and Captain General of the kingdom of New Mexico, Don Gervasio Cruzate y Góngora, for grants of land on both sides of the Chama River extending from the Arroyo de Abiquiú to a point about three miles east. The orders to settle stipulated that each petitioner was to inhabit his land and farm it within a years' time. Failure to do so would cause the land to revert to the Crown (SANM. Series 1, no. 954, SARC). Six

months later five other settlers and their families, requested a large land grant to the west of the grant made the previous year. These settlers cited the same reasons for their petition as did the previous settlers: "We find that we are homeless and without lands on which we can live and cultivate in order to meet our obligations being compelled to live in borrowed lands by which we meet with grave inconveniences every year." On March 9th of that year Diego de Torres, Alcalde Mayor in command of Abiquiú, conducted the appropriate ceremony and handed over to the settlers a grant which included lands on both sides of the Chama River (SANM, series 1, no. 847).

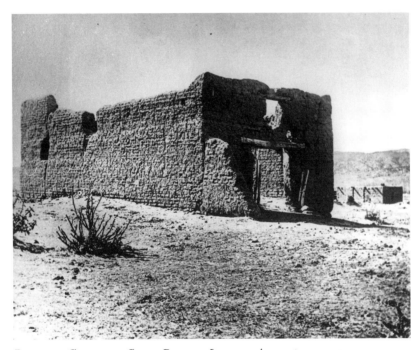

PLATE 45: CAPILLA DE SANTA ROSA DE LIMA DE ABIQUIÚ, EARLY 20TH CENTURY, ABIQUIÚ, NEW MEXICO
This photograph shows the Capilla in the state of abandonment; the roof beams and doors were already removed. Courtesy Museum of New Mexico Photo Archives, neg. no. 22844.

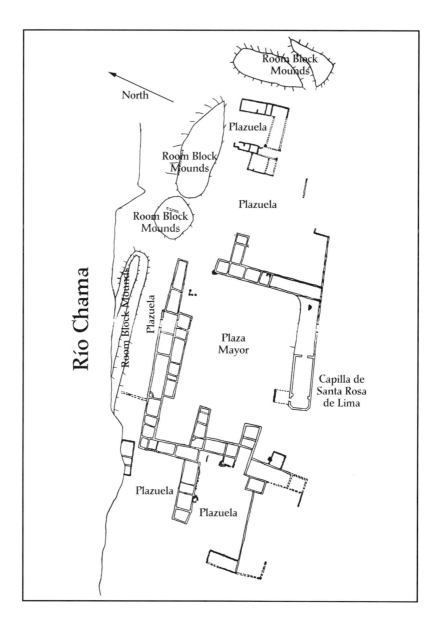

FIGURE 2: ARCHAEOLOGICAL SITE OF SANTA ROSA DE LIMA DE ABIQUIÚ, ABIQUIÚ, NEW MEXICO
Compiled by Charles M. Carrillo and Jimmy E. Trujillo, 1983.

PLATE 46: HISPANIC MICACEOUS WARE SHERDS, SANTA ROSA DE LIMA SITE, NEW MEXICO, 19TH CENTURY.
Note large inclusions of feldspar and quartzite in the paste body of these sherds.
Photograph by Paul Rhetts.

PLATE 47: MICACEOUS SHERDS, SANTA ROSA DE LIMA SITE, NEW MEXICO, 19TH CENTURY.
Photograph by Paul Rhetts.

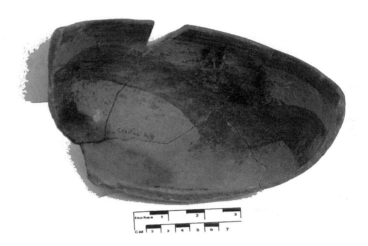

PLATE 48: CASITAS RED-ON-BROWN BOWL, SANTA ROSA DE LIMA SITE, NEW MEXICO, 19TH CENTURY.
Reconstructed from fragments. Photograph by Paul Rhetts.

PLATE 49: CASITAS RED-ON-BROWN BOWL, SANTA ROSA DE LIMA SITE, NEW MEXICO, 19TH CENTURY.
Reconstructed from fragments. Photograph by Paul Rhetts.

PLATE 50: CASITAS RED-ON-BROWN RIM SHERDS, SANTA ROSA DE LIMA SITE, NEW MEXICO, 19TH CENTURY.
Photograph by Paul Rhetts.

PLATE 51: EL RITO MICACEOUS SLIP RIM SHERDS, SANTA ROSA DE LIMA SITE, NEW MEXICO, 19TH CENTURY.
Photograph by Paul Rhetts.

PLATE 52: HISPANIC POLISHED BLACKWARE FLANGE PLATE FRAGMENTS, SANTA ROSA DE LIMA SITE, NEW MEXICO, 19TH CENTURY.
Note the indented serrated rims. Photograph by Paul Rhetts.

PLATE 53: HISPANIC POLISHED BLACKWARE PLATE FRAGMENTS, SANTA ROSA DE LIMA SITE, NEW MEXICO, 19TH CENTURY.
Photograph by Paul Rhetts.

*PLATE 54: HISPANIC POLISHED BLACKWARE BOWL, SANTA ROSA DE LIMA SITE, NEW MEXICO, 19TH CENTURY.
Photograph by Paul Rhetts.*

*PLATE 55: HISPANIC BLACKWARE BOWL RIM SHERDS, SANTA ROSA DE LIMA SITE, NEW MEXICO, 19TH CENTURY.
Photograph by Paul Rhetts.*

Few records of the Abiquiú settlements from the 1730's to the late 1740's have survived. Apparently the first license for the chapel of Santa Rosa de Lima de Abiquiú was issued in 1737 by Bishop Martín de Elizacoechea of Durango. Salazar maintains that the structure of the chapel was not yet finished by 1746 (Salazar 1976). One of the few documents that reports on Abiquiú is the 1744 report by Fray Miguel de Menchero who reported that twenty Spanish settlers were scattered in the Abiquiú area (SANM, series 1, no. 20).

Raids reached a peak of ferocity when Indians raided all settlements west of the Río Grande in August of 1747. Comanches struck Abiquiú on the morning of August 12, 1747 (SANM, Series II, no. 843). On the 28th day of March, 1748, the residents of Santa Rosa and Ojo Caliente and Pueblo Quemado (Córdova) petitioned the lieutenant of Santa Cruz, Juan de Beytia, for permission to abandon their grants temporarily and go live with relatives in places of greater safety (SANM, Series 1, no. 28). The abandonment was temporary; two years later the new Governor of New Mexico ordered the residents to return. As a measure to insure against future abandonments caused by Indian raids, Governor Vélez Cachupín prescribed several security measures to make any attack on the settlers unsuccessful. He forbade the building of isolated houses. He instructed the settlers to build and occupy plazas with houses joined together in a square. Furthermore the decree stated that all exits be barred with strong gates. Alcalde Mayor Juan Joseph Lovato, in accordance with the decree of his superior, met with several of the Abiquiú settlers in the Pueblo of San Juan on the 6th of March in 1750. There he read from the governor's decree instructing them to resettle the Abiquiú area immediately (SANM, Series 1, no. 1100). After many delays Governor Cachupín placed Juan Joseph Lovato in charge of the resettlement. On the 6th day of April in 1750 an escort and troops from the royal garrison were sent to see that the settlers arrived safely at their destination. Six families of Spanish colonists were resettled, along with thirteen genízaros. The genízaros were not placed at Santa Rosa with the other settlers but in the abandoned house of Miguel Montoya,

who family had fled the area in 1745. This house was located in the present-day village of Santo Tomás Apóstal de Abiquiú.

At a site chosen on the south bank of the Chama River the Alcalde stated:

> I made the resettlement at the place where the chapel is situated, and this being the center, I made the measurement and designated the plaza in a square, which consisted of 135 varas on each side (SANM, Series 1, no 1100).

This plaza of Santa Rosa de Lima, which measures about 370 feet square, surrounded the present ruins of the chapel which is known locally as " La Capilla de Santa Rosa" and is located about 1 ½ miles east of the present day church and plaza of Abiquiú.

Within four years of the Santa Rosa resettlement, Governor Cachupín made a land grant to *Genízaros* and named their settlement Santo Tomás Apóstol de Abiquiú. The eastern boundary of the Santo Tomás grant was the western boundary of the Santa Rosa grant.

After 1750 continued attacks by raiding Indians caused these settlements to be temporarily abandoned. Perhaps the most noted visit to Abiquiú area came as part of the Fray Francisco Atanasio Domínguez visitation of 1776. Domínguez seems to indicate that the community of Santa Rosa was already in decline, while other documents support the notion that Santa Rosa was a viable community (Adams and Chávez 1956:120). If the community was experiencing a decline, it would be unusual for the community to cast a bell which was placed in its Chapel of Santa Rosa. Fray Mariano Sánchez Vergara wrote about the bell on August 22, 1822 (AASF, Accts). Four years later vicar General Agustín Fernández San Vicente writes the last surviving nineteenth-century account that details the site of Santa Rosa.

It is not until after the turn of the century that archaeologists and architectural historians turned their attention to the crumbling ruins of Santa Rosa. While no systematic, intensive survey of archaeologi-

cal remains of Santa Rosa have been carried out, scholars for the past six decades have been interested in the ruins. In the 1930s Frank Hibben from the University of New Mexico conducted limited excavations. Herbert Dick of the Adams State College in Colorado also conducted field research and archaeological work on the site in the 1960s. Numerous other surveys and testing were conducted at the site. In 1975 villagers from Abiquiú formed a historical association and began in earnest to protect the site. That same year the site was turned over to the Archdiocese of Santa Fe. During the winter of 1976 the local history association known as "La Asociación de Santa Rosa de Lima" began plans to conduct archaeological work at the site. A contact was made with Ned Roberts at the University of New Mexico, who in turn contacted Linda Cordell of the Department of Anthropology at the University of New Mexico. She made arrangements to take me to one of the January meetings of the association. By February I was making plans to run a community-based archaeological program. Gilberto Benito Córdova and I walked around the site one cold February day and discussed the dreams of the community. He carefully pointed out to me the pottery that was scattered about the surface of the site. He then told me that some of it was made by the Hispanic villagers at the site. This was the first time I had ever heard about New Mexican *Spanish* pottery. Everything that I had ever read indicated that only Indians had made pottery in colonial New Mexico. This book is the result of that discussion. In 1977 I conducted my first field school at the site. My labor force consisted of local teenagers that worked both as field/excavation crews and labor force. During that summer the community began rebuilding and stabilizing the existing walls of the chapel. Stabilization on the eroded river bank edge of the site was also carried out. The excavation program lasted for three summers.

The archaeological site of Santa Rosa de Lima de Abiquiú consists of the remains of a single-nave adobe chapel and low mounds indicating at least twelve major roomblocks, comprising a minimum of eight *placitas* or *plazuelas* and a *plaza mayor*. The contiguous roomblocks

and the chapel on the south form a hollow square or central plaza (*plaza mayor*). An entrance on the eastern periphery of the site likely allowed access to the plaza. To the east of the chapel a *camposanto* or walled cemetery is indicated, for the early inhabitants buried their dead here. Archaeological work in 1979 indicated that the chapel interior as well as the walled *camposanto* were filled with burials. Two prominent trash mounds are visible outside the contiguous roomblocks, one at the far eastern extremity of the site and the other along the bank of the Chama River. This river has destroyed a major portion of the site, as is well documented by the aerial views taken by Charles Lindbergh in 1932 and the present location of the river in 1997 (Salazar 1976). Specialized features such as *hornos*, corner fireplaces, animal pens and small plaza openings are recognized by their distinctive shapes.

Hibben suggested that the site of Santa Rosa overlies an earlier Biscuitware site. The archaeological work in the late 1970s and early 1980s could not verify this claim. It is likely that the Biscuit series ceramics found at the site were probably scavenged by early Hispanic settlers from other nearby Biscuit sites. Chronologically the next series that occur at the site are the Tewa Series wares that range in date from 1500-1800 (Mera 1939). Tewa-made wares including Posuge Red (Mera 1939:12), Kapo Black (Mera 1939:82), San Juan Red-on-tan (Harlow 1973:82). Nambé Red (Harlow 1973:82) Powhoge Polychrome (Harlow 1973:31), Ogapoge Polychrome (Harlow 1973:30), Tesuque Polychrome (Harlow 1973:35) have been noted at the site.

Hispanic-made wares are even more common at the site. These include Casitas Red-on brown (jars, flange plate, soup bowls, large hemispherical bowls, small hemispherical bowls), Casitas plain (jars and pots), Carnué plain (jars, large pots), Hispanic blackware, also called Manzano Black (plates, flange plates, soup bowls, and jars), and Hispanic gray wares (soup bowls, plates, jars). Nearby clay deposits provided the clay that was used in the manufacture of Casitas and Hispanic blackwares. Additionally four types of micaceous wares

have also been noted at the site: El Rito Micaceous, Petaca Micaceous, Chacón Micaceous (Carrillo 1987), and an unnamed Hispanic micaceous ware. In short this is a key site for understanding the development of a Hispanic ceramic tradition among settlers in the Chama valley and other parts of northern New Mexico and southern Colorado. The village of Santa Rosa de Lima de Abiquiú was the mother community for much of northern New Mexico. It is very possible that the ceramic traditions of the colonial potters at the village of Santa Rosa de Lima de Abiquiú were carried to other village sites up the Gallinas and Chama valleys.

The San Luis Valley: Del Norte and La Loma

By the middle of the nineteenth century, Hispanic settlers were already establishing plazas at the upper reaches of the Río Grande. One such settlement known as La Loma de San José was established in the 1860s near Del Norte, Colorado (Lantis 1950). Evidence from partial excavation of the site suggests that it is the oldest Hispanic settlement on the headwaters of the Río Grande.

La Loma de San José, also known as "the Paulson Site," consists of a cemetery and two parallel contiguous rows of houses that are now mounds of earth. The earliest map reference to La Loma de San José appears on a 1874 map by J. B. Colton (Richmond 1973:2). The 1859 diary of Juan Bautista Silva[19] from New Mexico (in the possession of Ms. Josephine Silva in 1969) clarifies references to the original plaza and settlement. Excavations at the site revealed the presence of "Spanish types of pottery called Casitas Red-on-brown, Kapo Black, Petaca Micaceous, a type traded by Indians to the Spanish called Powhoge Polychrome, and an Apache trade pottery, Cimarrón Micaceous" (Dick 1968:83).

In 1988 this writer visited the Del Norte, Colorado, area and noted the presence of many archaeological sites that date from the 1860s to the turn of the century. Many of them contain Hispanic and some Native American pottery. The archaeological literature is silent on these sites, as none has been reported.

Micaceous Wares:
Market Demand and Craft Specialization
in Hispanic Villages in Northern New Mexico

References to micaceous[20] wares manufactured by Tewa, Tiwa, Jicarilla Apache, and Navajo potters are not uncommon in the archaeological literature for sites located in northwestern, north-central, and northeastern New Mexico. The micaceous wares associated with archaeological sites, Jicarilla settlements, Indian pueblos, and Hispanic villages range in date from A.D. 1300 to the present.

Numerous varieties of micaceous wares occur in the northern Río Grande, especially those tempered with mica or mica schist, those containing residual clays with an abundance of mica flakes, and those constructed of nonmicaceous clay but covered with a mica slip.

Early ribbed and smeared-indented utility wares known as Córdova and Cundiyó first appear about A.D. 1300; by A.D. 1400–1600 the predominant utility ware was Río Grande Micaceous, which is tempered with mica schist (Mera 1935).

At the seventeenth-century Spanish colonial sites of Las Majadas (LA 591) and Cochití Springs (LA 34), both in the Santo Domingo basin, thin micaceous slip wares are documented (Warren 1981:154).

Documentary records indicate that Jicarilla Apaches began to make their presence known in northern New Mexico as early as the 1730s. Baugh and Eddy (1987) suggest that contact with Puebloan groups caused the Jicarilla Apaches to become more sedentary and shift from a hunting and gathering subsistence strategy to one that also encompassed pastoralism and agriculture.

Historically Jicarilla Apache peoples were known for their pottery-making skills. A number of micaceous pottery types attributed to the Jicarilla are described in the archaeological literature, including Ocaté Micaceous (Gunnerson 1969), associated with sites on the eastern slopes of the Sangre de Cristos, and Chacón Micaceous (Carrillo 1987), associated with nineteenth-century sites near Coyote and Abiquiú, New Mexico.

By the eighteenth century, micaceous wares are common at sites in the upper Río Grande, become even more common in late eighteenth sites, and are actually abundant at nineteenth-century Hispanic village sites. Micaceous clay deposits were used historically by Apache, Pueblo, and Hispanic potters. Such deposits are found near La Petaca, Picurís Pueblo, Chamisal, Nambé Pueblo, Taos, and along the Pecos drainage near San José and San Miguel del Vado, all in New Mexico. In the Río Puerco drainage of west-central New Mexico, Navajo potters made a thin-walled striated pottery tempered with crushed micaceous rock (Brugge 1963).

The proliferation of the use of micaceous wares during the late eighteenth and nineteenth centuries attests to its popularity. The most complete treatment on micaceous wares can be found in the work of Warren (1981:149–166).

The origins and diffusion of mica wares have been the subject of considerable speculation and debate for the past five decades.

Speculations concerning the origins of historic micaceous wares are divided between those who believe the Jicarilla Apache obtained the technology from the Pueblos, and those who believe the reverse. Ellis and Brody (1964) concluded that since Taos made micaceous pottery during Pueblo IV times, the Jicarilla learned to make micaceous pottery from the Pueblos. Wedel (1959) was of the opinion that the micaceous pottery of the Dismal River sites was "almost certainly to have directly stimulated, if not actually imported, from the Southwest," since mica wares occurred in such low percentages on the plains. Gunnerson and Gunnerson (1971) concurred with this conclusion, but cautioned "at this moment it is not clear to us where the earliest form of Jicarilla pottery, called Ocaté Micaceous, is derived from Taos Micaceous, or whether the differences ... are innovations introduced by foothill Apache" (Warren 1981:159).

Warren (1981) suggested that mica wares may have been introduced into the Southwest by Mexican Indians who arrived with Hispanic settler populations.

The notion that Hispanic villagers participated in a micaceous pottery tradition has received little or no attention in the archaeological literature, except for the work by Hurt and Dick (1946:310), Dick (1968), and Warren (1981).

In a discussion about Santa Clara Pueblo, LeFree quotes Hill, who writes:

> A third micaceous type was derived from the Chimayó Valley. Some villagers journeyed to the sites; others obtained it from the neighboring Spanish-Americans who came to the pueblo to trade (LeFree 1975:80).

Most of the micaceous wares associated with Hispanic sites are thin-walled and were produced from residual micaceous clays. They include Ocaté Micaceous, Vadito Micaceous, Peñasco Micaceous, Cimarrón Micaceous, Manzano Micaceous wares, and the thick slablike micaceous wares associated with Hispanic villages in the Pecos drainage. Historical archaeological research will refine these typologies.

The ceramics that have most often survived as heirloom pieces or keepsakes in Hispanic homes in northern New Mexico and along the Pecos River valley are micaceous wares. Some are of Jicarilla manufacture and some are of Pueblo manufacture, yet the vast majority can be attributed to Hispanic manufacture. Micaceous wares identified as Hispanic-made pottery can be documented at 95% of the Hispanic villages for which ethnographic or oral history data have been found. Two distinct observations may serve to explain the presence of micaceous wares in Hispanic villages and the increasingly high frequencies of these wares in these villages.

Jicarilla Apaches were noted for their micaceous cooking pots. For example, in 1852 John Greiner reported that Jicarillas, under

their leader Chacón, intended to establish permanent communities
and manufacture pottery which they could use for barter or trade
(Gunnerson 1974:156). Many of these Jicarilla potters in fact mar-
ried into Hispanic families and through assimilation and accultura-
tion became part of the Hispanic population. The ethnographic in-
formation for La Madera, La Petaca, and Manuelitas, New Mexico,
attests to this situation (see pages 82-85). In many cases, when His-
panic New Mexicans speak about a grandmother or great-grand-
mother who was an *india* they may be speaking about Jicarilla women
who were raised as *criadas* in Hispanic families. Government offi-
cials were even known to complain about the large number of inter-
marriages between Hispanics and Jicarillas in the Abiquiú area:

> In the Hispanic villages where Jicarilla Apaches were
> absorbed into the Hispanic population, the expecta-
> tion is that Apachean pottery manufacturing tradi-
> tions were also adapted by Hispanic potters. Some
> of these potters may have had Apachean ancestry,
> while others may have learned the micaceous tradi-
> tions from other potters in their village. The contin-
> ued and increasing demand for micaceous wares was
> filled by two segments of late-eighteenth- and early-
> nineteenth-century New Mexican society (Carrillo
> 1987:302).

First, Jicarilla Apaches continued to manufacture micaceous wares.
In the spring of 1851, Lieutenant James N. Ward met with Chief
Chacón near San José, on the Pecos River. There Chacón explained
to Ward that he and his followers intended to obtain clay at San José
and to make pottery. Apparently some fifteen days later, Lieutenant
Chapman visited Chacón's camp around fifteen miles east-southeast
of San Miguel del Vado and found about fifty Apaches, some of who
were engaged in making pottery (Bender 1974:33).

Second, Hispanic villagers, including assimilated Jicarilla
Apaches, their children, and others who had learned to make mica-

ceous wares, continued to make these wares in Hispanic villages. In the New Mexican Hispanic dialect, the word *talco* specifically refers to pulverized mica or micaceous earth. This usage is not recorded in other Spanish-speaking areas of the world and is therefore unique (Cobos 1983:160).

The demand by Hispanic villagers for micaceous wares can best be understood when viewed over a time span that ranges from the late eighteenth century (around 1780), until the coming of the railroad in 1880 (Figure 3). James Moore recently noted that the use of locally produced pottery varied as access to imported cooking, serving, and storage vessels changed. He states:

> It is likely that trends in local ceramic type and vessel use are related to two factors – style and economy. The types of decorated wares favored for use changed over time, beginning with a dominance of glazewares during the early colonial period, and switching to matte-painted wares by the late colonial period. Similar tendencies are visible in the major plainware categories. Polished redwares comprise a large percentage of early colonial period assemblages, while polished blackwares are rare. Redwares waned in popularity through time, while blackwares increased in use until they were the most common types in the Santa Fe Trail and Railroad periods. The use of decorated wares also decreased significantly during these later periods. Micaceous wares followed a trajectory similar to that of the polished blackwares. Beginning as a minor component of early colonial assemblages, use of these wares increased considerably by the late colonial period, though they continued to be a minor part of the average assemblage. By the Santa Fe Trail and Railroad periods, micaceous wares were the second most common category (Moore 1996:149).

The increase in the use and manufacture of micaceous wares by Hispanic villagers is related to market demand. Arnold notes: Demand can provide both regulatory and deviation amplifying feedback for ceramic production. If there is no demand for ceramic containers, there is no advantage in making pottery and demand acts as a de-

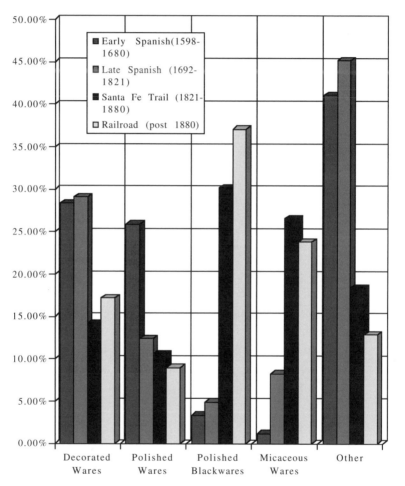

FIGURE 3: CERAMIC CATEGORY PERCENTAGES FOR HISPANIC SITES IN NEW MEXICO (adapted from Moore 1996:47)

viation counteracting mechanism, preventing the development of the craft. If the demand for ceramics is limited, demand acts as a deviation counteracting mechanism, permitting some production, but limiting its development into a full-time craft. If, however, demand for ceramic vessels is great or growing, demand acts as a deviation amplifying mechanism which results in the intensification of pottery making and its evolution into a full-time craft (Arnold 1985:12).

The marked increase in the use of micaceous wares and the market demand associated with these wares in the late eighteenth and nineteenth centuries until the coming of the railroad in 1880, and the presence of these wares as heirloom pieces in Hispanic households, may be directly related to preferences associated with particular cooking qualities of micaceous wares.

The popularity of micaceous wares may have increased because of the physical characteristics rather than visual style. In folk wisdom, micaceous vessels make the best bean pots. This may be due to the ability of mica to efficiently transmit heat, perhaps resulting in a more even distribution over the surface of the vessel than is possible with other wares (Moore 1996:49).

Similarly, the popularity of mica wares may relate to the "taste" that these vessels impart to substances cooked in them. Foster (1962:76) points out that one of the unchangeable values held by many cultures is the taste of food. Arnold's global survey concerning pottery demand documented the following:

In Guatemala, beans are said to have better taste when cooked in ceramic vessels than in metal vessels. … Among the Newari of Nepal, clay containers provide the best flavored pickles of lemon, cucumber and mangos … and impart a beneficial taste to milk products. In South America, … the *chicha* (a

fermented maize beer) will be made only in tradi-
tional vessels because of the distinctive flavor clay
vessels give the beverage. Clay vessels can impart a
good taste to water and to local dishes such as *arepas*
(Venezuelan corn-flour cakes), fried bananas, rice,
chicharón (fried pork) and toasted corn. ... Among the
Yoruba of Nigeria, food is said to taste better when
cooked in earthen-ware pots. ... In Spain, cooks and
potters alike claim that ceramic vessels season and
impart a distinctive flavor to food ... (Arnold
1985:138–139).

The assimilation and acculturation of Jicarilla Apache individu-
als into the Hispanic population of northern New Mexico from the
late eighteenth century, and throughout the nineteenth century, may
have brought about changes in the ceramic assemblages in Hispanic
villages. Moore (1996:46–49) documents an increasing presence of
these micaceous wares at Hispanic sites, an increase that is closely
associated with market demand. The demand for micaceous cooking
vessels is related at least in part to the technological advantages and
durability of micaceous wares, and especially to the idea that food
cooked in them tasted better.

In summary, micaceous vessels, especially cooking pots (bean
pots), offered practical advantages for the Hispanic population of New
Mexico which resulted in an increased demand for these wares. In
many cases, as the ethnographic documentation presented in this
work points out, the demand for micaceous pottery created by its
continued and increasing use by Hispanic families produced a de-
viation amplifying feedback mechanism that allowed some individu-
als in Hispanic villages to engage in ceramic craft specialization. This
specialization in micaceous vessels is documented in both the ar-
chaeological record and the ethnographic record of Hispanic village
life in northern New Mexico and accounts for the high visibility of
these heirloom wares in Hispanic households even today.

Chapter Three
Abiquiú: An Archaeological Case Study

An examination of the archaeological literature pertaining to sites listed in the previous chapter reveals that few of the ceramic assemblages have been systematically studied. Comparatively little has been written about Hispanic pottery assemblages; few technical reports exist. One exception is the ceramic analysis and interpretation of two Hispanic sites near Abiquiú, New Mexico.

The village of Abiquiú, perhaps the village about which more has been written than any other Hispanic village in New Mexico, has a complicated history. Present-day Abiquiú has its roots in Santa Rosa de Lima, a village of Spanish settlers begun in 1734, and in the *genízaro* village of Santo Tomás, established in 1754. The two sites examined in this section are part of the archaeological complex that relates to both villages.

An understanding of the history of Abiquiú is necessary to provide a context for the remainder of this discussion. Abiquiú was officially settled as a Hispanic community in 1734 at the site of Santa Rosa de Lima de Abiquiú (LA6602), though scattered *haciendas* and *ranchos* likely existed before formal settlement. Because of the threat posed by nomadic Indian raiders, the area was abandoned in 1748. It

remained uninhabited until 1750, when Governor Tomás Vélez
Cachupín ordered the original settlers from Abiquiú to resettle their
holdings in time for spring planting (SANM#1100), and so they
resettled the original site. Four years later the same governor and the
Franciscan *custodio* founded the mission of Santo Tomás for *genízaros*
at the present-day site of Abiquiú (NMLG reel 26, SG 140, Frame
34H).

The term *genízaro* usually refers to detribalized nomadic Indians
who were ransomed from captivity, were acquired by barter or trade,
or were captured in warfare, and who eventually became Hispani-
cized by adopting the Spanish language, religion, and culture.

> In Abiquiú the church records ... of later years show
> that people from Hopi villages, Zunis, Isletas, Santa
> Claras and other Pueblo Indians continued to come
> to Abiquiú throughout the eighteenth century, ap-
> parently forming the majority of the local *genízaro*
> population (Swadesh 1974:40).

These people assimilated into what is now the Hispanic populace of
New Mexico. Culturally these *genízaros* chose and successfully adopted
a Hispanic model. Today they see themselves as Hispanics. Although
in Abiquiú, as in certain other Hispanic villages, these people are
very much aware of their *genízaro* ancestry, they are also perfectly
clear about being Hispanics in terms of culture; for as Frances Swadesh
notes, "It is clear ... that cultural factors, rather than ancestry, were
the determinants of colonial population labels" (Swadesh 1974:45).
In short, the *genízaro* became Hispanic by means of passing through
various linguistic, political, economic, religious, and social processes
of assimilation. The *genízaro* acculturation succeeded because of sev-
eral factors: the assimilation and acculturation processes employed
by Franciscan missionaries at *genízaro* communities; the success of
the Brotherhood of Our Father Jesus the Nazarene[21] in completing
the acculturation process in smaller villages; intermarriage with His-
panic families; the 1821 Mexican *Plan de Iguala*[22] by which the entire

population was given citizen status and ethnic/racial identifications were made illegal; and finally financial success, for money is an unsurpassed cosmetic for whitening the skin.

Fray Francisco Atanacio Domínguez wrote about the poor condition of the Santa Rosa de Lima chapel in 1776. Apparently the settlement and chapel were already falling into disrepair when he visited the two settlements of Abiquiú (Adams and Chávez 1956:123). Although the historical records imply that there were occasional differences between the Hispanic settler population and the *genízaro* population as late as 1827, the two plazas had become one endogamous population by the end of the Mexican Republic period in 1846.

As the population of Abiquiú grew and the dynamics of social interaction between Hispanic and Pueblo neighbors evolved, so did the tradition of making pottery in this village. In 1776 there was no mention of a ceramic manufacturing tradition, but some twenty years later it was noteworthy.

At Abiquiú, documentary records indicate that the local priest supplied his own pottery. Domínguez notes in 1776: "They do not know how to make pottery, the father supplies what is necessary" (Adams and Chávez 1956:123). This reference to the lack of pottery manufacture for the needs of the Abiquiú mission church has been misinterpreted by most writers to mean that the *genízaro* women there were not engaged in pottery manufacture. Colonial records for many of the New Mexican mission churches indicate that tablewares were often imported from México. *Losa fina,* an imported tableware, had to be carefully transported to New Mexico and was expensive to import. Administrators of many of the mission churches in the Río Grande pueblos often relied on native potters to produce the necessary wares for everyday use. It is likely that after less than a decade of use, the Abiquiú mission was lacking the "necessary" wares when Domínguez visited in 1776.

Just twenty years later, in 1796, Fray José de la Prada wrote that the *genízaro* women in the village of Abiquiú "made pottery which is sold to *vecinos* for food supplies" (SANM II 21:537n, no Twitchell #, Benjamín M. Read collection NMSRCA). The *vecinos* in this case were

the residents of numerous other Hispanic settlements scattered near Abiquiú, as well as up and down the Río Chama drainage. This clear evidence of craft specialization by the *genízaro* women of Abiquiú helps establish a time-frame for understanding when pottery specialization appeared in the area; and thus it provides the framework for determining what kinds of "forcing conditions," environmental or sociopolitical or both, can lead to a craft specialization such as pottery production.

Anthropological field work in the early 1980s by this writer documented the tradition of pottery manufacture in Abiquiú as late as the 1940s. The oral record of the Abiquiú pottery tradition is examined in the ethnographic section of Chapter Two.

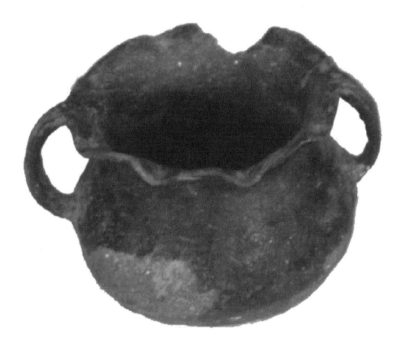

PLATE 56: ATOLE CUP, ABIQUIÚ, NEW MEXICO, 19TH CENTURY.
3" tall, 3 ¼" rim diameter. Collection of Debbie Carrillo. Photograph by Paul Rhetts.

Archaeological Evidence

As part of a larger mitigation project along six miles of Highway 84 in the Chama Valley, the Laboratory of Anthropology of the Museum of New Mexico excavated two Hispanic sites near the village of Abiquiú in 1988. The sites represent two distinct time periods of Hispanic occupation in the Chama Valley. The first site, known as La Puente (LA 54313), dates roughly from the mid 1730s to approximately 1821. This site is thought to be one of the earliest permanent Hispanic sites in the upper Chama drainage. Hispanic settlers from the area of Santa Cruz de la Cañada settled La Puente around 1750. There are no census data for the early occupation of La Puente except for a listing of families that settled the area, but the archaeological data reveal that the site was occupied until 1850. Swadesh (1974) maintains that La Puente is the location of the first settlement of Santa Rosa de Lima, dating to the 1730s; however, this assertion remains to be confirmed.

The second site was the home of Francisco Trujillo of Abiquiú. This site (LA59658) consists of the ruins of an eight-room structure. Associated with the house was a deep pit, apparently the borrow pit from which the adobes for the house were made. The pit was used as a trash dump during the entire occupation of the site, from the 1840s until the turn of the century. Highway construction in the 1940s razed the structure, leaving the lower walls and trash pit relatively undisturbed.

The ceramic assemblages from each site were analyzed. Levine states that "several technological differences became apparent within the assemblages that potentially represent the dichotomy between Tewa and Hispanic wares" (1990:173). Each site yielded four kinds of pottery: black, red, polychrome, and utility. Typically the black, red, and polychrome wares are classified using a typology established by Kidder and Shepard in 1936 and Harlow in 1973. The black wares are called Kapo Black and Santa Clara Black, while the red wares are referred to as San Juan Red-on-tan and Tewa Redware. Levine refers to all of these ceramics as plainwares to separate them from the poly-

chrome wares also found at both sites (Levine 1990). These Tewa wares typically have vitric tuff (volcanic ash) temper mixed with a much smaller quantity of pumice or fine sand or both.

As early as 1946, Hurt and Dick noted the possibility of Hispanic manufacture of ceramics, and they described for the first time in the archaeological literature a number of ceramic types thought to be of Hispanic manufacture. Many of the wares thought to be Hispanic appeared similar to those known to be of Puebloan manufacture. On closer examination, however, several differences were noted. The most discernible is the difference in temper selection. The wares ascribed to Hispanic manufacture typically contained high percentages of sand temper, an obvious difference from those described by Kidder and Shepard (1936), Harlow (1973), and Mera (1939).

For purposes of analysis, the term Hispanic Blackware was used in contrast to the Tewa ware known as Kapo Black. Casitas Red-on-brown was relabeled Hispanic Redware. Both types typically exhibited fine to medium fine sand temper, occasionally with a very small amount of tuff or pumice temper, or both, mixed in. During the course of the analysis, differences were also noted in surface treatment. Levine (1990) notes that the Tewa Blackwares had a thick well-polished slip while the Hispanic Blackwares characteristically had a thin, poorly polished slip. Analysis of blackwares revealed that Tewa Blackware bowls were generally well slipped on both the exterior and interior surfaces, while Hispanic Blackware bowls were generally slipped on the interior surface only, with a narrow slip band extending over the rim to the exterior.

The Hispanic Redware exhibited an uneven red-slipped band applied over the polished buff surface, while the red band on San Juan Red-on-tan was applied as a fine line with an even edge. As noted by Dick (1968:81), many of the Hispanic Redware bowls contain scrolls, circles, and blushes (Plate 55). In 1988, during pre-analysis consultation with lab staff, this author suggested that the uneven-edged band on Hispanic wares was likely due to the application of slip with a rag. Subsequent analysis showed that the red band on

San Juan Redware jars does not overlap the rim and extend into the interior of jars, while the band on Casitas Redware jars does. The application by brush of the banding on the Tewa material obviously differs from that on the Hispanic material.

At La Puente there is a high percentage of Tewa Polychrome, and more than 50% of the sherds of that ware type were jar forms. This percentage was higher than for any of the plain wares. The polychromes included Ogapoge and Powhoge, originating from the Tewa pueblos some twenty miles southeast of the Abiquiú area. This high percentage of large polychrome forms corresponds with the finding presented by Papousek (1984), and it calls attention to the fact that larger forms have a wider spatial distribution than smaller forms.

PLATE 57: CASITAS RED-ON-BROWN RIM SHERDS FROM LA PUENTE, NEW MEXICO. 19TH CENTURY.
Photograph by Contract Archaeology Office. Courtesy Museum of New Mexico.

In contrast to the high percentage of decorated polychrome jar forms found at the earlier site of La Puente, smaller numbers were found at the Trujillo site. This discrepancy is perhaps explained by the fact that the Trujillo House was occupied during the period when trade over the Santa Fe Trail was at its peak, and continued to be occupied during the period when the railroad arrived in New Mexico in 1879–1880. This period saw a shift from the use of Hispanic ceramics and Pueblo trade wares to the use of European-American manufactured goods, most notably metal containers. This trend was noted by Moore (1996:29–57):

> Decorated wares are relatively common on the late Spanish Colonial sites, but nearly two-thirds were used for storage-cooking. … Percentages of decorated wares dropped considerably during the Santa Fe Trail period, with nearly 60 percent of this category used for storage-cooking (Moore 1996:48).

and

> Perhaps the most interesting variation over time is in functional categories. Vessels used for serving and consumption comprise nearly 40 percent of early colonial assemblages, dropping to just over 30 percent of late colonial assemblages. During the Santa Fe Trail period, the percentage of vessels used for serving and consumption increased to nearly the early colonial level, and during the Railroad period it grew to nearly equal the percentage of vessels used for cooking and storage. This variation may be due to economic conditions, and in particular may reflect access to metal cooking vessels or alternative forms of storage (Moore 1996:50).

The amount of plain wares also differed at each site. At the colonial site of La Puente, there was more Hispanic Redware than Tewa Blackware, and there was more Tewa Blackware than Hispanic Blackware (Figure 4).

By contrast, as Figure 5 shows, at the Trujillo House, a territorial period site, the amounts of Hispanic Blackware and Hispanic Redware both exceeded the amount of Tewa Blackware. Tewa Redware constituted only an exceedingly small percentage of the plain ware assemblage.

Moore notes that "Polished redwares seem to decrease in importance over time, while polished blackwares become increasingly more popular" (Moore 1996:47). This trend is apparent at the later Trujillo House site, where Hispanic-made black wares and Tewa-made black wares predominate.

In the past two decades numerous Hispanic sites and villages have been surveyed and, in some cases, partially excavated. In almost every case, the archaeological analysis has indicated a significant presence of Historic matte-painted polychromes and Tewa plain wares (Harlow 1973). It is argued here that the large matte-painted polychrome wares of the seventeenth, eighteenth, and early nineteenth centuries represent a form of craft specialization among various pueblos. The following polychrome wares were manufactured in the pueblos: Zía, Zuní, Santa Ana, Acomita, Ako, Cochití, Santo Domingo, Kuia, Punamé, San Pablo, Trios Ranchitos, Ashiwi, Kiapwa, Laguna, and Powhoge (Harlow 1973). The potters in some pueblos may have specialized in particular forms or wares to "avoid competition and monopolize a market" (Kramer 1985).

At La Puente, as expected given the origin of the inhabitants, most of the jars were Tewa Blackware or Tewa Redware. These jars were probably used for food storage (Figure 6). There is a high jar-to-bowl ratio for La Puente and a high bowl-to-jar ratio at the Trujillo House (Figure 7).

The dramatic shift in the ceramic assemblages at La Puente and the Trujillo House suggests specialization. It is likely that Tewa pot-

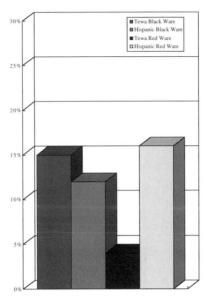

FIGURE 4: PERCENTAGE OF TEWA & HISPANIC PLAINWARES FROM LA PUENTE SITE (adapted from Levine 1996:1)

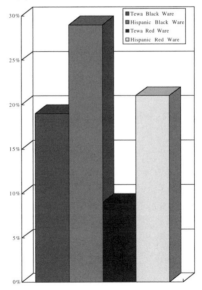

FIGURE 5: PERCENTAGE OF TEWA & HISPANIC PLAINWARES FROM TRUJILLO SITE (adapted from Levine (1996:2)

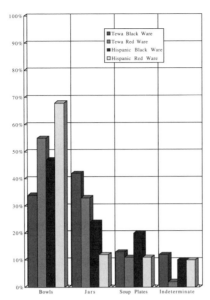

FIGURE 6: LA PUENTE VESSEL FORM PERCENTAGES
(adapted from Levine (1996:2)

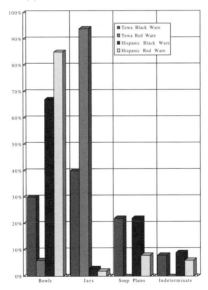

FIGURE 7: TRUJILLO HOUSE VESSEL FORM PERCENTAGES
(adapted from Levine (1996:2)

ters supplied the Hispanic population of the Chama Valley with large polychrome jar forms. At the Trujillo House few Tewa jars were found, a trend documented by Moore (1996:46–52). This is in marked contrast to the many Hispanic mold-made bowls that were found. These bowls had standardized rim diameters and were found in large numbers.

The interesting differences between the two sites suggest Hispanic ceramic specialization. Standardized rim diameters of bowls and plates argue strongly for the use of molds and indicate that Hispanic potters used a ceramic technology not employed by Pueblo potters. Figures 5 and 6 illustrate the difference in percentages at both sites, suggesting a change over time in which Hispanic households came to use more bowls for food service. The apparent demand for bowls of a standardized form indicates specialization.

It seems as though Tewa potters were manufacturing and supplying particularly large vessel forms to Hispanics, while Hispanics concentrated on manufacturing smaller bowls and other smaller utilitarian vessels for their own daily needs. The bowls and utilitarian items that were fashioned by Hispanic potters are the types that most frequently need to be replaced, because they are most often broken (due to daily use). Numerous scholars have suggested that the larger the ceramic container, the less frequently it will be moved; therefore, larger ceramic containers are less likely to be broken than small ceramic containers, like bowls which may be used daily (Deal 1985; DeBoer 1974, 1979). At the earlier site of La Puente, Tewa polychromes occurred at a higher percentage than at the later Trujillo site. American-made goods, available at the time the Trujillo House was occupied, likely replaced the Tewa polychrome jars that were previously used as storage containers by Hispanics.

Hispanic Bowl Standardization:
An Example of Molding

The consistency of rim diameters of Hispanic Blackware bowls from the Trujillo site suggests that the bowls were made in molds. Analysis of whole or reconstructed Hispanic Blackware bowl rims reveals that rim diameters ranged from 11 cm to 22 cm (Figure 8). The modal rim diameter of 16 cm, the highest frequency, represents 36% of the total. Bowls of 14 cm, just 2 cm smaller, constitute 16.3% and bowls of 18 cm, just 2 cm larger, constitute 17% of the total. The decrease in frequency occurs consistently from the middle to each end of the scale. In the range of 14 cm to 18 cm, 62% of the ceramic bowls occur.

Levine (1996) notes that the shapes and rim treatments of the reconstructed or partial bowl fragments are consistent. In contrast to Tewa bowls, which do not have standardized rim diameters, bowls of Hispanic manufacture are definitely molded, perhaps so several bowls of the same size can be nested and stacked (Plates 58, 59, and 60). Since the late 1970s, numerous archaeologists have discussed the problem of recognizing sociopolitical complexity associated with the appearance of full-time craft specialists. Rice (1981) and Hagstrum (1985) have proposed a relationship between specialization and product standardization. The arguments presented have stressed that standardization of pottery shows up in the relative lack of variation in vessel form and size. Longacre (1981) suggests that ethno–archaeological research is one way to access the proposed linkage between standardized pottery and specialist potters. He concludes that the data in the form of sample variation statistics "strongly indicate that pots produced by the full time potters are much more standardized." The archaeological data from the two Abiquiú sites of La Puente and the Trujillo House seem to indicate the presence of standardization among Hispanic potters producing hemispherical bowls. Levine suggests that molding techniques probably account for this high degree of standardization.

The bowls were most likely produced by a technique in which a flattened clay disc is molded over the inverted base of a larger bowl or pot and cut to size. This technique is termed "convex molding." Foster's (1948, 1955) work on Mexican pottery was the first to establish this method in the literature of pottery manufacture in the New World. Methods described as convex molding are also covered by Reina (1963:18–30) and Díaz (1966:143–44). Data on prehistoric pottery standardization in the American Southwest also have been examined by Feinman, Upham, and Lightfoot (1981), Hagstrum (1985), and Longacre, Kvamme, and Kobayashi (1988), but they do not report convex molding.

A recent comparative case study of the Mexican village of Acatecan by Lackey indicates that some potters mold the entire basic form using the convex technique, while others employ the convex mold for the base alone and then add coiled clay to construct the remainder of the form (Lackey 1982:73–107).

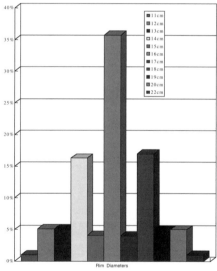

FIGURE 8: PERCENTAGES OF HISPANIC BLACKWARE BOWL RIM DIAMETERS FROM TRUJILLO SITE
(adapted from Levine (1996:3)

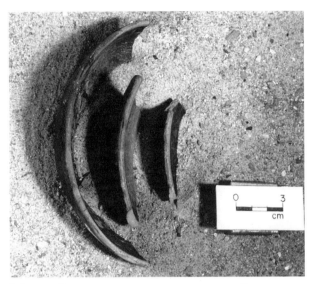

PLATE 58: MOLDED BLACKWARE BOWL FRAGMENTS FROM TRUJILLO SITE.
Photograph by Contract Archaeology Office. Courtesy Museum of New Mexico.

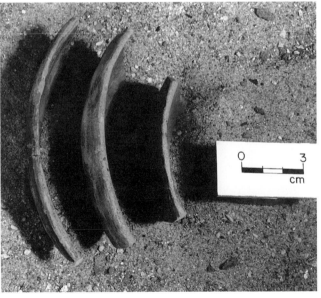

PLATE 59: MOLDED BLACKWARE BOWL FRAGMENTS FROM TRUJILLO SITE.
Photograph by Contract Archaeology Office. Courtesy Museum of New Mexico.

No data on convex molding in the Southwest currently exist; in fact, the present report may be the first to indicate a standardized manufacturing technique employed by Hispanic potters of the late eighteenth and early nineteenth centuries.

Standardization of ceramic forms and decoration has usually been interpreted as implying some type of craft specialization because it is

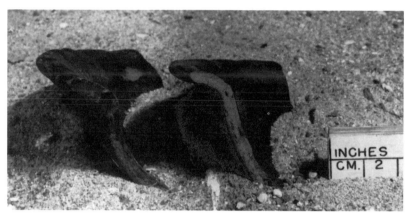

PLATE 60: RIM SHERDS OF SOUP PLATES/BOWLS FROM THE TRUJILLO SITE, ABIQUIÚ, NEW MEXICO, 19TH CENTURY.
Burnished black. Photograph by Contract Archaeology Office. Courtesy Museum of New Mexico.

FIGURE 9: MAKING OF MOLDED BOWLS
Left: clay slab inverted over older pot; Right: clay slab inverted over hemispherical mold. Illustration by Charles Carrillo.

thought that, with increasing production, the potters tend to shift toward greater efficiency in terms of time and labor expended. Noteworthy are the works by Philip Arnold (1986, 1988), Barnes (1987), Bronitsky (1983), Hagstrum (1985), and Rice (1981). For purposes of this discussion, standardization results from economic forces operating upon the potter in such a way that production becomes routine, involved in frugal strategies (e.g., Torrence 1986), and/or characterized by fewer potters who exhibit less variability in their work and tend to use a wider range of raw materials in the production of pottery (Peacock 1970; Rice 1981).

Our incomplete understanding of the production of standardized bowls or vessels by Hispanics in late colonial New Mexico requires additional investigation and cannot be adequately addressed in this research; however, future research must provide clear expectations as to the reasons why standardization occurs in response to the environment and market demand.

Ross Frank (1992) suggests that Pueblo pottery traditions changed markedly between 1750 and 1820, a process attributable to the increased economic activity associated with long-distance trade between New Mexico and northern New Spain. He suggests that Pueblo pottery traditions changed in order to produce ceramics for a non-Indian, non–New-Mexican market. Frank lists three major trends in the pottery of the late-eighteenth-century southern Tewa and northern Keres. First, the shapes generally changed from low-bulge forms to almost spherical forms. Second, design elements changed from cloud feather and formal designs to less formally decorative spaces and stylized shapes. And finally, new types show the marked degradation in quality of finish and decoration which is consistent with increased production for trade. While Frank does not address the question of craft specialization among the eighteenth-century Tewa and Keres potters, existing data from collections point to some type of specialization with regard to large spherical storage jars and large bowl forms.

This information may help explain the variation between the ceramics from the two Abiquiú sites. The assemblage at La Puente, the earlier site, is marked by the earlier large spherical Tewa forms, while the later Trujillo House site is marked by specialized forms manufactured by Hispanics. Apparently the appearance of polychromes in higher percentages at one trash deposit at La Puente represents a peak in the use of Tewa polychromes by the Hispanic settlers. Chronologically this occurs at the colonial-territorial transition in the early 1840s.

This striking specialization may very well be the Hispanic response to the marked increase of trade wares that the Pueblo people were being forced to produce for a southern market (Frank 1992:265–281). It may have been increasingly difficult for Hispanic villagers to obtain Tewa wares. We would then expect that the specialized wares recovered from the Trujillo House were manufactured by individuals or families who were disenfranchised and hence turned to pottery manufacture to supplement their income by filling the gap left by the increased trade of Pueblo pottery to the southern markets.

Papousek (1984) has proposed that under some conditions, larger vessels may have a wider spatial distribution than smaller pots. While this conjecture has not been tested with New Mexican Pueblo and Hispanic ceramic data, the records indicate a substantial trade in Pueblo wares to northern México (Frank 1992:265–281). The present writer proposes that significant economic developments based on long-distance trade, which included standardized Pueblo pottery, were among the catalysts that invited Hispanic potters to "fill the niche." While the archival record does not indicate clearly which type of pottery was made for export, it is most likely that these forms were standardized to meet the demands for the export market. And Hispanic potters of the period, in turn, specialized in standardized forms like molded hemispherical bowls and produced wares suitable for local consumption.

Current research concerning pottery specialization and especially morphological standardization has involved examinations of pot-

tery production itself. The bowls excavated from the Trujillo House site show evidence of pottery standardization, especially in the large number of molded bowls. The two distinct assemblages from Abiquiú suggest a Hispanic ceramic manufacturing tradition as early as the 1730s, based on the identification of sand-tempered thin-slipped sherds as Hispanic. Before the Pueblo Revolt of 1680, there is little doubt that Hispanic settlers depended on their Pueblo neighbors for many products, including pottery. This reliance of Hispanic settlers on native peoples for many household goods ultimately led many anthropologists and historians to assume that the practice continued unchanged after recolonization in 1693. However, the seventeenth-century *encomienda* system of tribute was not reinstituted after resettlement, so pottery no longer served as a tribute item. Rather, it had to be obtained through purchase or barter.

During the mid- to late-eighteenth century, the Hispanic populace of the Abiquiú region apparently continued to obtain pottery from nearby Tewa pueblos. At La Puente, Tewa polychrome jars are common. Gradually the demand for these polychromes decreased throughout the occupation of the Trujillo House (1840–1900), until few Tewa polychrome jars are found. There is a tremendous increase in the number of Hispanic Blackware bowls during this same era. Levine concludes that most of the Hispanic soup plates and hemispherical bowls from the Abiquiú area were mold-made (Levine 1990:180). This practice is unknown among Pueblo potters of the period, for it has not been documented or even suggested for Native American potters in general nor for Tewa potters in particular during the nineteenth century. As noted, hemispherical black ware bowls recovered from the Trujillo site exhibit a consistency in bowl diameters and suggest standardization achieved by Hispanic potters using a molding technique.

Raw Materials and Culture

The remains of pottery from archaeological contexts have traditionally been used to formulate typologies which have been used by archaeologists as the basis for chronologies. The chronologies have provided temporal sequences for particular pottery types. These sequences are believed to reflect changing cultural patterns, and the similarities and differences among types, styles, or attributes are understood to reflect these changes. In the Southwest, archaeologists have considered ceramics to be a reflection of culture, understanding that the cultural changes that shape a society are reflected in the pottery.

Analysis of ceramics from historic archaeological sites has used traditional typologies; however, these typologies only group ceramic assemblages in space and time. The present work focuses on the relationships of ceramics with the environment and non-ceramic aspects of culture.

Survey and excavation crews working in New Mexico have almost exclusively used traditional typologies based on Pueblo pottery nomenclature and thus they have overlooked or ignored the existence of Hispanic pottery traditions. For this reason, laboratory results and excavation data from the few excavated Spanish colonial sites in New Mexico are often misleading.

Archaeological field and survey work in New Mexico tends to emphasize Puebloan ceramic typologies and to ignore the significance of Hispanic pottery in its historical context. The concept that ceramics interact with the rest of culture and can provide information about other aspects of culture will be used in this research. Ceramics can indeed be used for synchronic social and cultural reconstructions of colonial New Mexico.

This presentation is not concerned with technical reporting of excavation data from archaeological sites. Its concern instead is to assemble and interpret a data base that will provide the reader with a general understanding of information that is necessary for archaeologists working in the field of colonial or historical archaeology.

Ethnographic descriptions of ceramic production usually indicate that the patterns associated with the selection and manipulation of raw materials, especially clay and tempering materials, are often correlated with the intended function of the finished container (Arnold 1971; Balfet 1965; DeGarmo 1975; Ericson et al. 1971; Plog 1980; Reina and Hill 1978; Rye 1976; Shepard 1956). Recently archaeologists have turned to the field of materials science and have attempted to identify the function of ceramic containers through an understanding of the selection and manipulation of raw materials (Braun 1983; Bronitsky 1984; DeAtley 1973; Mills 1984; Plog 1980; Raab 1973; Steponaitis 1980; Stone 1984).

The availability of raw materials suitable for producing pottery is crucial. In the following discussion, evidence for Hispanic pottery production starts with a discussion of raw materials – clay, temper, and fuel. All the examples provided here apply to Hispanic New Mexican pottery in general; however, the information used to illustrate the importance of raw materials in Hispanic pottery research have come from the Abiquiú area simply because archaeological work in the Abiquiú area has provided the most complete data available.

Clay

Analysis of ceramics from the two Abiquiú sites (La Puente and the Trujillo House) included the use of X-ray fluorescence. Bart Olinger of Los Alamos National Laboratory conducted the research, and his analysis revealed identical signatures for the clays used in the Tewa wares and in the Hispanic wares. The immediate conclusion, of course, could be that these wares are all made by the same people; however, numerous alternative hypotheses should be explored. Clay used by Tewa and Hispanic potters may have come from different locations within the same geologic formations.

When writing about pottery manufacture at Santa Clara Pueblo, Lange notes:

Earlier several types of clay were used. … A third
type, micaceous, was derived from the Chimayó Val-
ley. Some villagers journeyed to the sites; others ob-
tained it from neighboring Spanish-Americans who
came to the pueblo to trade (Lange 1982:83).

It is possible that both groups obtained clay from the same location
until changes in population dynamics and economics forced the San
Juan potters and other Tewas to select new sources closer to their
pueblos. Because many of the *genízaros* from the Mission of Santo
Tomás de Abiquiú were of Tewa origin, it is possible that when these
detribalized peoples were resettled in Abiquiú in the 1730s and be-
came Hispanicized, they continued to use the same clay sources they
and their ancestors had used before the Reconquest of the 1690s. The
use of these sources by their descendants and others who learned
the craft in Abiquiú may explain why identical clay appears in His-
panic and Tewa wares.

Although hundreds of small archaeological reports describe the
prehistoric and historical ceramics recovered during mitigation pro-
grams throughout the greater Southwest, few contain descriptive
analysis of raw material acquisition; therefore comparatively little is
known about the clay sources even for Puebloan and Athabascan
potters of the historical period. The Native American potters of the
eighteenth and nineteenth centuries used numerous clay and tem-
per sources, and in some cases they continue to use the same sources
even today. However, most of the Spanish colonial, Mexican, and
American territorial raw material acquisition sites used by Pueblo
potters are undocumented, and even less is known about the raw-
material acquisition sites used by Hispanic potters. Part of the reason,
doubtless, is that New Mexican potters in general perceive their
sources as privileged "insider" information, to be guarded rather than
shared with outsiders.

Knowledge of the differences in raw clay and temper preferences,
and of the differences in firing practices, is crucial to an understand-

ing of the diversity of Hispanic and Indian pottery in New Mexico. While clay seems to be an ubiquitous resource throughout the Río Grande Valley and the nearby mountain ranges, specific clays and tempers, each with unique attributes, played an important role in diversifying ceramic manufacture by Native American and Hispanic potters.

Although little is known about raw material acquisition among Pueblo potters, the fact of Hispanic pottery manufacture and raw material acquisition can be proven by comparison and contrast with a known or documented group of Pueblo ceramics. The following section will examine Tewa wares and compare them with data derived from the Hispanic settlements in and near Abiquiú. While all the pottery-producing Tewa Pueblos employ the same basic pottery-making techniques, variations do occur (Schroeder 1964:46). Of interest in this discussion is the degree to which Tewa pottery, notably that of San Juan Pueblo and Nambé, differs from the pottery produced at Abiquiú and other nearby Hispanic settlements.

Olinger indicates that X-ray fluorescence and optical descriptions can be used together to characterize and discriminate different pastes of a single pottery type if the pastes came from different sources. Concerning the X-ray fluorescence technique, Olinger (1992) writes:

All chemical elements in the pottery emit x-rays of specific energies when excited by x-rays from a Cd (cadmium) 109 isotope source. These x-rays are counted and stored on floppy disks for future reference in the form of an energy spectrum for each sherd measured. Only a few of these chemical elements are present in sufficient amounts and have sufficiently strong and well-resolved x-rays in Southwest pottery to be useful for analysis using the apparatus I have available. These eight elements are Ca (calcium), Fe (iron), Pb (lead), Rb (rubidium), Sr (strontium), Y (yttrium), Zr (zirconium) and Nb (niobium). Furthermore, because Fe, Zr and Sr consistently pro-

duce sufficient x-rays having low uncertainties as-
sociated with them, their x-ray counts relative to their
sum are used as the discriminating variables for clus-
ter diagrams. These diagrams show the degree of
homogeneity of the relative amounts of these three
elements among a group of sherds. The remaining
x-ray counts from the other elements can be used as
indicators if are uniquely strong or weak.

Further testing of historical "Tewa" wares that have been found dur-
ing archaeological survey work or excavation in the Pecos Valley,
the Taos Valley, the Belén area, and Los Ranchos de Albuquerque
will certainly help archaeologists understand trade networks and
perhaps even prove certain pottery assemblages to be of Hispanic
and not Tewa origin. Archaeologists working for the Laboratory of
Anthropology analyzed the ceramics from two sites in the Abiquiú
area and concluded:

> During the analysis of ceramics from La Puente and
> the Trujillo House, several technological differences
> became apparent within the assemblages that po-
> tentially represent the dichotomy between Tewa and
> Hispanics wares (Levine 1990:1).

and

> Regardless of who actually made the pottery in ques-
> tion, the fact remains that two similar but distinct
> ceramic traditions occur throughout the state. Dick
> (1968) feels that Casitas Red-on-brown ranges from
> Mesilla north to southern Colorado, and the sand-
> tempered blackwares may have a similar distribu-
> tion. Despite Snow's assertion that pottery found at
> Hispanic sites is indistinguishable technologically
> from pueblo ceramics (Snow 1984:94), analysis from
> several Spanish sites, including La Puente and the
> Trujillo House, demonstrate the opposite. Both the

blackwares and the red-on-buff wares have fine to
coarse sand temper, and are generally more friable
than the tuff-tempered Tewa wares. The extent of slip
and polish also differs on both the red and the black
wares, and design style and quality vary within the
redwares. There is enough of a difference to suggest
that the Tewas were not producing this pottery
(Levine 1990:23).

The two important works that examine specific attributes of histori-
cal Tewa pottery are Mera (1939) and Olinger (1992).
 Most of the pastes in Tewa and Hispanic pottery from the Abiquiú
area appear similar. The exceptions are the various mica-bearing (mi-
caceous) clays used by Northern Tiwa, Tewa, Hispanic, and Jicarilla
Apache potters. Olinger writes:

The pottery from the Tewa-speaking pueblos that sur-
round Santa Fe, New Mexico, was traded and used
throughout the northern Río Grande Valley by Indi-
ans and Hispanics from first contact until the begin-
ning of this century. The ability to identify the source
of pottery from the various Tewa pueblos helps to
establish patterns of interaction among Indian Pueb-
los and with the Spanish settlers. The object of this
study is to identify sources of pottery made by Tewa-
speaking Pueblo Indians north and south of Santa
Fe, New Mexico, during the 1600s and 1700s. I have
measured the trace elements of collections of sherds
from the pueblos to identify those that have sources
of temper and clay in common and are made from a
common mixture of the two. These sherds were then
examined for physical characteristics in the paste,
and when combined with the trace element content,
the pottery is uniquely identified as coming from a
particular source (Olinger 1992:55).

The results of X-ray fluorescence and physical descriptions of the paste from different pottery-producing Tewa villages such as Cuyamungué (LA38), Nambé (LA17), Pojoaqué (LA61), San Ildefonso (LA6188), San Juan (LA874), Santa Clara (LA925), and Tesuqué (LA1064) indicate that the pastes are similar in appearance, and that all of these pottery-producing Pueblos add fine volcanic ash (tuff) to the clay body (Olinger 1992:55–66).

This is because the northern Tewa potters gather clay from Pliocene alluvial deposits in the Santa Fe formation of the Española Valley. About an equal amount of fine volcanic ash is added to the clay as a temper, the inert material that prevents cracking as the clay dries. The ash deposits are from beds in the same formation and are composed of fine glass fragments. In addition, the potters add sand to the clay-and-ash mix (Olinger 1992:55).

Because Olinger's work indicates that the Abiquiú Hispanic and San Juan Pueblo clay pastes have the same spectrographic signature, it is important to examine the literature concerning clay deposits and pottery production at San Juan Pueblo.

In 1916 Harrington noted that Tewa potters obtained their micaceous slips and clays from four different locations. In each case, these sources of pottery materials were located in or near a Hispanic community, which traded in the raw material. These locations are Tierra Amarilla, La Petaca (near Ojo Caliente), Truchas, and Santa Fe Canyon.

Interestingly, the revival of pottery production at San Juan Pueblo in the 1930s was principally instigated by a Hispanic woman married to a San Juan man (Schroeder 1964:48). It is not documented how or where the potters involved in the revival selected the clay they used, nor is it known whether the clays used were different from, similar to, or identical with those of the San Juan potters of the past. It is known, however, that the first slips used in the 1930s were

obtained from Hispanic villagers from Abiquiú and Cañones. Abiquiú Hispanics traded a red slip, and those from Cañones traded a white kaolinlike slip (field notes from 1980; also Schroeder 1964:48). The fact that Harrington identified clay mines located within or near Hispanic communities may present an important clue to understanding raw material acquisition during the colonial era in New Mexico. When Hispanic settlers obtained a land grant that contained a traditional clay source used by native peoples, they may have closed that resource to all former users who were not residents of the grant. The manner in which Hispanic landowners and Tewa potters worked out the accessibility problem is undocumented, but the fact that many Hispanics engaged in a barter system with nearby pueblos presents a clue toward a final answer. Rice (1981:219) notes: "From an ecological and environmental perspective, social stratification and economic specialization reflect the differential distribution of resources and the societal management of these sources." While there is no archaeological evidence conclusively documenting either the sources of raw materials such as clay or whether the eighteenth- and nineteenth-century clays used in Abiquiú and San Juan are similar to those used since the pottery revival in the 1930s, there are abandoned clay workings in the Abiquiú area.

Preliminary field data collected by this author (in 1987) and Felipe Ortega (in 1982; personal communication, La Madera, New Mexico, 1995) indicate that clay located along El Rito Arroyo or Wash, six miles north of Abiquiú and thirty miles northwest of San Juan Pueblo, may in fact be the ancestral clay source for San Juan Tewa pottery. The mere size of the clay pits indicates long-term use. These clay pits are located within the Juan José Lovato Grant, which dates from the 1730s. It is possible that both Tewas from San Juan and Hispanics from the Chama Valley and El Rito areas used the raw material source until population pressures in the region forced the Hispanic residents to deny the Tewa potters further access. The settler population probably perceived the clay as a nonrenewable community resource and may have forced the late-nineteenth-century potters of San Juan to find another clay source.

In the present study, attention to raw material acquisition is important because it helps construct the theoretical framework within which Hispanic pottery can be understood and is therefore an improvement over using only the simple standard typological analysis. The restriction of access to raw material here suggests the presence of competition among producers that resulted in the production of both wares made by Tewas and wares made by Hispanics. This ceramic variability results from a progressively more complex cultural system, complicated by the land-use system common among Hispanic villagers during the late eighteenth and nineteenth centuries.

As Arnold's model will suggest, the research presented here views ceramic specialization by Hispanic potters as a systemic process influenced and shaped by social, political, and most especially demographic processes. Some Hispanic villagers became landless or had access only to less desirable or less productive agricultural lands, and hence they fell from their former occupational status as landowning farmer-rancher to the lower-status alternative of handicraft production. This socioeconomic process resulted in the creation of specialists who turned to the raw materials of their local environment (in the case at hand, the extraction of clay) and applied readily learned labor-intensive skills (pottery manufacture) as a resource buffering strategy.

The production of pottery at Abiquiú by a handful of individuals or even families can best be understood in terms of craft specialization. In San Juan Pueblo, "since most Pueblo women knew how to make pottery, the ability to do so did not create special prestige in the village" (Schroeder 1964:47). On the other hand, since Abiquiú was a *genízaro* village, some of whose inhabitants had previously been nomadic while others had previously been Pueblo, a limited number of individuals and families who could manufacture quality pottery may have used their ability during times of deteriorating economic circumstances to become craft specialists.

Temper

In order to understand how and why temper helps archaeologists to distinguish between pottery made by Hispanics and pottery made by Tewa Pueblo peoples, it is important to understand what archaeologists can learn from temper analysis, and why it is one of their most important research methodologies. Tempering materials enable them to identify on a macroscopic scale the differences in raw materials which indicate differences in ceramic types.

Alfred Kidder[23] was one of the first southwestern archaeologists to use temper analysis to sort ceramic assemblages and to date them. His work and that of his student Anna Shepard at Pecos Pueblo formed the great Pecos Classification system (Kidder and Shepard 1936).

During the analysis of the ceramic wares from the eighteenth-century Abiquiú site of La Puente (LA54313) and the nineteenth-century occupation at the Trujillo House (LA59658), temper was the strongest determinant for separating Tewa-made wares from Hispanic-made wares. Tewa Redwares, Blackwares, Polychromes, and Plainwares typically exhibit a vitric tuff temper, sometimes containing pumice and/or sand that was also mixed into the clay. In contrast, the ceramics identified as Hispanic (Redwares and Blackwares) typically exhibited a fine to medium sand temper, sometimes also containing tuff. Differences also were noted in the surface treatment of each group; they will be discussed in a separate section.

Tuff and/or pumice was the dominant tempering material in 81% of the Tewa sherds of both plain and polychrome wares from La Puente (LA54313). Tuff or pumice temper was found in only 4% of the wares identified as Hispanic. In sharp contrast, sand was the almost exclusive temper in 96% of Hispanic wares and in only 7% of Tewa wares (Figure10). Levine (1996) notes that several temper combinations were recorded.

> Pumice/tuff was most prevalent within the Tewa types (27 percent), followed by a combination of mainly tuff with a small amount of sand (17 percent). Within the Hispanic wares, sand temper oc-

curred in 77 percent of the sherds, followed by a pre-
dominately sand temper with a small amount of tuff
mixed in (18 percent) (Levine 1996:13).

The Trujillo House in Abiquiú exhibited similar patterns (Figure
11). Tuff and pumice temper was found in 84% of the Tewa wares
and only 4% of Hispanic wares, while sand temper was found in
90% of Hispanic wares and only 12% of Tewa wares.

Within the Tewa wares at this site, tuff/sand was the most com-
mon temper (41 percent), followed by pumice/tuff (17 percent), a
reversal from La Puente. Sand/tuff (52 percent), followed by sand (38
percent) predominated in the Hispanic wares, again a reversal from
the colonial site (Levine 1996:13).

The obvious differences in the use of tempering material by Tewa
potters and Hispanic potters clearly point to two distinct traditions.
Tuff and combinations of tuff and other materials are found predomi-
nately in those sherds classified as Tewa from both the colonial site
and the territorial period site. On the other hand, sand and combina-
tions of sand and other tempering materials predominated in the
Hispanic wares from both sites.

In the vicinity of the Abiquiú settlements, no local outcrops of
tuff (volcanic ash) or pumice occur. Sand is the most readily avail-
able tempering material, and it occurs throughout the Chama Valley.

Kidder and Shepard (1936), Harlow (1973), Schroeder (1964), and
Batkin (1989) are among the scholars who have noted that tuff or
pumice temper is the preferred choice of Tewa potters, who obtain
this volcanic material from the southern flanks of the Jémez Moun-
tains. While limited archaeological work has been conducted on Tewa
sites, the preponderance of the ceramic analysis from these sites clearly
shows that tuff temper is the preferred material (Table 1).

Although more than twenty historic Tewa archaeological sites
are listed in the Archaeological Resource Management files housed
at the Laboratory of Anthropology in Santa Fe, little if any pottery
recovered from these sites has been analyzed. The pottery that was

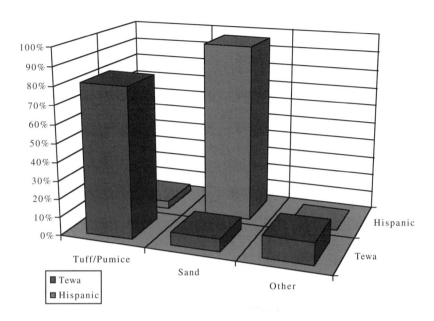

FIGURE 10: TEMPER ANALYSIS – LA PUENTE

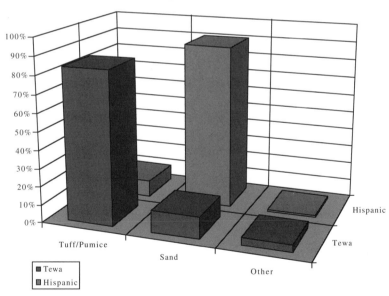

FIGURE 11: TEMPER ANALYSIS – TRUJILLO HOUSE

examined was assumed to be of Tewa origin if it appeared to fit the
typological categories established by Kidder and Shepard (1936), Mera
(1939), and other researchers. This has resulted in a biased classifica-
tion of historical archaeological sites and a scenario in which any
site with ceramic material that was not obviously a Hispanic site
was assumed to be a Tewa site. This situation makes it difficult to
compare the tempering material of the Hispanic pottery recovered
from the Abiquiú sites with temper in the pottery from a "pure" Tewa
site.

Tewa Pueblos	Temper/Paste
Nambé Pueblo	Ash temper; Paste has gold and silver mica flakes, sometimes shows presence of large quartz sand
Pojoaque Pueblo	Probably ash temper that has vitrified, plus some fine sand; Paste has some residual mica and rounded nodules of fired clay
San Ildefonso Pueblo	Fine ash temper, with little sand; Paste has small amounts of residual mica and chalky white nodules from the clay or temper
San Juan Pueblo	Fine glass-shard ash temper and some fine sand; Paste has small amounts of residual silver-colored mica particles
Santa Clara Pueblo	Large glass-shard ash temper; Paste has trace amounts of fine sand and no mica particles
Tesuque Pueblo	Smaller amounts of chunky white inclusions from ash; Paste has fewer mica flakes than Nambé

TABLE 1. TEMPERING MATERIAL AND PASTE CHARACTERISTICS OF HISTORICAL
NORTHERN TEWA POTTERY
(adapted from Olinger 1992:58–66)

Nevertheless, several assumptions can be made based on the analysis of the Abiquiú material, which contained both Tewa and Hispanic ceramics. First, it is clear from the X-ray fluorescence conducted by Olinger (1992) that pottery manufactured in each Tewa village had specific characteristics. Second, pottery from almost all the northern Tewa villages typically contained some amounts of ash temper (volcanic tuff). This volcanic ash temper is generally described in the literature as tuff, and it distinguishes Tewa pottery from most other pottery. The sand-tempered pottery from the Abiquiú sites is unlike any other pottery produced historically in Tewa pueblos. Levine inquired:

> Why were the pueblos producing traditional well-polished tuff-tempered jars in addition to the poorly polished, sand-tempered bowls for trade? It could be argued that the bowls and soup plates were "inferior" because they are not traditional forms, and therefore the Indians had less interest in using traditional temper and slip. But the Spanish probably would have been aware of this inconsistency and demanded the same quality that they saw in the pueblo jars. Conversely, the bowls and soup plates may be of Hispanic manufacture (Levine 1996:23).

The difference in tempering materials is an important piece of evidence that Hispanic potters had different access to tempers than did their Tewa counterparts and chose to use the material that was most easily acquired, sand. Sand also was used as a tempering material for the polished Red-on-tan/Brownwares and the polished Blackwares at other Hispanic sites, including Belén (field notes in the author's possession), Las Huertas (Ferg 1984), Los Poblanos (Rudecoff and Carrillo 1987), Manzano (Hurt and Dick 1946), and in the Río Abajo district (Marshall and Marshall 1992).

Fuel

Third and finally in this brief treatment of raw materials, the availability of the fuel needed for firing pottery has had a major impact on the differentiation of Hispanic pottery from Tewa pottery. This variable is very difficult to address because archaeological documentation for southwestern firing practices is minimal. Ethnographic work in the Southwest has, in a generic sense, underscored the scarcity of documentation of fuel sources for ceramic production. Bunzel (1929) and others have noted that various types of dung are used by modern potters. The shift in fuel from locally available native woods from the *piñón* and juniper woodlands to animal dung derived from European-introduced animals is perhaps best understood in terms of Hispanic settlement patterns and customs of land use during the colonial period.

Soon after the recolonization of New Mexico in 1693 by the Spanish, a number of important changes took place along the major watercourses in northern New Mexico. During this time, Hispanic colonists, following the basic outlines of Spanish law, implemented the common-lands pattern in all the communities of the frontier colony, including community land grants, Indian pueblos, and even municipalities. An outgrowth of this development was the concept of *ejidos,* lands that had a specific status unlike those merely in the public domain; "but they used the word loosely, in a more generic sense, to underscore the rights of citizens to wood, water, pasture and other resources on the public lands" (Tyler 1989:24).

Confusion about the meaning of the term has led to serious misunderstanding in New Mexico, which is unfortunate because the legal status of *ejidos* is central to understanding the issues of land use and tenure during the colonial period. In some cases the *ejidos* were *ejidos en común,* suggesting that the land under question was technically controlled by a sovereign but available for use by anyone. On the other hand, some *ejidos* were given as part of community grants, removing them from use and settlement by others (Tyler 1988:26). The right to use available water, wood, pasture, and other resources

in the public domain was often confused with specific rights and responsibilities accruing to recipients of legitimate *ejidos*. The use of *ejidos* was central to Hispanic New Mexican land tenure practices, for although the system was misinterpreted and misused, the practice ensured that the right to use resources (water, wood, pasture, and presumably clay) on common land was maintained by a specific community. As new land grants or settlements were established in New Mexico, villages already in existence often sought to protect their commons from newcomers or outsiders.

Tyler comments that the clearest distinction between *ejidos* and common rights on public domain appears in the documents of the Mesilla Civil Colony Grant of 1850. Commissioner Guadalupe Miranda established the Mesilla colony with two leagues of farming land with an *ejido* set aside for the common enjoyment of the colonists and to be shared with outsiders only by permission.

In sum, the word *ejido* was often used incorrectly to stress the rights of Hispanic citizens to the use of grass, wood, water and other resources of the public domain. Its real meaning according to the laws of Spain and México, as well as to the customary and accepted practices of New Mexico prior to United States occupation, was that a special portion of land was removed from the public domain, attached to a community which had legal title to and the rights of Hispanic citizens to the use of grass, wood, water and other resources of the public domain. Its real meaning according to the laws of Spain and México, as well as to the customary and accepted practices of New Mexico prior to United States occupation, was that a special portion of land was removed from the public domain, attached to a community which had legal title to and control of an area into which new settlers were expected to expand and in which they, too, had common use rights (Tyler 1988:29).

Between 1701 and 1829, ninety-six land grants[24] were established in New Mexico (Map 3). These grants were concentrated along the Río Grande and its tributaries between Taos and Belén. Most of the land grants in north-central New Mexico lie in close proximity to Pueblo grants. Many of the Spanish land grants box in or surround Pueblo lands. The Tewa Basin, where the pottery discussed in this section was made, lies immediately north of Santa Fe. It is a wide V-shaped natural basin which is bounded roughly on the west by the Jémez Mountains and on the east by the Sangre de Cristo Mountains, and it contains twenty such land grants. The confluence of the Río Grande and the Río Chama marks the approximate center of this culturally defined basin.

The land grants of the Tewa Basin include the Antonio Abeyta grant of 1736, the Plaza Colorada of 1739, the Plaza Blanca of 1739, the Black Mesa of 1743, the Sebastián Martín of 1751, the Piedra Lumbre of 1766, the Santa Cruz de la Cañada of 1767, and many more individual and community grants that encompassed virtually all the ancestral use-lands of the Tewa along the Río Chama, in addition to lands east of the present-day Tewa pueblos. Land grants made by various New Mexican governors specified that all of the granted land was for the grantees' sole use and that the resources found within its limits, such as firewood and pasture, could only be used by the said grantees (see the San Joaquín Land Grant,[25] SANM I 1769, report 66 [reel 20, frame 10], as an example of such an order).

This policy of restricting access to resources may have prevented various pueblos from using traditional areas where raw material had previously been available. The impact of the colonial policies on the opportunity to chop, gather, haul, and use firewood from areas formerly used for fuel gathering by Pueblo potters or their fuel suppliers may have resulted in a gradual shift on the part of the Pueblos from fuel woods to animal dung more commonly available from horse and cattle corrals, sheepfolds, goat pens, and pasture lands surrounding the pueblos.

Hispanic members of individual land grants jealously controlled access to the natural resources contained within their ejido, based on

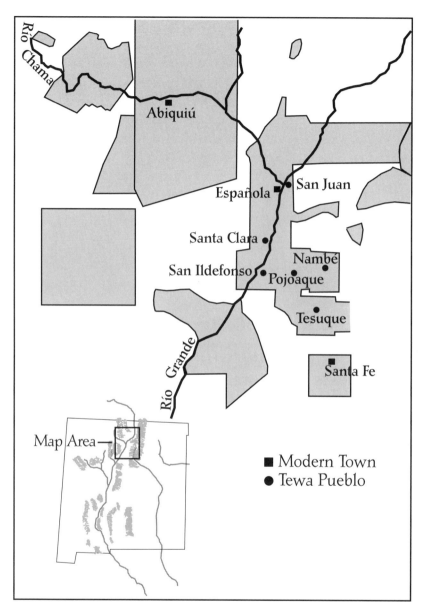

MAP 3: SEVENTEENTH- AND EIGHTEENTH-CENTURY SPANISH LAND GRANTS IN THE TEWA BASIN.
Map illustration by Paul Rhetts.

the understanding that these lands were removed from the public domain. They therefore declared these resources off-limits to outsiders. It is the hypothesis of the present writer that as firewood became more difficult for native peoples to obtain, especially in pueblos surrounded by Hispanic land grants, Native American potters used alternative fuels for firing their ceramics out of doors and conserved firewood for cooking and heating within their homes. In short, the use of scarce firewood for firing ceramics became prohibitive for most Pueblo potters, who turned to the alternative fuel source of animal dung.

Although considerable time has been spent on the analysis of historical pottery made by Native Americans of the Southwest, no explanation has ever been offered for explaining the transition from the use of firewood to the use of animal dung.

The first reference to the use of animal dung by Pueblo potters was made in 1803 by Governor Fernándo de Chacón, who wrote:

The trade of potter which produces ordinary wares as well as jars, crocks, cooking pots, flat bowls, etc., is pursued by the Pueblo Indians who make everything patiently by hand, instead of using a wheel, which is their way. Afterwards they fire it with manure and without using anything for glaze because they are not familiar with this materials. (Quoted in Simmons 1991:162–172).

The original Spanish text reads:

El oficio de Alfairarero en losa ordinaria como son ollas, cazuelas, pucheros, cajetas, etca, lo egersen las Yndias de los Pueblos no en rueda, sino de a mano y con la paciencia que lo es propia, cociendola despues con estiercol, sin usar de ninguno ingrediente, para vidriarla por la falta de conocimientos con esta materia. (*New Mexico Archives, Documents 1803-04*, ff. 1501)

Recent analysis by Bart Olinger (1992) indicates that Tewa ce-
ramics from the recent past were normally fired using relatively low
temperatures. This finding confirms work by Bunzel (1929) and sub-
sequent research by Shepard (1956), both of whom recognized the
low firing temperatures used for historical Pueblo pottery.

As discussed in the beginning of this chapter, the archaeological
work performed by the Museum of New Mexico's Laboratory of An-
thropology on numerous sites in the Chama Valley between La
Puente and Abiquiú, a distance of some six miles, revealed numer-
ous Hispanic sites that were occupied between the 1730s and the
early years of the twentieth century. The ceramic data from two sites,
La Puente and the Trujillo House, are used to test the hypothesis that
certain of the differences between Tewa and Hispanic ceramics may
be the result of firing differences, with the Tewa potters using dried
dung while the Hispanics used firewood.

Explaining some of the differences between the two distinct as-
semblages as having been determined by differences in firing prac-
tices has the potential for shedding new light on resource acquisi-
tion during the colonial period. It has been previously noted that
Tewa potters were already using animal dung as early as 1803. By

FIGURE 12: COLONIAL FIRE PIT
*Pots were fired upside down in a shallow sand basin on a platform of stone. In this
illustration pots are covered by sabina twigs and branches. Illustration by Charles
Carrillo.*

this time, most of the Hispanic land grants and their communities that ring the Tewa pueblos were well established, and they had likely asserted their rights to keep outsiders from using their resources, thus forcing the Tewas to use animal dung rather than fuelwood.

Field work by the author in 1980 revealed that numerous residents of Abiquiú recalled that potters who lived in Abiquiú fired pottery with *sabina* or white cedar wood. None of the informants recalled the use of animal dung for firing pottery. They recalled that the firing of pottery tended to use four to six armloads of split cedar or cedar branches and that numerous handfuls of *cuipas* (juniper or cedar bark shavings) were also used. During the firing process, additional firewood was added to ensure an even firing. Again, broken juniper or cedar twigs were used. This ongoing practice could consume a considerable amount of fuel. The informants related that the firewood was brought from the cedar-covered hills within the Abiquiú land-grant *ejidos* and that the firing usually took place in a dry sandy arroyo. The cedar trees should be nearby so the dried twigs could be gathered during the firing process. Ethnographic work by Foster in the Mexican village of Tzintzuntzán indicates that primitive aboveground kilns used by local potters required two to four burro loads of wood for initial firings (Foster 1967).

Modern Tewa potters normally use enough animal dung chips to cover the unfired pottery evenly and completely. They place the pottery on a metal grate that allows air to pass under the chips, which are ignited with cedar shavings and oftentimes crumpled paper.

Shepard's seminal work of 1956 indicates that, although experimental firing with dung and juniper produced similar maximum temperatures, the dung fire lasted approximately one hour and cooled off rapidly (Figure 13). Experimental work at Zía Pueblo indicated that thick slabs of compacted dung obtained from sheep corrals resulted in a higher temperature for a longer period of time. The juniper wood fire lasted three times longer and maintained an even temperature above 700°C for at least two hours. Additional experiments using pit kilns with juniper wood indicated that maximum tem-

peratures could be obtained that were 200°C hotter than those produced by dung fires. Long-burning fuels afford an advantage when oxidation is required, because the requisite temperature is maintained for a longer time. Modern potters making Tewa smudge or black wares can get by with lower firing temperatures.

Understanding historical firing techniques used by Pueblo potters, notably the Tewa, is an important step in distinguishing between Hispanic and other pottery. The observation that Tewa potters were utilizing animal dung fuel as early as 1803 provides an impetus for understanding why Pueblo peoples in the Tewa Basin switched from using firewood, a limited resource, to using readily available animal dung to fire their pottery.

Typically it becomes the task of the archaeologist to "reconstruct" the firing conditions. Kramer (1985) notes that variations in firing technology often relate to differing abilities to sustain fuel costs or the convenience of suitable fuels. In many areas of the world popu-

FIGURE 13: TEMPERATURES FOR EXPERIMENTAL FIRING
(adapted from Shepard 1956:79)

lation pressure can be linked to changes in fuel selection, a situation that presented itself in eighteenth- and nineteenth-century New Mexico. The fact that fuels from traditional wood gathering areas were unavailable, coupled with rising population and the subsequent demand placed on firewood, caused the Pueblo potters to change fuel use practices.

> Shortage of traditional wood for firing (because of deforestation) around Tonalá, México, has caused potters to expand their range of fuels to include more available materials like scrap wood, dry bushes, branches, cow dung and occasionally sawdust (Díaz 1966:149). Similarly, shortage of traditional fuel for firing among Acatlán potters has caused a shift towards a new fuel source (Arnold 1985:54). ·

Arnold notes, "It is clear that fuels used by potters are local materials, but few data exist on precise distance to the resources" (1985:53). In the case of Hispanic ceramic technology, their use of firewood from *ejido* lands played a crucial role in differentiating Pueblo firing technologies from those used by Hispanic potters in the eighteenth and nineteenth centuries.

In summary, the differences in fuel resources used by Tewa potters and those used by Hispanic potters resulted in quantifiable differences in firing temperatures. This difference may play a crucial role in understanding the subtle differences between eighteenth- and nineteenth-century Pueblo wares (most notably Tewa pottery) and Hispanic wares.

Chapter Four
The Arnold Model

Traditionally, archaeologists have used ceramic typologies and ceramics themselves to probe the culture of a group of people. Archaeologists have more recently turned to ethnoarchaeological work by studying contemporary pottery-making societies or groups. Much of the current research was stimulated by the work of Deetz in 1965 and Longacre in 1970. Typically, the archaeological studies that followed did not adequately address questions regarding the articulation of variation in pottery-making with the organization and development of past cultural systems. In order to control for a number of methodological problems, archaeologists have turned to direct observation to understand the articulation between contemporary potters and their products.

Only recently have scholars attempted to develop data on the relationships of ceramics to the physical environment. Previous work by American archaeologists concerning ceramic studies had generally ignored the role of environment, as Dean Arnold notes:

> The pot, then, was affected more by particularistic historical factors of tradition, aesthetic considerations and more recently, social structure, than to the environment. Among archaeologists, the environment

was viewed as having no significant relationship to
ceramics except as providing the necessary raw ma-
terials (D. Arnold 1985:9).

Arnold recalls his frustration at the paucity of generalizations
and methodological theory in the extensive literature on ethnographic
ceramics and at the fact that this literature had not been synthesized
and applied to archaeological research. He presents a masterful syn-
thesis of much of the ethnographic literature concerning ceramics.
He assembles an array of data from around the world, including
information on clay sources, climatic factors, subsistence practices,
work scheduling, division of labor, social status, and economic com-
plexity. In this study, Arnold's goal was to build a set of universal
processes that were grounded in systems theory and that would sub-
sume all variation in pottery-making in time and space.

Arnold's central work presents a set of generalizations described
as feedback mechanisms which stimulate or inhibit ceramic produc-
tion. His thesis is that there are certain universal processes involving
ceramics that are tied to ecological, cultural, and chemical factors;
that these processes occur throughout the world among different
groups of people; and that the ethnographic data gained from these
groups are useful in providing solid empirical data for interpreting
archaeological ceramics. His methodological approach is a cross-cul-
tural ethnographic examination of the relationships between ceram-
ics and a variety of environmental and cultural factors.

Arnold proposes a model based on three major theoretical per-
spectives. The first of these perspectives is a systems paradigm, the
second is cultural ecology, and the third is ethnoarchaeology. In the
systems paradigm the relationships among entities are more reveal-
ing than the entities themselves: the principles of organization are
more important than the intrinsic properties of the units of organiza-
tion. Systems are thus concerned with wholes. Arnold writes:

The "state" of a system at any given point in time is
not just based on the initial conditions, however, but

is characterized more by the experiences that come to it. Since any one component is related causally to other components in a given period of time, change in the system will affect any one relationship in several ways. Thus causation in a systems paradigm in not mono-causal, but multi-causal (Arnold 1985:13).

Arnold turns next to cultural ecology, the second theoretical approach in his model. He builds this component of his thesis on the work of Steward (1955) and Matson (1965). Except for simple discussions of the obvious importance of resources, the concept of the environment had basically been excluded from ceramic research. Cultural ecology seeks to generalize about cultural similarities and differences by analyzing the relationships of the technologies of a given culture to the particular environments that sustain them. This research on Hispanic pottery from New Mexico will first relate the ceramics and the environment and then examine ceramics in relationship to other subsystems of culture such as belief systems.

Matson (1965) was one of the first to relate the cultural-ecological work of Steward to ceramic studies. Matson coined the phrase "ceramic ecology," and numerous other scholars, including D. Arnold (1975a, 1978b, 1985), Kolb (1976), Rice (1981), and van der Leeuw (1976) have added to this increasingly active field of research. Matson's attempt to understand the relationship between raw materials, technologies, and the finished products led him to create an analytical method which he termed "ceramic ecology." His observations led him to write, "Unless ceramic studies lead to a better understanding of the cultural context in which they were made, they form a sterile record of limited worth" (Matson 1965:202). Many writers following Matson's clue approached the analytical study of ceramics using scientific data that is framed by socioeconomic, sociopolitical, and ecological references (Arnold 1971, 1981; Kolb 1976; Kramer 1985; Rice 1981).

Matson's work (1965, 1973, 1974, 1981) was highly influential in advancing the field in ceramic studies and has fostered further model building by D. Arnold (1985:12–15), Kempton (1981), Kolb (1976:45–47), Rye (1981), and van der Leeuw and Pritchard (1984), among others.

Finally, Arnold's analysis of previous ceramic research showed that little was known ethnographically about the manner in which ceramics articulate with the environment and culture. Arnold proposed that what was needed was a ceramic theory drawn from ethnographic research.

Arnold applied the generalizing power of a systems approach to ethnoarchaeological data by focusing on ceramics, a small part of material culture. His work was intended to provide cross-cultural generalizations that would apply to a variety of societies in the present and in the past. By deriving generalizations from the study of living peoples, Arnold shows that it is possible to understand and explain how ceramics articulate with the rest of culture and the environment, and in the application of these generalizations he shows that it is possible to formulate a more precise interpretation of how archaeological ceramics relate to a past environment and culture.

Arnold's research focuses on the ceramic-producing populations, not the pottery itself, and on the interface between culture and the environment. He states:

> The relevance of this book to archaeology lies in its elucidation and explanation of the universal processes which relate ceramics to the environment and culture. These processes can be viewed as a set of some of the feedback processes that stimulate or limit ceramic production and can aid in interpreting the role of ceramics in the ancient society (Arnold 1985:18).

More specifically related to the present research on Hispanic ceramics of colonial New Mexico is the part of Arnold's model that

examines man-land relationships. This portion of Arnold's model, which involves the relationship of a pottery-making population to their agricultural land, can be understood as a feedback mechanism. This feedback relationship can best be expressed as a general principle: when a population exceeds the ability of the land to sustain it (and thus exceeds its carrying capacity), there is movement into other occupations like pottery-making. Expressed differently, as available land or the productivity of land for agriculture decreases per capita, people will increasingly turn to crafts like pottery (1985:168).

The role of population pressure in the development of pottery specialization is the focus of Arnold's attention in Chapter Seven of his book. He shows that potters emerge from families with an agricultural land base that has declined in quantity and quality. Four empirical phenomena result from this process.

1. Potters (or other craftspersons) who possess marginal or insufficient agricultural land use their craft as a supplement (Arnold 1985:179).

2. People without any agricultural land at all depend totally on craft work (Arnold 1985:193).

3. When agriculture (or any other sector) once again offers a better living with more secure and steady work, people abandon pottery-making (Arnold 1985:193).

4. Potters are poor and socially marginal (Arnold 1985:195).

The movement of disenfranchised individuals into craft specialization and more specifically into pottery-making is, according to Arnold, due to population pressure. In other words, exceeding the land's carrying capacity drives individuals or families into specialized labor or a commodity marketplace. Households whipsawed by increasing population size and decreasing per capita agricultural productivity have adopted craft specialization (including pottery) as

one alternative for survival. Arnold suggests that pottery can be ex-
changed for food or sold, and because this is a less secure tactic than
direct food production, it will be selected only when a household
lacks sufficient land to feed itself. Arnold uses a worldwide sample
of some sixty groups to illustrate his model. The model, in short,
argues that marginal households are pushed into craft specialization.

Archaeologists have generally ignored this hypothesis regarding
the relationship between population pressure, social complexity, and
craft specialization. This model indeed can be applied to the historic
record of Hispanic New Mexico from 1790 to 1890, a decade follow-
ing the introduction of the railroad. In previous chapters inferences
were made about the nature and production of Hispanic New Mexi-
can pottery in late eighteenth and nineteenth century New Mexico.
These inferences are the groundwork for building a comprehensive
theory relating pottery-production in colonial and territorial New
Mexico to the environment and culture through the local commu-
nity of potters. This view sees pottery in terms of a material and
ecological systems theory, focusing on major processes that either
force and promote or constrain and limit the production of pottery
by the Hispanic population of colonial New Mexico. The historical
processes that led to craft specialization in eighteenth and nineteenth
century New Mexico among Hispanics can be understood in terms
of Arnold's model.

Chapter Five
Hispanic Craft Specialization: A Model

The factors at work in New Mexican Hispanic communities from 1790 to 1890 are isomorphous with those that have affected numerous other groups of people throughout the world. They illustrate the principle that sociocultural systems, including ceramic production, are ultimately framed by various relationships to ecological systems. The proposed model for linking these systems is derived from Dean Arnold's 1985 classic research. It relates pottery specialization on the part of Hispanics to a host of interrelated environmental, social, and economic factors which may encourage or discourage production of pottery.

Increasing population pressure in Hispanic New Mexican communities is suggested as the leading agent in population-resource imbalances. This illustrates how the resource imbalance created a need for craft specialization. In other words, pottery production by Hispanic villagers was a product of disenfranchisement; individuals with poor-quality land, insufficient land, or no land at all turned from agricultural pursuits to pottery production to sustain themselves. This specialization was considered to be a last resort, however, and it may have conferred a low status on the specialists (David and Hennig 1972; Foster 1965; Matson 1965).

Specialists in an undeveloped economic system are often perceived as "scramblers," or persons who overcome their economic position and gain a viable economic foothold (Binford 1983). The degree of specialization by Hispanic potters may have depended largely upon a variety of constraining environmental, social, and economic factors. These include such variables as the following: the extent of socioeconomic disenfranchisement (including the lack of other means of support), demand, competition from other potters (from within the same village and also from other cultures), distribution systems (trade and exchange), resource availability (especially of clay and fuel), climatic factors (seasons of the year and drought cycles), and finally labor scheduling requirements such as planting and harvesting (D. Arnold 1975a, 1978a, 1978b, 1980, 1981, 1985; P. J. Arnold 1986; Matson 1965; Papousek 1984; Rice 1981; and van der Leeuw and Pritchard 1984). In response to these factors ceramic specialists would cut back to a low-intensity part-time pursuit or increase it to a high-intensity full-time occupation (D. Arnold 1985). This research will examine both possibilities for the ceramic production by Hispanic potters in the late colonial and territorial periods in New Mexico.

The starting date, 1790, was chosen because during the 35 years from 1776 to 1810 the Hispanic region expanded beyond the peripheries of the 1598-1775 area into previously unsettled secondary drainage basins. It was a period of relative peace because Governor Juan Bautista de Anza had made a successful alliance with the Comanches, and other nomadic groups tended to keep their distance. The colonial population of this time period lived in relative prosperity because the Bourbon economic reforms initiated in New Spain were beginning to have a beneficial impact on New Mexico.

Application of the Arnold Model

Arnold (1985) provides cross-cultural generalizations concerning a series of relationships of ceramics to the environment and to the rest of the cultural system in many societies around the world. He provides an understanding of those relationships in space, before the variable of time is added.

The present work on the Hispanic population of late colonial New Mexico will demonstrate how an understanding of the generalizing power of cultural ecology interpretations, when they are applied to ethnoarchaeological research and culture-specific interests, can lead to a comprehension of universal principles that can be used to interpret ceramics recovered from historical sites and to address the long-debated issue of Hispanic pottery manufacture. Arnold states:

> The basic assumption is that relationships between the technology (in this case, the ceramics) and the environment must be worked out before ceramics can be related to the rest of culture. … By deriving generalizations from modern cultures, it is possible to understand and explain how ceramics articulate with the rest of culture and the environment. By applying these generalizations to the past, it is possible to develop a more precise interpretation of how archaeological ceramics relate to an ancient environment and culture (Arnold 1985:16).

Arnold's model demonstrates how certain environmental and socioeconomic configurations create cultural conditions that strongly encourage the local production of various crafts. He states that a deteriorating man-to-land relationship provides the occasion for craft development among sedentary agricultural communities, bringing about the continuation of part-time production in certain individuals and certain communities and the evolution of part-time craft specialists into full-time producers in others. His model can be used to explain why some of the same feedback mechanisms affecting craft specialization operated in New Mexico. In commenting about these general principles he writes:

> This feedback mechanism favors the development of specialists who not only make pots for their own use, but are economically dependent on the craft to supplement or replace subsistence activities (Arnold 1985:168).

The increasing population in colonial New Mexico and the lim-
ited availability of arable lands put increasing pressure on the avail-
able agricultural resources. Population growth along the Río Grande
corridor and in central New Mexico prior to 1790 resulted in the
intensification of agricultural practices and the movement of a por-
tion of the surplus Hispanic populace to outlying areas along the
Chama and Pecos river drainages.

Chapter One, detailing the history of colonial New Mexico, pro-
vides the backdrop for using Arnold's model to explain the presence
of a colonial pottery tradition in New Mexico. Ceramic production
and the sociocultural system that used the ceramics have never be-
fore been analyzed in such a way as to elucidate the relationship
between New Mexican Hispanic culture and its ceramics. A broader
relational paradigm like that proposed by Arnold will enable research-
ers and scholars to learn vastly more about the Hispanic people of
New Mexico and southern Colorado and to reach insights that the
traditional view of ceramics has rendered impossible.

Ceramic studies in historical archaeology and more specifically
in the archaeology of Hispanic New Mexican material culture have
yet to offer a clear explanation of how ceramics articulate with the
cultural and physical environment. There are few models for under-
standing the relationships among various environmental, social-cul-
tural, and economic factors and ceramic production for other groups
around the world, and the few that do exist have not yet been ap-
plied adequately to research in the Southwest. Most of the research
concerning ceramic specialization in the Southwest has been lim-
ited to prehistoric studies, which include work by Hagstrum (1985),
Feinman, Upham and Lightfoot (1981:871–884), and Morales (1988).

As outlined by Arnold, the relationship of ceramics to environ-
ment and culture and the process by which it works itself out in
history can be well documented in colonial New Mexico, especially
after the last quarter of the eighteenth century. Archival evidence
indicates that population pressure and growth had been a continu-
ing feature of the New Mexican colony since shortly after the

recolonization of 1693. At this time the native Pueblo population was centered in scattered villages along the Río Grande and to the west. Nomadic peoples, mainly Athabascans, Utes, and Comanches, were located on the periphery on all sides.

As detailed in Chapter One, the previous colonial regime, lasting from 1598 to 1680, was principally a missionaries' and soldiers' colony. The friars' system of missions and the soldiers' system of *encomienda* were in large part responsible for the Pueblo Revolt of 1680. With the new colonization effort, the colony became principally a settlers' colony. The Hispanic settlers were forced to seek out new areas for development. Access to these areas was limited not only by physical and natural boundaries but by the nomadic Indians who occupied these areas. Carniero (1970) points out that in areas circumscribed by physical and geologic barriers such as mountain ranges and deserts, population growth results in pressure on resources because access to new agricultural land is often limited. Initial settlement during the reoccupation of New Mexico by Hispanics centered on the north-central portion of New Mexico. Within fifteen years, however, documents reveal that families were constantly petitioning colonial authorities for new lands. Land grant records and successive censuses indicate an amazing increase in population movement from central New Mexico to outlying areas. Land had become a precious commodity. As the population concentrated in the "source communities" of Albuquerque, Santa Fe, and Santa Cruz de la Cañada, many individuals found themselves without access to land, as is particularly evident in a formal complaint written in 1789, when Governor Fernando de la Concha[26] writes, "today there are not two *varas* of land without an owner in the entire province" (AGN:PI 161:4, 49R-50V).

The Hispanic practice of settlement in both community and individual grants made for an uneasy situation as it was customary for the Hispanic people to partition land into long strips perpendicular to a watercourse in such a way that everyone, the original settlers and the heirs, had equal access to irrigable, arable land and to pastures. In succeeding generations, as families and communities grew,

properties were often divided and subdivided until the tracts of land became too small to support families.

Within only sixty years of recolonization, the increasingly severe attacks of Apaches, Comanches, Navajos, and Utes checked the rate of expansion of the colonial population by cutting the people off from potential new agricultural lands, and these attacks ultimately hindered commercial activities, especially the annual southern trading caravans to larger population centers south along the Camino Real. In a recent examination of economic development in colonial New Mexico, Ross Frank writes:

> The correspondence between the governors of New Mexico and the high officials and bureaucrats in the government of New Spain leaves no doubt that the Indian hostilities of the 1760s and 1770s had a serious impact on the economy of New Mexico. Indians and *vecinos* (Hispanic settlers) both abandoned land needed for agricultural production and [animal] husbandry (Frank 1992:61).

It is not surprising then to find that, by the 1780s and 1790s, much of the Hispanic population was still located in the same areas that were recolonized or within the geographical limits of the recolonization of the 1690s. Even as late as 1780, Hispanics were still living within the immediate area, and even within the very houseblocks, of the pueblo of Taos. This was the northernmost occupation of Hispanic peoples at that time. In the southern part of the province, the plazas of Belén were established by 1790. In the east, Hispanic populations were established along the upper Pecos River valley in the late 1790s and early 1800s. In the northwest, Hispanic settlers ventured from established communities like Abiquiú and founded new villages like El Rito in 1808, then moved farther up the Chama Valley to the Tierra Amarilla Grant in 1814. By the second quarter of the nineteenth century, Hispanic settlers pushed into the Puerco Valley (a western tributary of the Río Grande) and into the

vicinity of Laguna (Jones 1979:116–117; Meinig 1970:27–35). But these additions of farming and ranching land were still too small to alleviate the continual expansion of the New Mexican Hispanic population.

When expansion to other regions was impossible or restricted and family landholdings became incapable of continued high productivity, Hispanics often turned to alternative subsistence strategies. The 1790 census clearly indicates that Hispanic settlers were engaged in more than thirty specialized occupations. Men and a few women were identified as blacksmiths, carders, carpenters, cobblers, hatters, masons, merchants, tailors, tanners, and weavers (Tjarks 1978:86). The listed occupations did not include part-time or seasonal work such as that done by buffalo hunters, saint makers, and potters. It can be securely argued that the most noteworthy artistic tradition among Hispanics was the making of *santos,* holy images of both the flat *(retablo)* and sculpted *(bulto)* types, but no saint makers were ever listed in the colonial censuses according to their profession. We should assume that the same was true for the Hispanic potters, many of whom doubtless engaged in part-time, seasonal work. Though the weavers of colonial New Mexico produced items for export to the south, potters produced everyday objects that had little status value compared with that of the imported wares from the Orient or New Spain. New Mexican Hispanic pottery used for cooking, serving, and storage was economically unimportant beyond the limits of the local community. Unlike potters, those involved with the textile industry were likely enumerated for two reasons. First, from an administrative vantage, colonial New Mexican officials needed to demonstrate the production capabilities of New Mexico to the higher authorities in New Spain. Second, the textiles woven in New Mexico were an extremely valuable commercial resource. New Mexican woolen products were traded widely in México and thus were an important revenue-generating industry (Baxter 1987).

Frank notes that the colonial economy of New Mexico was shaped during two periods of economic curtailment/contraction. Beginning

in 1740 and ending in the 1770s, the economy was dependent upon the exchange of trade goods among Hispanics, Pueblos, and nomadic Indians, which in turn provided the basis for long-distance trade with the internal provinces of México, especially Chihuahua. The second economy, established in New Mexico from 1770 to 1820, capitalized on the relative peace that was secured by Governor de Anza, the growing Hispanic population, increased production by the Hispanic textile industry, and an increased demand for New Mexican Hispanic weaving in southern markets (Frank 1992:211–281).

The difficult frontier conditions in colonial New Mexico were aggravated not only by population pressure, but also by a complex of issues related to warfare and social change. For example, David Weber comments on the disenfranchisement of women and colonial conditions:

> Perhaps the most extreme examples of the impact of frontier conditions on women's occupations existed in communities which bore the brunt of warfare against Indians, such as Abiquiú, New Mexico, or San Antonio, Texas. The violent deaths of many young men in these towns left a disproportionate number of widows and single women who had no choice but to carry on alone (Weber 1982:216).

The complex relationships between the growing Hispanic population and the development of full-time or part-time potters in some Hispanic villages in New Mexico is not well documented. In the following section of this chapter, the relationship between the Hispanic potters of colonial New Mexico and population pressure will be examined.

Population Pressure and Ceramics: A World View

This section examines a variety of contemporary pottery-producing groups from around the world. The information derived from the general observations of these groups will help formulate generalizations that relate ceramics to environment and culture. More specifically, the data derived from a global examination of pottery-producing groups will elucidate the manner in which New Mexican Hispanics became engaged in a ceramic tradition. The global overview shows why Arnold's model is applicable to archaeological research in areas like New Mexico.

Arnold notes that as available land or the productivity of that land for agricultural pursuits decreases per capita, the people who inhabit the area will increasingly turn to a variety of specialties, pottery among them. This mechanism moves people into non-agricultural pursuits, but it takes many other mechanisms, some as general and uncontrollable as environment and weather and others as specific as available resources and demand, to channel people into becoming specialists, and more specifically potters. Any reduction in the per capita return from agricultural land will set the deviation-amplifying mechanism into operation. Arnold (1985:168) notes two situations in which the deviation-amplifying mechanism will operate:

1. an increase in population with no increase in the amount or the productivity of agricultural land that is necessary to sustain the population;

2. a decrease in the carrying capacity of the land-base without a corresponding decrease in population.

Each mechanism will cause population pressure in similar ways around the world. The following examples illustrate similarities noted in the anthropological literature. These examples provide a comparison for understanding the relationship of a pottery-making town, population segment, or individual to land used for agriculture. More specifically, these examples from around the world will illustrate

that craft specialization in pottery by New Mexican Hispanic people in the eighteenth and nineteenth centuries is not as unusual as has hitherto been thought. The development of pottery specialization among the sedentary agricultural communities inhabited by Hispanics therefore appears to be a normal response to nearly inevitable population pressure. The examples provided below serve to illustrate similar responses in pottery-making societies throughout history and throughout the world.

Perhaps the best illustration of population pressure and low agricultural subsistence activities comes from Guatemala. Numerous studies, including work by Hinshaw (1975:150), Reina (1959:13, 1960:68, 1966:41–47, 1969:107), and D. Arnold (1978a, 1978b), have shown that families with no land, little land, or poor land must rely on other subsistence strategies to supplement their income. In Guatemala, pottery-making is an important household activity for supplementing the proceeds from subsistence agriculture.

Foster (1967:37) found the same pattern in the village of Tzintzuntzán, Michoacán, México, as did Kemper (1976:55–56) a decade later in the same region. Lackey (1982:41) noted a similar pattern in Acatlán, México, as did Turner (1977) in Chiapas, México.

Chatterjee (1975) noted that population pressure on the island of Chowra in the Indian Ocean also played an important role in pottery specialization among the island's inhabitants. On another island, Hogbin (1951:81) noted that a pottery-making village of the Huon in New Guinea lay in a region of noticeably poor agricultural land and that the potters bartered pottery with their fellow villagers for foodstuffs. The same was true for the potters of the Amphlett Islands off the east coast of New Guinea (Lauer 1970:165). Among the Ibo of Nigeria, the pottery specialists are to be found in the area where land is marginal (Murray 1972); in like manner, the pottery-making villagers of Bailén, Spain, live on marginal land (Curtis 1962:487). In Perú, especially in the village of Quinua, potters live in an agriculturally marginal environment. In other areas of the world, some potters do not even own land. In San Nicolás Province of Flocos

Norte in the Philippines, research by Scheans (1965:9) indicates that only two-thirds of the pottery families own land. Landless potters are also noted in Chirag Dilli, India (Gupta 1969:21).

Population pressure results in a deviation-amplifying mechanism for the development of craft specialization in communities throughout the world. These particular cases involve pottery or ceramic specialization. Loss of land in other communities produces numerous varieties of specialists, potters being only one sort. Hammond (1966) notes that among the Masai of western Africa, former herders of the Upper Volta supplement their income with various crafts, pottery among them. Any sort of craft offers an alternative economic strategy and explains why craftsmen either live in towns or cities and why, if they continue to live in their natal village, they are often either landless or own land that is inadequate in quality, quantity, or both. Since the same conditions became quite common in late eighteenth and early nineteenth century Hispanic New Mexican villages, those conditions led significant numbers of Hispanics to become part-time or even full-time potters.

In New Mexico, as in other areas of the world, craft specialization appears to have taken the form of noncentralized production. Noncentralized production occurs on a limited scale and is not tied to an administered or centralized production unit. In her discussion of the organization of craft production in southern India, Sinopoli notes:

> Goods are produced by specialists, working either full-or part-time at their crafts, but workshops are small, and output comparatively lower than in centralized contexts. … Noncentralized workshops are small and widespread, and would likely produce a wide range of material variants of their products to meet the needs of nearby consumers. When the products of such workshops are considered over a region or over a large urban site, considerable diversity in the overall industry, be it ceramic, metal, or stone,

might be expected, as a result of variation between each individual shop in methods and materials (Sinopoli 1988:581).

Hispanic potters working in colonial New Mexico acted as do many potters working throughout the world. In the noncentralized production that took place in colonial New Mexico, there is a tendency for potters to adhere to familiar ceramic forms – forms defined by local tradition or, as was the case in colonial New Mexico, traditions that may have been largely defined by ceramic traditions originating in New Spain. The long-standing debate about the emergence of new pottery styles after the reconquest has rested upon arguments made by various authors like Reed and Wendorf who argue for Meso-American connections and influences (Wendorf and Reed 1955). A broad range of technical variation existed in the Hispanic pottery tradition of colonial New Mexico because of the large numbers of self-sufficient and relatively isolated villages in which pottery was produced. The presence of these broadly similar pottery traditions is the result of a multitude of factors, some social, others technological, and still others due to environmental factors such as access to raw materials.

Archaeologists excavating Hispanic colonial sites from the Las Cruces area in southern New Mexico and as far north as southern Colorado have noted the presence of "Pueblo or Tewa-like" ceramics. The traditional Puebloan typologies set forth by Kidder and Shepard in 1936 are still used by archaeologists today. These typologies have been used to establish the temporal sequences for most of the archaeological research concerning eighteenth- and nineteenth-century sites in New Mexico. However, archaeologists have also noted that from area to area these ceramics are more often heterogeneous than homogeneous. At first glance the red-on-tan (red-on-Brown) wares from southern New Mexico are rather like the red-on-tan wares from northern New Mexico, yet closer examination reveals that the two types might be placed in two different categories if it were not

clear that they are stylistic variants of a single class of Hispanic ceramics. The prevailing attitude has often been that these ceramics cannot be sorted, that discrete, easily definable and sortable types do not exist. In archaeological research, ceramic types are inferred through a series of observations like composition, content, vessel form, design, and other definable and qualifiable factors; however, the archaeological situation creates a major analytical hurdle because the statistics that are used to describe the variation in ceramics are completely dependent on how the ceramic types are defined. This writer argues that the noncentralized nature of Hispanic pottery production in New Mexico resulted in a pottery tradition with considerable diversity and variation from place to place and from time to time. The variation in Hispanic ceramic production resulted from the use of localized clay deposits, and the varying technical ability of the potter. For example, in some areas of colonial New Mexico ceramics may have been manufactured for use in wine-producing communities. The construction of large ceramic vats has been noted at many Hispanic sites in central and southern New Mexico. Another example would be micaceous wares. The range of micaceous wares is limited to Hispanic villages and sites in northern New Mexico and southern Colorado, where micaceous clay is readily accessible. Cooking pots or utilitarian vessels were typically made with micaceous clays, these being the most popular cooking wares used by Hispanic families (see previous discussion on micaceous wares in Chapter 2).

Other ceramics may have been made for specialized local uses such as *atole* cups or candleholders (both examples come from Abiquiú). The production of such specialized forms would lead to broad variation within different functional classes of pottery and thus precondition the manner in which archaeologists have traditionally interpreted ceramics.

The fact that Hispanic pottery is represented by a broad range of stylistic as well as functional categories of pottery poses complex interpretive problems in the study of late-eighteenth- and nineteenth-century ceramics in New Mexico. Some types of Hispanic pottery

can be easily identified, such as the sand-tempered polished wares from Abiquiú (Levine 1996:1–23) and the sand-tempered burnished wares from Casa Colorada (Marshall and Marshall 1992:74), while other types pose more questions. This complex mixture of multiple traits relates to the differences in environmental, social, and economic complexes operating in New Mexico from 1790 until 1890.

Building on the general assumption that aspects of Hispanic cultural behavior have material correlates (in this case ceramics) which are observable in the archaeological record, this investigation has several implications. First, the archaeological data for pottery recovered from eighteenth- and nineteenth-century Hispanic sites in New Mexico draw too exclusively on traditional Puebloan pottery typologies established more than half a century ago. Unnuanced, this normative approach is erroneous and inappropriate for ceramic analysis.

Secondly, the heterogeneity of Hispanic pottery traditions reaffirms the ethnographic record, which documents a dynamic colonial frontier in which ethnicity did not always represent culture. The acculturation of different native groups into Hispanic communities and the subsequent adoption of different techniques of production are evident from the archaeological remains.

And finally, a conceptual tool that examines craft specialization in terms of the progressive elimination of primary subsistence activities because of increasing population and inability to acquire more land for farming and herding is important if Hispanic ceramics are to be understood in their proper context.

Conclusions

Archaeologists have traditionally used ceramics to create typologies from which chronologies are formed. In the American Southwest these chronologies usually represent a series of ceramic types that span a specific temporal sequence. Since the pioneering work in the Southwest by Kidder and Shepard in 1936, Mera in 1939, and Shepard in 1956, ceramic types have been thought to reflect temporal relationships. These relationships are based in part on the similarities and differences between types, styles, or attributes. Archaeologists have rested these beliefs on three basic assumptions:

1. Ceramics reflect the culture of a group of people, and changes in ceramics made by these people reflect changes in their society.
2. Cultural contact or diffusion by trade, exchange, migration, or conquest can be measured in typological or attribute similarities.
3. The environment is not a factor in ceramic studies, except as a source of raw materials.

In 1985, Dean Arnold challenged all three of these assumptions. Although ecological perspectives have formed the general theoretical backdrop in anthropology for the past three decades, correspond-

ing interest in the ecology of crafts has been conspicuously absent (Arnold 1985:2). Archaeologists have simply ignored the importance of ecological facts for explaining the presence of ceramics.

Since the late 1960s, Southwestern archaeology has been characterized by a shift in perspectives from traditional archaeological reasoning to what is known as "new archaeology." This paradigm, of which Lewis Binford[27] is a leading proponent, sees cultural ecology as a basis for understanding cultural processes (Steward 1955). The foundation for providing cross-cultural generalizations comes from such a perspective. No theoretical perspective has ever been proposed for ceramics recovered from Hispanic sites and villages in New Mexico and southern Colorado. The present research is based upon the theoretical model proposed by Arnold in 1985. Methodologically, this approach is consistent with the cross-cultural generalizations elucidated by Arnold (1985), and it provides an explanatory framework for understanding the evolution of ceramic craft specialization among Hispanics in late colonial New Mexico. The research discussed here presents a model for examining the conditions in which craft specialization could take place among eighteenth- and nineteenth-century Hispanic villagers. The model does not maintain that craft specialization took place in every Hispanic village; it does, however, elucidate the conditions in which such specialization could have occurred. The strength of this model is that it is useful in the formation of hypotheses about Hispanic ceramic manufacture. These hypotheses can be tested against independent sets of ethnographic, archival, and even archaeological data. It is assumed that the conditions that favored the development of ceramic craft specialists among Hispanic villagers in New Mexico between 1790 and 1890 have material correlates in the archaeological record; these remains may be used to develop inferences about the behaviors with which they are associated.

The observations made here can facilitate the development and refinement of insights into Hispanic village life and more specifically the development of ceramic traditions, particularly when the

ethnographic record complements the archaeological record. This thesis provides an interpretation for the conditions that favored the development of the Hispanic craft, one that has virtually been ignored for seven decades by archaeologists working in the Southwest.

In order to understand the mechanisms that channel people into occupations such as ceramic production, a historical backdrop is necessary. Chapter 1 provides this backdrop and lays the essential foundation for understanding the cultural and historical data on Hispanic settlement and land tenure. The role of Hispanic ceramic production in late colonial New Mexico is contextualized by population pressure and settlement history.

As the population in colonial New Mexico exploded, the agricultural base of some of the Hispanic population was progressively eliminated. These disenfranchised people turned to crafts to provide an alternative subsistence base for their families. Arnold writes:

> The increasing population thus provides a ready market for potters who are forced to rely on their craft for subsistence. With more demographic pressure, the greater the potters' dependence on ceramics and trade, the more intensive their specialization, and the more demand for craft products that are necessary to sustain the craftsman (Arnold 1985:199).

In New Mexico, where Hispanic potters depended on their craft to either make a living or supplement their income, other portions of the society, namely agricultural producers, had to support intensified agricultural production at levels which permitted the exchange of food for ceramics.

Archival data, the oral historical record of Hispanic New Mexicans, ethnographic data collected by anthropologists, and the archaeological record of Hispanic settlements and excavated sites provide the evidence that confirms the existence of Hispanic ceramic specialists in late colonial New Mexico. The data presented in Chapter

2, albeit fragmentary, are a compilation of various forms of information that provide the empirical evidence and thus the proof that a ceramic tradition developed among landless Hispanic people as an alternative subsistence strategy. As noted in Chapter 1, if population pressure is responsible for the development of craft specialization in general and ceramic specialization in particular, those manufacturing the ceramics would likely control a land base for agriculture that is dwindling in quantity and quality. Subsequently, this process results in four kinds of empirical phenomena (Arnold 1985:179–195).

The first of the four phenomena is that land used by craftsmen (potters) for agricultural purposes will typically be marginal in quality or insufficient in quantity. In late colonial New Mexico, when demographic pressures resulted in land debasing, evidence suggests that the population spread from larger population centers into new tributary basins where the agricultural land was often less desirable. In the mountainous area of New Mexico, settlements like Córdova, Los Ojitas, and Truchas are prime examples where pottery manufacture occurred and where agricultural land is marginal in both quality and quantity.

Chapter 3 provides a case study of the Hispanic village of Abiquiú, New Mexico. At this point in time, Abiquiú is the only village for which there is archaeological, ethnographic, and archival documentation for the presence of a Hispanic pottery tradition. The Abiquiú case has several implications for the study of Hispanic pottery. This chapter provides the pivotal data for inferring a Hispanic ceramic tradition.

The analysis of the Abiquiú ceramic data reveals that two distinct types of pottery were used by the Hispanic population in the eighteenth and nineteenth centuries. The traditional approach to understanding the ceramic data from Abiquiú would be to assume that all pottery found at the sites was of Native American manufacture. Hispanic-made pottery might go unnoticed if this approach were used. In 1989 this author proposed a different approach for the analysis of ceramics from Abiquiú. The clear division between ash-tempered

and sand-tempered pottery supports a new classification of ceramics. The ash- or tuff-tempered ceramics known to be made at Tewa villages can be separated from the sand-tempered ceramics made in Hispanic villages. Differences of style, decoration, vessel form, and size in Hispanic-made wares can be used to identify different areas and to the economic needs of certain villages. In the particular case of the mold-made blackware bowls from the Trujillo site in the Abiquiú area, measurements of rim diameters yield the clear-cut patterning associated with standardization. Standardization in turn suggests specialization on the part of the Hispanic potters.

Investigation of micaceous wares associated with Hispanic sites poses another question. The possibility that archaeologists working with sufficiently large samples of micaceous wares from numerous Hispanic sites and villages in northern New Mexico would achieve some understanding of the cognitive basis of production and even of the variability in micaceous wares would depend upon the assumptions brought to the study. Acknowledging the possibility that Hispanic villagers produced micaceous ware will help in an overall evaluation of the social and economic conditions of the late colonial frontier in New Mexico and in large part would depend on an understanding of the ethnic and demographic composition of a particular village or site. In some villages, Puebloan and/or Apachean ceramic traditions were infused into Hispanic ceramic manufacturing techniques. Addressing the issue of integration in the frontier setting of New Mexico, Moore writes:

> On a general level this means the assimilation of part or all of a native technology to improve chances of survival. At a specific level there will be variation in the extent to which different communities of the colonizing group adopt native technologies, depending on degree of access to manufactured goods (Moore 1996:4).

Study of the fuel used for the firing of ceramics led to the under-standing of changes in Pueblo pottery-firing practices in colonial New Mexico. While records detailing historical Pueblo pottery-firing practices are incomplete, a shift from wood fuel to animal dung fuel was noted. Although our knowledge of the archaeological record is incomplete, there is a suggestion, at least, of the relationship be-tween Hispanic land grants and changes in Puebloan firing prac-tices. A simple pattern emerges: as more Hispanic land grants were established, limiting Pueblo access to traditional land use areas for fuel resources, Pueblo potters began to use a readily available alter-native fuel source. This shift is manifested in the differences between Pueblo and Hispanic ceramics, and it is likely an important indicator of the similar yet distinct traditions that are represented by Pueblo and Hispanic traditions.

Chapter 4 provides a working hypothesis for understanding the development and maintenance of a Hispanic ceramic tradition in late colonial New Mexico. This is accomplished by examining the role of population pressure and ceramic production in areas outside New Mexico. Specifically, ethnographic examples from around the world are discussed. Similarities to the postulated Hispanic traditions in late colonial New Mexico clearly indicate that population pres-sure played a major role in the development of alternatives to farm-ing in colonial New Mexico.

People disenfranchised from their land, that is people without a land base, make up the second segment of Arnold's empirical phe-nomena (Arnold 1985:193). Documented population pressure in late colonial New Mexico created a situation in which many people lost their land base, for numerous reasons. Some of the factors or mecha-nisms that created this situation are discussed in Chapter 5. The most critical was the subdivision of land, until landholdings were insuffi-cient for the needs of many families. Netting (1974:40) notes that craft specialization due to population pressure is not a desirable oc-cupation for most farmers. The myriad of data concerning land ten-ure in colonial New Mexico bemoan the land situation and the con-sequences of loss of land.

If population pressure was a deviation-amplifying mechanism for ceramic production, one would expect that if agricultural land became available or if the living sustained from that agricultural land provided a more secure living or consistent work, craft specialization would be abandoned. In other words, those who depend on ceramic specialization do so out of economic necessity; when better opportunities come about, crafts are usually abandoned (Arnold 1985:194; Behura 1978:222–223; Foster 1965:47; Netting 1974:40). This is the third of the empirical phenomena outlined by Arnold (1985:194).

Although Hispanic ceramic manufacture took place in isolated instances before the late 1790s, the archival, archaeological, and oral historical record overwhelmingly points to the 1790s as the period when a ceramic tradition developed among disenfranchised Hispanics. This tradition was maintained in many villages until a decade after the coming of the railroad in 1880. The railroad had a tremendous impact on the economy of New Mexico, forever changing the rural economy of Hispanic villagers. The oral history of Hispanic village life relates that widows and other disenfranchised individuals practiced a ceramic tradition until right before the turn of the century. For this reason, the 1890 date was chosen as the end date of this study, with the understanding that ceramic manufacture or production did occur prior to 1790 and after 1890. While the preponderance of the archaeological evidence suggests that most of the Hispanic-made pottery was made in the mid to late nineteenth century, it also shows that not much pottery was made after the railroad era. This should not be taken to mean that the coming of the railroad caused the sudden and total demise of the ceramic tradition; rather it suggests that Hispanic villagers engaged in other activities as strategies for economic survival and that they slowly abandoned pottery making when other economic strategies emerged.

The fourth empirical phenomenon is that craft specialists, especially in the case of pottery, are usually poor or socially marginal individuals. Actually, this point is emphasized in the three preceding observations. The examples from the villages of Abiquiú, Córdova, and Manzano help illustrate this point. In these villages the potters

were often widows who sold or traded their wares for food. Those who had little or no land were often marginal in society. In New Mexico land was everything, and to be without land meant that one was indeed marginal. The changing economy and the opportunities that opened up in the southern markets because of the Bourbon reforms brought about a wealthy elite class along with a peon class which was largely composed of small farmers and pastoralists.

An alternative to the typical chronological orientation of ceramic studies was needed for examining the possibility of Hispanic ceramic production in New Mexico and southern Colorado. Chapter 5 provides a review and evaluation of one such alternative. This theoretical perspective, delineated by Arnold in 1985, forms the basis for understanding ceramic craft specialization in late colonial New Mexico. Arnold's examination of man-land relationships is a critical element of the present research. The development and maintenance of non-agricultural subsistence activities is well illustrated in Arnold's model, especially as it relates to population pressure and low agricultural productivity.

In review, then, deviation-amplifying mechanisms such as population pressure in late colonial New Mexico favored the economic dependence on ceramic manufacture by disenfranchised Hispanics, which eventually led to craft specialization. The ample number of cases cited in the literature aid in explaining why the same mechanisms were operative in late colonial New Mexico. In short, when some New Mexican Hispanics could not realize sufficient return from poor or marginal land or when they no longer had any land from which they could extract a return, they turned their efforts to craft specialization as an alternative economic pursuit. In many cases, pottery making became the craft of choice.

Archaeological Implications

The existence of and rational for a ceramic tradition among Hispanic settlers in colonial and territorial New Mexico has heretofore been undocumented. Except for a few articles that have either questioned mention of it in the archival, ethnographic, or archaeological record or causally referred to such mention as curiosities, the literature is silent. In only three published articles has the presence of Hispanic ceramics been taken seriously (Levine 1990; Carrillo 1987; Dick 1968). The idea of using Arnold's model as the theoretical basis for ceramic craft specialization came from a critical review of ethnographic literature. This processual approach to understanding ceramic data was presented as a series of cross-cultural generalizations, which showed not only how ceramics and the environment are interrelated but why the interrelationships exist. The data concerning Hispanic ceramic traditions can provide insight not only for future research in New Mexico and can also supplement the data presented by Arnold in 1985.

The elucidation and explanation of the universal processes that relate ceramic production to the environment and to culture are Arnold's stated goals (Arnold 1985). The relationships of Hispanic potters to the late colonial environment and culture have been shown in the present book to be a series of feedback mechanisms. The process which explains the evolution of ceramic specialization relates specifically to conditions in which individuals in late colonial New Mexico became disenfranchised from their land. The progressive weakening of agricultural pursuits, which were the primary subsistence activities of the Hispanic population, led to the selection of alternative strategies that compensated for the disenfranchisement.

Pottery production by disenfranchised individuals was a specific kind of non-agricultural recourse. While some families or individuals chose craft specializations such as weaving, pottery production became an alternative for others. The conditions that favored this development provide the basis for understanding the relationships of Hispanic-made ceramics to the environment and New Mexican

colonial culture, apart from any ideological factors. The deviation-
amplifying mechanisms in operation in late colonial New Mexico
stimulated the development of the Hispanic ceramic tradition. The
same mechanisms likely wrought change among Pueblo potters of
the same period. The shapes, design formats, and quality of most
Pueblo pottery changed dramatically during the period from 1740 to
1820 (Frank 1992:247–315).

The classification of Hispanic-made pottery in the archaeologi-
cal record in New Mexico and southern Colorado should reflect be-
havior in such a manner as to enable identification of cultural pro-
cesses in the colonial period. Hispanic ceramics can be understood
in their proper behavioral context, and inferences can be made about
other non-material aspects of colonial life in New Mexico when clas-
sification is accomplished. These inferences will then provide a be-
havioral basis for inferring cultural processes in colonial New Mexico
that cannot be identified in the ethnographic record.

I have intentionally limited my use of traditional ceramic
typologies. First of all, the archaeological literature is silent on His-
panic wares because no one was looking for them, and researchers
usually concluded that wares found at Hispanic sites were manufac-
tured by Puebloan or Athabascan groups. It is appropriate at this
point to list the salient properties of Hispanic ceramics. The informa-
tion presented below is derived from the work of Dick (1968:77–94),
Levine (1996:1–26), Marshall and Marshall (1992), Warren (1981:149–
165), and most especially from my own observations made over a
fifteen-year period. The list of Hispanic pottery traits presented in
Table 2 is not definitive, but it is a useful and general guide.

The majority of these wares were made using the coil-and-scrape
technique. As noted in Chapter 3, Hispanic bowls from the Trujillo
House site in Abiquiú, dating to the territorial period (1846–1912),
were mold-made. Apart from a single wheel/coil-made bean pot from
San Rafael in western New Mexico (see page 81), the technique
invariably favored by Hispanic potters was coil and scrape. The dif-
ference in clays used by Hispanic potters throughout New Mexico is
enormous; in general most of the clays are thought to be of the

Smectite category (Hawkes 1970). While polished Red-on-brown wares sometimes exhibit additional designs like "bulls eyes" or splattering, the only notable exception comes from Casa Colorada (Marshall and Marshall 1992).

Ceramic Type/ Range & Date	Description
Casitas Red-on-brown from the Mesilla Valley in southern New Mexico to southern Colorado, and Manzano, N.M. 1730–1860 (The majority of this ware ranges from 1760 to 1840)	This type is also known as Casitas Red-on-brown, also Casitas Plain, Casitas Orange-on tan and Casitas Red-on-gray. Temper: Sand. Paste: Very fine/friable. Forms: Bowls, wide mouthed jars, soup plates, pitchers. Surface finish: poor stone polishing. Diagnostic feature: Red band on upper part on both inside and outside, never more than 1/3 the vertical distance down the outside of the vessel. Some red bands appear to be rag polished. Red paint designs consisting of splatters, swirls, loops, "bulls eyes" and dribbles.
Polished Black from the lower Río Grande to southern Colorado, also at Manzano, N.M. 1730–1880	This type is also known as Manzano Burnished Blackware (Hispanic Black). Temper: Sand. Paste: Fine to very fine/friable. Forms: molded bowls, bowls, soup plates, water jars. Surface finish: Gray to black, reduced fired, stone-polished surface. Diagnostic features: This ware was fired in a reducing atmosphere, turning the surface a lustrous black. Firing conditions sometimes result in gray wares.
Plainware/Carnué Bernalillo, Tijeras Canyon (Carnué site) U.S. forts below Socorro from Belén to southern Colorado 1760–1880	There are many Hispanic-made types of plainware. Carnué plain is the type name for most of these wares. Temper: Fine sand to coarse sand. Forms: mostly jars, wine vats, pots, and bowls. Surface finish: semipolished to polished interior, temper grains on exterior surface, coarse appearance. Diagnostic features: Paste is crumbly, sandy and friable.

Ceramic Type/ Range & Date	Description
Micaceous wares These types of pottery only occur in northern New Mexico and also at Manzano, N.M. 1760–1940s	At least five micaceous types are associated with Hispanic sites: Manzano Micaceous, Cimarrón Micaceous, Valdito Micaceous, Peñasco Micaceous, and El Rito Micaceous slip. With the exception of El Rito Micaceous slip, these wares are made from residual micaceous clays; no temper is added. The paste is very durable and not easily broken. Surface finish: Variable. Some wares are slipped with fine mica slip, others exhibit surface striations, often called corncob scrapings. Forms: mostly bean pots and water jars, although molded bowls, flange plates, and shallow bowls are recorded. Small handled pots known as atolé cups are documented, as well as candleholders and comales or griddles. Diagnostic features: Micaceous clay, rounded rims, and handled pots.
Decorated wares Casa Colorada in the Río Abajo, 1813–1900	Marshall and Marshall (1992) describe floral patterns on plainware sherds. Casitas White slipped. Casitas White banded.
Other wares from southern New Mexico to southern Colorado Hispanic sites dating from 1760 to 1900	Numerous other wares are associated with Hispanic sites throughout New Mexico. Sand temper is always present in these wares; they are likely related to the Casitas and Carnué traditions, though the sample number is low. A very hard fired, grayish brown ware is associated with Hispanic sites in the Pecos Valley from San José to Antón Chico. The large vatlike vessels from the Río Abajo may represent another class or type of ware. These vessels have a heavy groglike temper and are polished on the interior surface; the interior surface is almost always smudged.

TABLE 2: HISPANIC CERAMIC DESCRIPTIONS, GEOGRAPHIC RANGE, AND DATES

The presence of Hispanic-made ceramics at villages, ranches, farms, and herders' sites challenges the archaeologist to understand the behavioral contexts in which they occurred. In the case of Hispanic-made ceramics, we are challenged to understand pottery in terms of non-centralized, localized craft specialization. The archaeological assemblages of Hispanic-made ceramics from sites throughout New Mexico and southern Colorado indicate that ceramics vary somewhat independently of specific type classification. The data invite comparisons of ceramic assemblages from southern New Mexico with those from Manzano north to Vadito. One solution lies in the explanatory model presented in this research. A comprehensive understanding of land disenfranchisement and the selection of alternative subsistence strategies by Hispanics will lead to further insights about craft specialization. Given the complex frontier conditions in which craft specialization appeared in New Mexico, the apparent contrasts in Hispanic ceramic assemblages from area to area may be related to what Binford termed "self image:"

My present guess is that many of the suspected contrasts will relate to differential degrees that persons identify with their products as extensions of the self-image. ... I suspect that in the latter types of societies, insofar as crafts are concerned, there is a greater attempt at conformity and less "self expression" in the manufacture of role specific items. On the other hand, craft specialization in which role identity is directly related to the products produced in the context of performance may well manifest greater variability. Craft specialists may develop self-images through greater attempts in individualized production. In short, variability in items produced may well vary directly with the character of the role structure in the society and the degree that it provides criteria for evaluating performance as a component in the development of self images (Binford 1972:454).

The qualitative differences among Puebloan, Athabascan, and Hispanic ceramics are apparent, but unfortunately quantitative data are unavailable because archaeologists still use temporally diagnostic ceramics to identify both site occupation and patterns of regional exchange. The use of traditional ceramic classifications established more than half a century ago will undoubtedly continue to blur our ability to understand Hispanic settlement patterns, trade and exchange patterns, and a whole host of interrelated subjects. In short, the presence of heretofore unrecognized Hispanic-made ceramics has important implications for understanding Hispanic culture in New Mexico during the period from the middle of the eighteenth century until after the coming of the railroad in 1880.

Additionally, this work can contribute to Southwestern archaeology by investigating the nature of Hispanic-Pueblo interaction during the late eighteenth century, in light of the Bourbon reforms that affected New Mexico. One aspect of this interaction, the change in Pueblo ceramics and the development of a distinctive Hispanic culture, has only recently been addressed (Frank 1992). This research will help rectify the perfunctory and indifferent attitude toward Hispanic ceramics in the archaeological literature of New Mexico and southern Colorado. Because it has been demonstrated that a ceramic tradition emerged among disenfranchised Hispanics, the notion of craft specialization is to be understood as an alternative explanation to traditional approaches typically employed in current archaeological research.

This study has presented and tested a processual model which accounts for the development of Hispanic ceramic specialization in late colonial New Mexico. Any such study, poses a question like this: What does the presence of Hispanic-made ceramics say, if anything, about the nature of craft specialization in late colonial New Mexico, throughout the Mexican Republic period, and into Terretorial times until after the coming of the railroad? The arguments that I have made in this research have relied on several sets of data. Because archival, oral historical, ethnographic, and archaeological data

from New Mexico support this model and validate its theoretical position, this work will also provide an inferential tool for future research concerning Hispanic New Mexican ceramics.

This model depends on a deductive approach that includes general analogies as well as "lawlike generalizations" (Sabloff et al. 1973). From the work of Arnold (1985) I was able to draw generalizations that were then applied as paradigms to evidence from Hispanic archaeological sites and contemporary villages from throughout New Mexico. Arnold's global study of ceramics synthesized ethnographic data on ceramics and enabled his readers to understand a set of relationships that exist between ceramics and the natural and cultural environment. In terms of theory, the data presented here on Hispanic ceramics conform to Arnold's (1985) criteria for the emergence of craft specialization. The ability to confirm the hypothesis is restricted because of the fragmentary nature of archaeological data from Hispanic sites. This work has therefore relied on analogy. Discerning "lawlike generalizations" applicable to craft specialization is dependent upon recourse to analogies from existing cultures. Since few scholarly studies have been conducted on Hispanic ceramics, the analysis of a statistically adequate sample of ceramics is not possible at this time, and quantitative inquiries cannot be mounted. Thus, this study can serve as a tool for future research. This means that archaeologists working with data from seventeenth-, eighteenth-, and nineteenth-century New Mexico must understand the evolving frontier conditions that precipitate change, and challenge traditional interpretations. Those dealing specifically with the Spanish Colonial (1692–1821), Mexican Republic (1821–1846), and Territorial (1846–1912) periods must understand that changing demographic patterns, population pressure and land use, and disenfranchisement will affect the role of ceramics and ceramic craft specialization among Hispanic villagers.

In the preceding research I have examined the conditions in which ceramic craft specialization evolved in some Hispanic settlements prior to the arrival of the railroad in 1880. Chiefly, specializa-

tion occurred when population pressure brought about disenfran-
chisement and some members of the Hispanic population sought to
supplement their income by adopting alternative occupations. One
such strategy was ceramic production. By the end of the eighteenth
century, the Bourbon reforms taking place in México also affected
social and economic conditions in colonial New Mexico. Archival
data indicate that the long-distance trade of New Mexican–made
goods, especially Pueblo pottery, likely had an additional impact on
the Hispanic population and more specifically on those choosing
ceramic production as an alternative occupation. As cultural demo-
graphics also changed, there is an appreciable decline at Hispanic
sites and villages in the use of polished wares made by both Pueblo
potters and Hispanic potters, and there is a corresponding increase
in the use of micaceous wares. These micaceous wares seem to be
what the recent ethnographic record refers to as Hispanic pottery, for
these wares more than any other Hispanic pottery are still kept as
heirlooms by Hispanic families throughout northern New Mexico.
The ethnographic record for Hispanic villages has barely been tapped.
In the future these data will be invaluable for theory building, espe-
cially in the construction of robust models for examining the rela-
tionships between Hispanics and their physical and social environ-
ment. I hope this book will serve as an occasion for further research
and thus contribute to a fuller understanding of Hispanic culture in
the late eighteenth and nineteenth centuries.

Afterword

Hispanic New Mexican Pottery is an important book for all students of the Southwest – for historians, archaeologists, artists, and for *los vecinos*, the people themselves. In writing this book, Charlie Carrillo has given us something new. Archaeologists and laypersons who roam the southwestern landscape find broken pieces of pottery that are ubiquitous relics of the past. Archaeologists have named more than 2500 types of southwestern pottery and use these types as ceramic clues to past peoples and past events. Virtually all of these types are the products of Native Americans. Archaeologists and historians have not acknowledged that pottery was produced in the Hispanic villages of New Mexico, and pottery has been excluded from representation among Spanish Colonial crafts.

 Charlie explores the reasons behind this neglect in this book, but one factor in dismissing Hispanic pottery production is the assumption that it was not culturally valued. Articulating this view, David Snow (1984) wrote that in colonial Latin America in general, pottery making was considered a low income, low status, Indian occupation. Hence, archaeologists have assumed that pottery found at Hispanic village sites was Indian-made. Such unexamined assumptions stand in the way of progress in learning about the past. Charlie is a man

with an inquiring mind. His major professor, Lewis Binford, encour-
aged generations of archaeology students to question all unexamined
interpretations of archaeological remains.

Armed with questions about pottery in Hispanic villages, Char-
lie developed his thesis. His attack on received wisdom takes two
paths. First, he examines the social, political, and economic context
of pottery production in north-central New Mexico from 1790 to
1890. Second, he considers variability in the technology of manufac-
ture of the pottery from that period. He argues that population growth
in the Hispanic settlements, increasing encroachment from nomadic
tribes, and the changing policies of land grants and trade relation-
ships with Old Mexico created a local market for Hispanic pottery
and a landless, disenfranchised group of women who could improve
their lot by making needed pottery vessels.

Hispanic women probably did not make all the kinds of pottery
found at colonial sites. Charlie argues that the women produced cer-
tain kinds of cooking and serving vessels that could not, at the time,
readily be obtained from neighboring Tewa Indian communities. He
is able to show and explain the reasons behind technological differ-
ences between this pottery and ceramics that were Tewa-made. The
differences reflect restricted access to resources, such as materials used
to temper the clays and the fuel used to fire the pots. Here Charlie
has made a strong argument, one that has broad implications for
other new, archaeological studies of ceramic production and distri-
bution in the Southwest (e.g. Mills and Crown 1995).

For me, archaeology is one way of learning something new about
the past. The ability to really learn something new often derives from
a willingness to question our most basic assumptions about the ob-
jects we study and their contexts. This book pushes us to do just that.
If we accept its logic, we cannot help learn more that is new about
the very old.

<div align="right">
Linda Cordell, Director

University Museum

University of Colorado, Boulder, Colorado
</div>

Epilogue

'*Mana* Benita Domínguez, my mother's Godmother, was making and firing micaceous clay pottery in the village of Ancones, north of La Madera, as late as 1947. This information was related to me by her grandson, the late Jimmy Griego, who helped his grandmother with the firing process, clay digging and preparation. I came to know all of this information after the Spanish Colonial Arts Society's screening/jurying committee denied me admittance to Spanish Market in 1978. I was asked how much Indian blood I had and was flatly told that the "Spanish" people of New Mexico DID NOT make pottery, that craft/art was the domain of the Indian people. After that humiliating experience, I was determined to find out where these people had gotten their erroneous information or lack thereof and started doing my own research.

I came to find out that 17 Hispanic women in the surrounding villages were making pottery from the end of the previous century until around 1950. The last Hispanic woman potter from the village of Servilleta, '*Mana* Albinita Jaramillo, died in 1996 at the age of 97. All these 17 women were primarily Hispanic (of course one needs to remember that very few Hispanics in New Mexico do not have Indian blood – but Hispanic is culturally Hispanic). My own pottery mentor was part Hispanic and part Jicarilla Apache. She taught me

shapes that were a departure from Jicarilla Apache traditional ware of the previous century and included various "Hispanic" shapes such as tea pots (*teteras/patos*), open flanged bowls (*charolas*), pitchers (*picheles*), cups (*tasas*), and griddles (*comales*). I created many pottery pieces using the fluted rim designs and lots of handled vessels.

I researched the traditional Jicarilla Apache pottery of the previous century that are housed at the School of American Research and the Laboratory of Anthropology, both in Santa Fe, the Maxwell Museum in Albuquerque, and both the Natural History Museum and Denver Art Museum in Denver. I also traveled to the Museum of the American Indian in the Bronx to see their collection before it became part of the Smithsonian Institution. Needless to say, I found various "Hispanic" pots mislabeled as Jicarilla Apache, Taos, or Picurís Pueblo, and even some as Nambé Pueblo. It became clear to me that many archivists did not have a clue that there was a tradition among the Hispanic peoples of Northern New Mexico of creating micaceous clay vessels for trade and/or personal use.

I have traveled throughout the state of New Mexico identifying sources for micaceous clay pottery in various locales – from Amalia, New Mexico, in the northernmost section of the state, to Socorro, on the southern end of the micaceous clay band, and from Ocaté, on the easternmost part of the Precambrian mica-shist formation, to Tierra Amarilla (the technical name for micaceous clay among the Hispanic people), on the western part of that same ridge. I have collected clay and fired the samples so that I could have a visible and tangible aid to my research. Thus, I have been able to go to museums and visibly identify pots, as to their origins, by their construction, clay coloration, and style. And if I had had access to chemical analysis of the pottery in question, I would have been able to have been even more precise in my conclusions. But, I can, with certainty, identify the pots by the tradition that created them: Navajo, Ute, Jicarilla Apache, Taos, Picurís, Nambé, San Juan, Tesuqué, Truchas, Chimayó, Cundiyó, La Petaca, La Madera, El Rito, Abiquiú, Tecolote, Villanueva, Ocaté, Mora, Ledoux, Tierra Amarilla, and the most ancient of mica wares, Sapawi corrugated and Potsuwii smeared indented.

During my research, I have found two people that were willing to talk with me and verify the information that I had found about pottery production from the various traditions: Herb Dick, now deceased, and Charlie Carrillo, then a Ph.D. candidate at the University of New Mexico. They both gave me ample opportunity to share my very personal experience with this clay as both a potter and an amateur researcher.

I am grateful to Charlie Carrillo for taking this information along with his own research and bringing about an understanding of tradition among Hispanic peoples as potters using various clay bodies. Thanks to his efforts, many of my students are recognized potters at the Spanish Market, and it was largely through his insistence that these students were admitted to show at this prestigious show. Ironically, I still stand unaccepted at Market; my pottery would not meet the strict parameters arbitrarily created by non-potters, non-Hispanic, traditionally-biased members of the Spanish Colonial Arts Society screening/jurying committee. It is my hope that the publication of this most timely book will signal to the academic community that those of us in our particular traditions can speak, research, publish our own understanding about ourselves and our traditions without having to rely on those who stand outside our tradition. I am grateful that in the past those people have written their own understandings, but it was with that impetus that Charlie Carrillo has stepped forward to tell our story in its entirety.

I also want to remember all those women and men who have handed on the tradition to us, and, especially to me, the memory of Jesusita Martínez, my mentor.

Felipe Ortega
Hispanic Potter
La Madera, New Mexico

Footnotes

1. The Bourbon Reforms were a movement to unify and centralize government in Spain and was begun by King Felipe (1700-1746) of the Bourbon dynasty. Felipe was the first Bourbon monarch (of the French dynasty) in Spain. The Bourbon Reform system helped to regulate government and commerce on both the Iberian peninsula and in the Spanish colonies of the Americas. This reform system helped set the Independence movement of the Américas during the early nineteenth century (Payne 1973:351-371). [page 24]

2. The village of Santa Rosa de Lima de Abiquiú was begun in 1734. The *Genízaro* village of Santo Tomás Apostal de Abiquiú was established in 1754. [page 27]

3. Don José Antonio de Villaseñor y Sánchez was the *"contador general de la real contaduria de azogue y cosmógrafo"* of the Viceroyalty of New Spain. He compiled a general description of New Spain for the viceroy which he published in 1746 entitled, *Teatro americano*. This description included detailed information regarding New Mexico. [page 32]

4. R. Frank defines a *vecino* to be a: 1) householder or resident of a community; 2) citizen; 3) neighbor (1992:474). [page 32]

5. King Carlos III, a Bourbon king, reigned from 1759 to 1788 when he succeeded his brother King Fernando VI who had reigned from 1746-1759. His administration was a great reform period for Spain and its colonial holdings. In 1767, he expelled the Jesuits from Spain and from Spanish holdings. The prosperity of his reforms created a class of wealthy creole elites in the Americas who would eventually lead to seek independence from Spain (Payne 1973:359-360). [page 38]

6. The Works Project Administration (WPA) was an Act of Congress of 1935 during the administration of President Franklin Delano Roosevelt. The WPA dispursed $11 billion among 3.2 million Americans between 1935 and 1942. Among the many projects provided by this dispursement were federal funds for federal theater, the arts, and writers' projects. [page 61]

7. Seventy families settled in Manzano between 1824 and 1826. Thirty-one additional families arrived in 1829. The bulk of these families were from villages along the Río Grande Valley such as Tomé, Valencia, Casa Colorada, and Belén (Stanley 1962:3-7). [page 64]

8. The first eighteen families in Antón Chico were from San Miguel del Vado. These settlers petitioned for a land grant in 1822. The settlement of Antón Chico was abandoned in either 1827 or 1828 due to Comanche raids. The land grant was resettled in 1834 by fourteen heads of families. These families were also from San Miguel del Vado (Rock 1980:87). [page 65]

9. Carrillo and O'Hara's nomination of the Antón Chico Land Grant was completed in 1985 and included the study of Antón Chico and other communities within the Grant boundaries. During the building and archaeological survey historic ceramics were noted. They included some Tewa Redwares, as well as Hispanic wares. The Hispanic wares included Casitas Red-on-brown, Carnué Plain, Manzano Black, and a variety of micaceous wares, including both Hispanic micaceous wares as well as Jicarilla micaceous wares. [page 67]

10. The correct Spanish spelling of "*Ojitos*" is "*Hojitas*" which means "small leaves." In Spanish, the letter "h" is silent when placed before a vowel. Many non-Spanish speakers are often confused with this orthographical rule (including many others) and will misspell many Spanish words. After the arrival of the railroad in New Mexico, several post offices were established throughout the territory. Many Spanish place-names were misspelled such as "Albuquerque," "San Jon," and "San Acacia." The post offices and later the State Highway Department added to the persistence of bad Spanish orthography. [page 74]

11. Gilberto Benito Córdova was one of the founding members of La Asociación de Santa Rosa de Lima de Abiquiú in 1976. He is a descendent of an Abiquiú *Genízaro* family. Córdova's extensive research concerning the *Genízaro* settlement of Abiquiú can be found in his doctoral thesis finished at the University of New Mexico. The dissertation is titled "Missionization and Hispanicization of Santo Tomás Apóstol de Abiquiú 1750-1770." [page 77]

12. The original name of the settlement of San Rafael was "Ojo del Gallo." This settlement appears on a map dated 1779 which was drawn by don Bernardo de Miera y Pacheco (J. Barela 1975:7). [page 81]

13. Hispanic settlers first moved into the Mora Valley as early as 1818. In 1818 there were "300 souls" living in the "*Puesto nombrado lo de Mora*" (Chávez 1955:318-23). [page 83]

14. The settlement of the Paraje of Fray Cristóval was probably named after the pioneer Franciscan, Fray Cristóval de Salazar. He was a cousin of don Juan de Oñate and died in 1599 while returning to México. The *paraje* or "resting-stop" of Fray Cristóval was located at the upper terminal of the Jornada del Muerto. A mountain range of this same name is located in Sierra County on the east bank of the Río Grande parallel to the Jornada del Muerto (Chávez 1949:373; Marshall 1984:240-1). [page 89]

15. An "L.A.#" is the number assigned to archaeological sites in New Mexico by the Laboratory of Anthropology in Santa Fe. The initials of the Laboratory of Anthropology are followed by the number of each particular archaeological site. Each number is assigned sequentially according to the time of recordation. [page 90]

16. Bishop Pedro de Tamarón y Romeral (d. 1768) was a native of Castilla la Vieja in Spain and traveled to Venezuela in 1719. Pope Benedict XIV issued a Papal Bull in 1757 which named Tamarón as the sixteenth bishop of Durango, México. In 1759-60, Bishop Tamarón began his episcopate with a pastoral visit to his vast diocese which included the provinces of Sinaloa, Sonora, Chihuahua, and Nuevo México. In 1765, he published his diary and recollections of his episcopal journeys in his *Demostración del vastisimo obispado de la Nueva Viscaya* (Bravo *Diócesis* 1941:32, *Colección* 1965:48-49; Gallegos 1969:235-240; Tamarón 1937:V-VII, XVI). [page 95]

17. MAPCO refers to the Tulsa-based Mid-American Pipeline Company and also the cultural resource inventory of a proposed 50-foot wide Liquid Hydrocarbons pipeline that resulted in an archaeological mitigation and clearence project from 1979-1983. [page 104]

18. A "*majada*" is sheltered place where shepherds put up for the night with their flocks (Chávez 1950:69). [page 108]

19. The Silva Diary, a travel account of Juan Bautista Silva, documents the journey of fourteen families that left New Mexico to settle La Loma, near Del Norte, Colorado. The trip began on May 6, 1859 and ended July 20, 1859. See *The San Luis Valley Historian* Vol V, No 3 and 4, 1973. [page 124]

20. Micaceous clay contains large amounts of mica minerals. All micas are characterized by a platy morphology, giving them excellent insulation qualities. The micaceous clay used by both Native American and Hispanic potters seem to be derived from serecite deposites rich in muscovite mica (Dick n.d.) [page 125]

21. This lay brotherhood of Catholic men known today as La Piadosa Fraternidad de Nuestro Padre Jesús Nazareno came into existence at the end of the eighteenth century. Known commonly as "Los Penitentes," this confraternity is focused on the passion and death of Christ and the practice of Catholic spirituality. The members also played an active role in the maintenance of Hispano culture in most New Mexican Hispanic villages. The Brotherhood served as a welfare agency, political force, and spiritual foundation for northern New Mexican and southern Colorado Hispanic villages throughout the nineteenth century. (See Fray Angélico Chávez "The Penitentes of New Mexico." *New Mexico Historical Review* 29:2 [1954], 110-112. Marta Weigle, *Brothers of Light, Brothers of Blood*. University of New Mexico Press, Albuquerque: 1976 and Thomas J. Steele, S.J. and Rowena A. Rivera, *Penitente Self Government: Brotherhoods and Councils 1797-1947*. Ancient City Press, Santa Fe: 1985. [page 134]

22. The *Plan de Iguala* was proclaimed on February 24, 1821 by don Agustín de Iturbide, who became the first emperor of the infant nation of México. The *Plan* consisted of two documents redacted along with the insurgent *caudillo* don Vicente Guerrero. The first document was a proclamation of independence from Spain and the second document was, in fact, a plan which contained the "Three Guarantees." These were: the conservation of the Catholic religion, national independence, and the intimate union of Europeans and *americanos*. The *Plan de Iguala* was first proclaimed in the pueblo of Iguala, Guerrero, hence the name. It was immediately promulgated through the use of a small printing press which accompanied Iturbide ("Plan de Iguala" 1995:2745-2747). [page 134]

23. Alfred V. Kidder (1885-1963). Kidder was acknowledged as the dean of southwestern archaeology. He was trained at Harvard University and his research at Pecos Pueblo and Mission lasted from 1915-1929. His work led to the development of a unified system of ceramic nomenclature known as "The Pecos Classification." This system is still in use today. [page 161]

24. The Court of Private Land Claims was established in 1891 when it was created by an Act of Congress. During the thirteen years which the court sat, approximately 300 claims to land grants were heard regarding roughly 35,000,000 acres (Van Ness 1980:10). [page 168]

25. A nice, succinct history of the San Joaquín del Nacimiento Land Grant of 1769 can be found in H. Luna 1975:19-33. [page 168]

26. Concha was governor in New Mexico from 1788 to 1794. [page 185]

27. Lewis R. Binford, Professor of Anthropology at Southern Methodist University, Dallas, is rightly called "the father of new archaeology" because he formulated a coherent program for archaeological research that utilized evolutionary and environmental thinking and synthesized these with a system outlook and deductive reasoning. [page 196]

Pottery Shapes

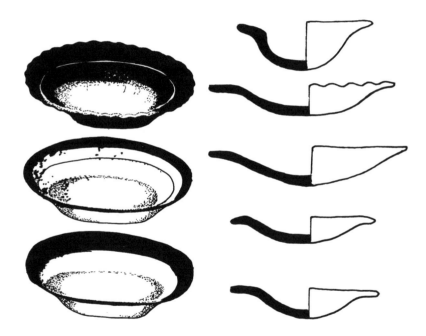

SOUP PLATES/FLANGED BOWLS
Top: Hispanic Blackware
Middle: Casitas Red-on-brown
Bottom: Casitas Red-on-brown
Illustration by Charles Carrillo.

SOUP PLATES/FLANGED BOWLS
Top: from private collection;
Others: reconstructed from archaeological data.
Illustration by Charles Carrillo.

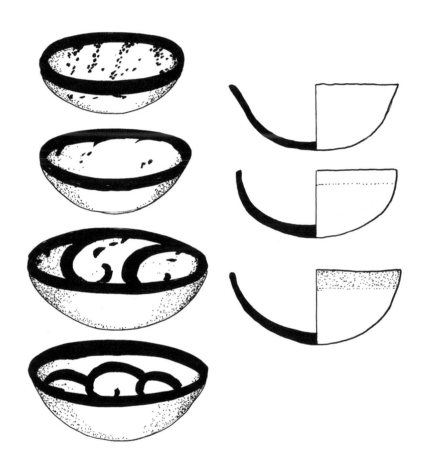

BOWLS
Casitas Red-on-brown bowls, taken from reconstructed bowl fragments from throughout New Mexico.
Illustration by Charles Carrillo.

MOLDED HEMISPHERICAL BOWLS
Top: Outflaring rim; Middle: Incurving rim; Bottom: Straight rim (Casitas style red banded rim). Reconstructed from archaeological samples.
Illustration by Charles Carrillo.

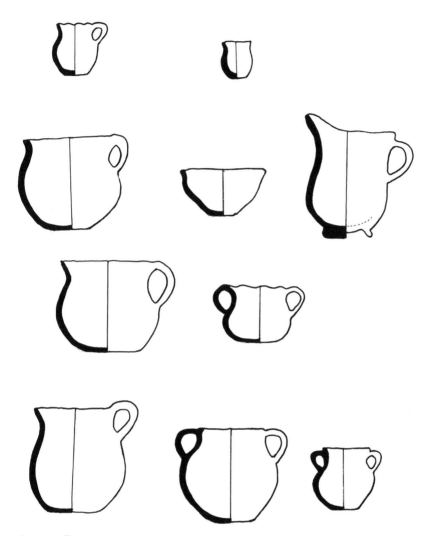

POTTERY FORMS
These samples are of actual vessels.
Top row: Candle holder and pinch or cosmetic pot (both from Abiquiú);
Second row: Abiquiú style olla (left), Mora area taza and pitcher (center/right);
Third row: Córdova style olla (left), Abiquiú style tazita de atolé (right);
Bottom row: Vadito style olla (left), Abiquiú style ollitas(center and right).
Illustration by Charles Carrillo.

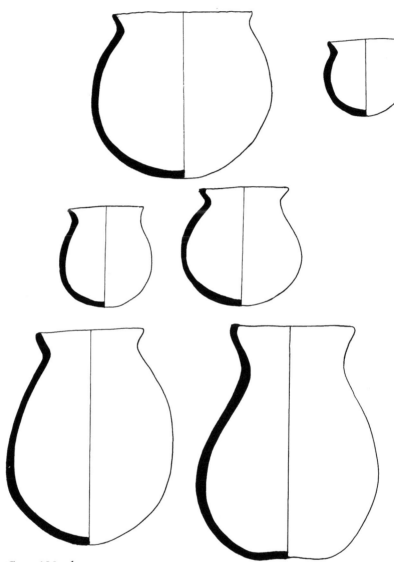

Carnué Vessels
Reconstructed from archaeological sites throughout New Mexico
Top row: Rounded bottom Carnué Plainware Ollas;
Second row: Carnué Plainware Ollas;
Third row: Carnué Plainware Tinajas (these may have been wine vessels/vats);
Illustration by Charles Carrillo.

Hispanic Settlements

This is a partial list of Hispanic villages and settlements from 1700-1900. Pottery was not necessarily made in all of these villages. But it is important to understand where pottery could have been made. This is a helpful resource to anyone conducting archaeological and/or ethnographic research on Hispanic New Mexico and southern Colorado. In every one of these villages pottery was used on a day-to-day basis. Most households had only pottery containers before the opening of the Santa Fe Trail and the subsequent opening of the AT&SF/Santa Fe Railroad. These settlements are listed by areas from southern New Mexico going north to southern Colorado.

RÍO ABAJO (160)
Abeytas
Abo (Ranchos)
Alameda de las Lomas
Alamillo
Alamitos
Alamocita (Monticello)
Alburquerque, La Villa de
 (Albuquerque)
Alma Valley
Atrisco (Atilxco)
Ballecito
Bosque de los Pinos
 (Bosque Farms)

Bosquecito
Bowling Green
Bacaville
Barelas
Barranquitas
Belén
Bernardo
Bernabeo Montaño
 (Bernalillo)
Bosquecito
Bowling Green
Cañada Alamosa
Cañoncito
Canta Récio (Cantarecio)

Carrizozo
Casa Colorada del Sur
 (Turn)
Contadero
Coyote
Chamizal
Chihuahua
Cienéga
Corrales (Isleta)
Cubero
Cuchilla
Cuchillo Negro
Durán
El Contadero

El Tajo
Esmeralda (Azul)
Florida
Jaral Largo
Jarales
Juan Tomás
La Alameda
La Bajada
La Cañada
La Escondida
La Florida
La Joya (Contreras)
La Joya (de Sevilleta)
La Joyita
La Ladera
La Madera
Las Majadas
La Mesa de San Marcial
La Oyada de Civoyeta
La Parida
La Placita de los Garcías
La Vega
Laborcita
Las Majadas (Cochití
 Springs)
Las Nutrias
Latear (Los Balen Buelas/
 Valenzuelas)
Lavagada (La Bajada)
Lemitar
Lentes (Los Lunas)
Los Algodones
Los Amoles
Los Arenales
Los Candelarias
Los Chavéz
Los Chulos
Los Enlames (Adelino)
Los Garcías
Los Lunas
Los Padillas
Los Pajaritos
Los Pinos (Peralta)
Los Pueblitos y el Bosque

Los Ranchos de Tomé
Los Trujillos
Luis López
Mangas
Mesilla
Mongoyón
Nuestra Señora de
 Guadalupe de los
 Chávez
Nuestra Señora de
 Guadalupe de los
 Griegos
Nuestra Señora de
 Guadalupe de Peralta
Nuestra Señora de los
 Dolores de los Genízaros
Nuestra Señora de los
 Jarales de Belén
Nuestra Señora de Pilar de
 Belén (Plaza de los
 Garcías/Los Pueblitos)
Nuestra Señora de Socorro
 de Pilabo
Ojo de la Cabra (Goat
 Springs)
Ojo de las Casas
Padillas
Palomas
Paraje
Paraje de Fray Cristóval
Park City
Peña Blanca
Peralta
Picacho
Placitas
Plaza de Arriba
Plaza de los Bacas
Polvadera
Ponderosa
Pueblita de la Parida
Pueblito
Pueblitos
Puertecito
Quemado

Rancho de Sabinal
Rincón
Rincon de Socorro
Río Bonito (Lincoln)
Rito Quemado
Ruiz
Sabinal
Sabino
San Acacia
San Albino
San Antonio
San Antonio (Estancia de
 San Antonio)
San Antonio de las
 Huertas
San Antonio de los
 Poblanos
San Antonio de Sabinal
San Antonio de los
 Trujillos de Belén
San Clemente
San Diego (Tonuco)
San Fernández
San Fernando
San Francisco
San Gerónimo
San Ignacio
San Isidro de los Corrales
San José
San Juan
San Marcial
San Miguel Laredo (San
 Miguel Laredo de
 Carnué/Carnuel)
San Pedro
San Pedro (Don Pedro)
Santa Rita (Riley)
Santa Rosalía de Corrales
Sauzal
Sedillo
Señor San José de los
 Duranes
Señor San José de los
 Gallegos

Señor San José de los
 Ranchos (Ranchos de
 Albuquerque)
Silla (Sile)
Socorro
Tabalopa (Tavalopa)
Tejón
Tomé
Tres Hermanos
Valencia
Valverde
Veguita
Zacates
Zapato

MANZANO MTNS/
 ESTANCIA VALLEY (16)
Casaus
Cedro
Chacón
Charillos
Chililí
El Chato
Escobosa
Estancia
Manzano
Miera
Pinos Wells
Punta de Agua
San Antonito
Cienéga
Tajique
Torreón

PUERCO VALLEY (36)
Alcatráz
Amado
Atarque
Betano
Cabezón (La Posta)
Cañín de Jémez (Cañón)
Casa Salazar
Cebolleta (Seboyeta)
Cebolletita

Cuba
Cubero
El Ojo del Espíritu Santo
Encinal
Guadalupe (Ojo del Padre)
La Cueva
La Jara
La Posta
La Ventana
Laguna
Los Alamitos (Grants)
Los Cerros Cuate
Los Torreones
Nacimiento (Cuba)
Ponderosa
Portería
Quelites
Regina
San Fernando del Río
 Puerco
San Ignacio
San Luis (La Tijera)
San Mateo
San Rafael
San Ysidro
Santa Rita del Cobre
Tinaja
Vallecito de los Indios

CHAMA VALLEY (42)
Abiquiú
Ancones
Cañón Plaza
Cañones
Casa Blanca
Casita Vieja (Casitas)
Cebolla
Coyote
El Canjilón
El Duende
El Gavilán
El Rito
El Vado
Ensenada

Gallinas
La Casita
La Cueva
La Madera
La Petaca
La Puente
Los Luceros
Los Ranchitos
Ojo Caliente
Plaza Blanca
Plaza Colorada
Plaza de los Encinos
 (Youngsville)
Plaza Larga
Río del Oso
San Gabriel
 (Yunqueouinge)
San José de Chama
 (Hernández)
San Pedro de Chama
San Antonio de los
 Vallecitos
San Lorenzo (Río de Oso
 Canyon)
San Pedro
Santa Rosa de Lima de
 Abiquiú
Santo Tomás Apostal de
 Abiquiú
Servilleta
Servilleta Plaza
Vallecitos
Vaqueros
Youngsville

PECOS VALLEY (56)
Agua Sarca
Antón Chico
Bosque Grande
Casa Blanca
Chaperito
Ciruela
Cuervo
Dilia

Dolores
El Cerrito
El Macho
El Mestero
El Pedernal
El Pueblo
El Puertecito (Sena)
El Sastre
Galisteo
Guadalupe
La Cuesta (Villanueva)
La Fragua
La Liendre
La Loma de San José
La Placita de Abajo
Lagunita
Las Colonias de San José
Las Gallinas
Las Mulas
Las Ruedas
Las Tortolas
Leyba
Los Chávez
Los Montoyas
Los Ojos
Los Placitas del Río Pecos
Los Valles (San Augustín/
 Lourdes)
Mesteño
Milagro
Ojitos Frios (Gabaldon)
Pajarito
Pecos
Plaza de Arriba
Plaza de los Esteros
Puertecito
Puerto de Luna
Rancho del Medio
Rayado
Ribera
Romeroville
San Ignacio
San José de las Colonias
San Miguel del Vado

San Pablo
San Ysidro
Santa Rosa
Tecolote
Tecolotito

MORA VALLEY (129)
Abuelo
Agua Dulce
Agua Fría
Agua Negra (Holman)
Agua Azul
Aguila
Aurupa (Jorupa/Orrupa)
Bernal
Buena Vista
Cañón del Agua
Carmen
Casa Grande
Ceruilita
Chacón
Chaperito
Charco
Chico Springs
Cimarrón
Cimarrón Seco
Cimarroncito
Ciruela
Corazón
El Armenta
El Begoso
El Cañón Largo
El Cerro
El Chorro
El Coyote
El Encinosa
El Llano
El Montón de los Alamos
El Porvenir
El Rayado
El Rincón
El Rincón de Arriba
El Rito de Agua Negra
El Sabinoso

El Valle de Arriba
El Valle de la Cebolla
El Vermejo
Encierre
Escondido
Estrada
Eureka
Gallinas
Golondrinas
Guadalupita
Hot Springs
La Aguita
La Cañada del Cerro
La Cañada Conita
La Cañada Vegue
La Cinta
La Cueva
La Junta (Watrous)
La Liendre
La Loma Parda
La Manga
La Tablazón
La Tara
Laguna Regra
Lagunita
Las Ciruela
Las Colonias
Las Golondrinas
Las Tecolonenos
Las Tramperas
Las Tusas
Las Vegas
Ledoux
Llano
Llano de Coyote
 (Rainsville)
Loma Parda
Los Alamos
Los Bueyeros
Los Chávez
Los Chupaderos
Los Fuertes
Los Jacales
Los Leflevres

Los Martinez
Los Montes (Des Montes)
Los Naranjos
Los Pinos Altos
Los Torres
Los Trujillos
Los Valles de San
 Gerónimo del Tecolote
Los Vigiles
Los Vueros (Los Güeros)
Manueles
Manuelitas
Martínez (Aurora)
Montón de Alamos
Mora
Mosquero
Ocaté
Ojo de las Conchas
Ojo Feliz
Peña Flor
Piñavititos
Placitas de la Cevoya
Plaza del Lumbre
Ponil
Ponilito
Rayado
Rincón del Tecolote
Río La Vaca
Rociada
Saint Andrew
San Antonio lo de Mora
 (El Valle de San
 Antonio)
San Hilario
San Ignacio
San Lorenzo
San Luis
San Rafael
Sánchez
Santa Bárbara
Santa Gertrudis lo de
 Mora
Sapelló
Sierra de Ocote

Tequesquite
Terqueskiti
Tierra Blanca
Tres Ritos
Trincherita
Valmora
Variadero (Trementina)
Vermejo Abajo
Vermejo Arriba

RÍO ARRIBA (143)
Agua Fría
Ajuelos
Alire
Ancones
Angostura
Apodaca
Arroyo Hondo
Arroyo Seco
Bacas
Boquilla
Bosque
Cabilar
Cañón
Cañón Largo
Cañón Plaza
Cañoncito
Canova
Capilla de San Antonio
Carracas
Carson
Casitas
Cavarista
Cebolla
Cerrillos
Cerro
Chamisal
Chamita
Chilí
Chimayó
Chupadero
Chupangue
Cieneguilla
Claro

Comales
Costilla
Coyote
Cundiyó
Dolores
Don Fernando de Taos
El Barraderio
El Barranco
El Bosquecito
El Cerro
El Cerro del Corazon
El Guacho (El Guache)
El Guique
El Potrero
El Vadito
El Valle
Embudo
Ensenada
Española
Galisteo
Jacona
La Calebra (Amalia)
La Ciénega
La Cinta
La Cañón Largo
La Cuchilla/La Chuachia
La Cueva
La Ensenada
La Jolla (Velarde)
La Puebla
La Puente
La Villita
Las Nutrias
Las Placitas del Río
Las Trampas
Las Trampas de Taos
 (Ranchos de Taos)
Leyden
Llano
Llano Largo
Llano Leyba
Loma
Los Alamitos
Los Brazos

Los Conejos
Los Córdovas
Los Luceros
Los Mochos
Los Ojos
Los Oros
Los Pachecos
Los Placeros de San
 Francisco (Golden)
Los Ranchitos
Los Valles
Lumberton
Lyden
Madrid
Mesilla
Monero
Moreno Mines
Nambé
Ojo Caliente
Ojitas
Ojo Sarco
Ortiz
Pacheco
Pajarito
Peñasco
Pilar
Placita
Placita de los Luceros
Plaza Abajo
Plaza Blanca
Plaza de Abajo
Plaza de Alcalde
Plaza del Cerro
Puente
Quarteles
Ranchito

Ranchitos
Ranchos (Llano)
Real de Dolores
Real de San Francisco
 (Golden)
Rechuelos
Rincón
Rinconada
Río Chiquito
Río Colorado (Questa)
Río de San Juan
Río de Tesuque (Tesuque)
Río del Pueblo
Río en Medio
Río Lucío
Río Navajó
Rodarte
Rosa
San Antonio (Valdéz)
San Antonio del Embudo
 (Dixon)
San Antonio del Llano
 Quemado (Córdova)
San Cristobál
Santa Cruz de la Cañada,
 La Villa de
Santa Fe, La Villa de
San Francisco
San Rafael (Quiqui)
Servilleta
Sombrillo
Talpa
Tejón
Tierra Amarilla
Tres Piedras
Truchas

SOUTHERN COLORADO (25)
Alamosa
Antonito
Cerritos
Chama
Conejos
Del Norte
El Cañón
El Rito de los Indios (Fort
 Garland)
García
Isla
La Garita
La Placita de los Córdovas
La Placita de los Madriles
La Plaza de los
 Manzanares
Las Sauces
Los Fuertes
Los Pinos
Los Valdézes
Plaza de Alta (La Loma
 San José)
Plaza de Don Hilario
 Abajo
Plaza de los Pinos de la
 Loma
San Acacio
San Luis
San Pedro
Trinidad

Glossary of Spanish Terms

atole A drinkable mush or gruel made from toasted, finely ground and cooked blue cornmeal

bulto An image of a holy person or saint that is carved in the round, usually from cottonwood root, and painted

camposanto Holy ground or burial yard

comal A griddle

criado A Native American Indian servant raised in a Hispanic family

cuipas Shavings or pieces of cedar or juniper bark

custodia In Franciscan use, a lesser group of friars or missions dependent on a Province and administered by a *custos*; also, a monstrance

dicho A proverb or saying

encomienda A grant of Indian tribute

ejido	Common land owned by a community lying outside the immediate village area; wood, water, pasture
genízaro	A Native American, usually of nomadic origin, but sometimes of Pueblo origin, who was ransomed or captured, or who voluntarily was detribalized, hispanicized, and lived in a settled community
hispano	An individual who was culturally, though not necessarily biologically, Spanish. *Hispanos* resided in Hispanic villages; spoke Spanish, and practiced Catholicism
losa fina	Fine pottery; usually *majólica* wares or fine ceramics made in México
majólica	A wheel-made decorated glazed earthenware
malacate	A whorl-spindle used in preparing wool for yarn
'mana	A familiar title used for women in northern New Mexico which is short of *hermana* or sister
manta	Indian-made blanket
ollita	Small pot
piñón	The edible nut of the piñón tree
placita	A fortified settlement or patio
Plan de Iguala	The Mexican Republic plan in which all residents of the Mexican Republic were considered equal citizens
plaza mayor	Main or central plaza, public square, or similar open area in a village
plazuela	Small plaza within a room block; see placita

poblano	Someone who is from the city of Puebla de los Angeles, Puebla, México
pueblo	Either a permanent Native American village or an unincorporated Hispanic village
reducción	The Spanish mission center established for the conversion of nomadic Indians
repartimiento	The distribution of Native American labor used in early colonial New Mexico, or the forced distribution of trade goods to native peoples for credit, that could be used for exchange of native-made goods
retablo	A holy image painted on a prepared wooden panel; also an altarscreen
sabanilla	Woolen handspun yardage
sabina	Juniper/cedar
santo	A holy image, either a *retablo*, a *bulto*, or an image painted on hide or canvas
solar	A house site or small area of land designated for a home
suerte	A plot of farmland chosen by lottery
talco	Mica sheets, pulverized mica
tata	Elder, grandfather
telpacate	Pot sherd or broken pot
tinamaste (or *tenamaste*)	An iron trivet
tinaja	A large ceramic jar, frequently used as a wine vat

tortilla A flat bread made of either corn or wheat

vara A variable unit of measurement, 33 inches, approximately 2.8 feet

vecino A resident of a community, a neighbor, or a citizen

Sources

ARCHIVAL SOURCES

Archives of the Archdiocese of Santa Fe (AASF): baptismal, marriage, and burial books.
Archivo Franciscano Biblioteca San Augustín (AFBN), México, D.F.
Archivo General de la Nación (AGN), México City.
Mexican Archives of New Mexico (MANM), State Records Center and Archives, Santa Fe.
Spanish Archives of New Mexico (SANM I and SANM II), series I, land grant records, and series II, provincial records, State Records Center and Archives, (SRCA), Santa Fe.
Territorial Archives of New Mexico (TANM), State Records Center and Archives, Santa Fe.

PUBLISHED SOURCES

Adams, Eleanor B.
　　1954　　*Bishop Tamarón's Visitation of New Mexico, 1760.* Publications in History, Vol. 15. Historical Society of New Mexico, Santa Fe.
Adams, Eleanor B., and Angélico Chávez
　　1956　　*The Missions of New Mexico, 1776 – A Description by Fray Francisco Atanasio Domínguez.* University of New Mexico Press, Albuquerque.
Arnold, D. E.
　　1971　　Ethnomineralogy of Ticul, Yucatán Potters: Etics and Emics. *American Antiquity* 36:20–40.
　　1972a　　Native Pottery Making in Quinua, Perú. *Anthropos* 67:858–872.
　　1972b　　Mineralogical Analyses of Ceramic Materials from Quinua, Department of Ayacucho, Perú. *Archaeometry* 14:93–101.
　　1975a　　Ceramic Ecology of the Ayacucho Basin, Perú: Implications for Prehistory. *Current Anthropology* 16:183–205.

1975b Some Principles of Paste Analysis: A Preliminary Formulation. *Journal of the Steward Anthropological Society* 6(1):33–47.

1976 Ecological Variables and Ceramic Production: Towards a General Model. In *Primitive Art and Technology*, edited by J. S. Raymond, B. Loveseth, C. Arnold, and G. Reardon. Pp. 92–108. Archaeological Association, Department of Archaeology, University of Calgary, Alberta, Canada.

1978a Ceramic Variability, Environment and Culture History among the Pokom in the Valley of Guatemala. In *The Spatial Organization of Culture*, edited by I. Hodder. Pp. 39–59. Gerald Duckworth, London.

1978b The Ethnography of Pottery Making in the Valley of Guatemala. In *The Ceramics of Kaminaljuyu*, edited by R. Wetherington. Pp. 327–400. Pennsylvania State University Press, University Park.

1980 Localized Exchange: An Ethnoarchaeological Perspective. In *Models and Methods in Regional Exchange*, edited by R. E. Fry. Pp. 147-150. Society for American Archaeology Papers No. 1.

1981 A Model for the Identification of Non-Local Ceramic Distribution: A View from the Present. In *Production and Distribution: A Ceramic Viewpoint*, edited by H. Howard and E. Morris. Pp. 31–44. BAR International Series 120.

1985 *Ceramic Theory and Cultural Process*. Cambridge University Press, Cambridge.

Arnold, Jeanne
1984 Economic Specialization in Prehistory: Methods of Documenting the Rise of Lithic Craft Specialization. In *Lithic Resource Procurement: Proceedings from the Second Conference on Prehistoric Chert Exploitation*, edited by Susan Vehik. Pp. 37–58. Center for Archaeological Investigations, Southern Illinois University, Occasional Paper 4. Carbondale.

1987 Craft Specialization in the Prehistoric Channel Islands, California. University of California Publications in Anthropology, Vol. 18. University of California Press, Berkeley.

Arnold, Philip J.
1986 Ceramic Production and the Archaeological Record: Some Questions and Considerations. *Haliksa'i: UNM Contributions to Anthropology* 5:57–73.

1988 *The Household Potters of Las Tuxtlas: An Ethnoarchaeological Study of Ceramic Production and Site Structure*. Ph.D. Dissertation, Department of Anthropology, University of New Mexico, Albuquerque.

Balfet, Hélène
1965 Ethnographical Observations in North Africa and Archaeological Interpretations: The Pottery of the Maghreb. In *Ceramics and Man*, edited by Frederick R. Matson. Pp. 161–177. Viking Fund Publications in Anthropology No. 41. Aldine, Chicago.

Barela, Josephine
1975 *Ojo del Gallo: A Nostalgic Narrative of Historic San Rafael*. Sleeping Fox Enterprises, Santa Fe.

Barnes, Gina
 1987 The Role of the *Be* in the Formation of Yamato State. In *Specialization, Exchange, and Complex Societies*, edited by E. Brunfiel and T. Earle. Pp. 86–101. Cambridge: Cambridge University Press.
Batkin, Jonathan
 1989 *Pottery of the Pueblos of New Mexico, 1700–1940.* Taylor Art Museum, Colorado Springs.
Baugh, Timothy G., and Frank W. Eddy
 1987 Rethinking Apachean Ceramics: The 1985 Southern Athapascan Ceramic Conference. *American Antiquity* 52:793–798.
Baxter, John O.
 1987 *Las Carneradas: Sheep Trade in New Mexico, 1700–1860.* University of New Mexico Press, Albuquerque.
Bender, Averam B.
 1974 A Study of Jicarilla Apache Indians, 1846–1887. In *Apache Indians IX*, pp. 9–149. American Indian Ethnohistory: Indians of the Southwest. Garland, New York.
Berns, M.
 1986 *Art and History in the Lower Gongola Valley, Northeastern Nigeria.* Ph.D. dissertation, Department of Art, University of California, Los Angeles.
Binford, Lewis R.
 1983 *In Pursuit of the Past: Decoding the Archaeological Record.* Thames and Hudson, New York and London.
Bloom, Lansing B.
 1913–1914 New Mexico under Mexican Administration, 1821–1846. *Old Santa Fe* 1:9–49, 131–175, 235–287.
 1934 Bourke on the Southwest, II. *New Mexico Historical Review* 9:33-77; Bourke on the Southwest, III. *New Mexico Historical Review* 9:159-183; Bourke on the Southwest, IV. *New Mexico Historical Review* 9;273-289; Bourke on the Southwest, V. *New Mexico Historical Review* 9:374-435.
 1936 Bourke on the Southwest. *New Mexico Historical Review* 11:77-122.
Boserup, Esther
 1965 *The Conditions of Agricultural Growth: The Economics of Agrarian Change under Population Pressure.* Aldine, Chicago.
Boyd, Douglas K.
 1986 *Paraje (de Fray Cristóbal): Investigations of a Territorial Period Hispanic Village Site in Southern New Mexico.* U.S. Department of the Interior, Bureau of Reclamation, Southwest Region, Amarillo.
Boyd, Elizabeth
 1959 *Popular Arts of Colonial New Mexico.* Museum of International Folk Art, Santa Fe.
 1974 *Popular Arts of Spanish New Mexico.* Museum of New Mexico Press, Santa Fe.
Braun, D.
 1983 Pots as Tools. In *Archaeological Hammers and Theories*, edited by A. S. Keene and J. A. Moore, eds. Pp. 107–134. Academic Press, New York.
Bravo Ugarte, S. J. José
 1941 *Diócesis y obispos de la iglesia mexicana, 1519-1965.* Buena Prensa, México, D.F.

1965 Diócesis y obispos de la iglesia mexicana, 1519-1965. *Colección México Heróico.* Editorial Jus., México.

Brody, Jerry J., and Anne Colberg
1966 A Spanish-American Homestead near Placitas, New Mexico. *El Palacio* 73(2):11–20.

Bronitsky, Gordon
1983 Economic Change in the Río Grande Valley. In *Ecological Models in Economic Prehistory,* edited by G. J. Bronitsky. Pp. 168–188. Anthropological Research Papers No. 29. Arizona State University, Tempe.

Brown, Lorin W., Charles L. Briggs, and Marta Weigle
1978 *Hispano Folklife of New Mexico.* University of New Mexico Press, Albuquerque.

Bunzel, Ruth L.
1929 *The Pueblo Potter: A Study in Creative Imagination in Primitive Art.* Columbia University Contributions to Anthropology, vol. 8. Columbia University Press, New York.

Burroughs, Jean M.
1977 From Coronado's Churros. *El Palacio* 83(1):9–13.

Bustamante, Adrian H.
1982 *Los Hispanos: Ethnicity and Social Change in New Mexico.* Ph.D. Dissertation, Department of American Studies, University of New Mexico, Albuquerque.

Bustamante, Adrian H., and Marc Simmons
1995 *The Exposition on the Province of New Mexico, 1812 by Don Pedro Bautista Pino.* University of New Mexico Press, Albuquerque.

Brugge, David M.
1963 *Navajo Pottery and Ethnohistory.* Series 2, No. 2. Navajoland Publications, Window Rock.

Carneiro, Robert
1970 A Theory of the Origin of the State. *Science* 169:733–738.

Carrillo, Charles M.
1980 Field notes from Abiquiú. In author's possession, Santa Fe, New Mexico.

1987 "Abiquiú Ceramics and Historical Evidence for Jicarilla Apache Pottery Manufacture," *Report of Surface Collection and Testing at 18 sites near Abiquiú Reservoir Northern N.M.* prepared for U.S. Army Corps of Engineers, Albuquerque District, N.M. by Miriah Associates Inc.

Carrillo, Charles M., and James O'Hara
1985 *The Antón Chico Land Grant Partial Inventory: Historic Archaeological Proveniences and Architectural Properties.* National Register of Historic Places Inventory-Nomination Form. On file, New Mexico Historic Preservation Division, Santa Fe.

Carter, Rufus H.
1953 *A Historical Study of Floods Prior to 1892 in the Río Grande Watershed, New Mexico.* Unpublished Masters thesis, Department of Civil Engineering, University of New Mexico, Albuquerque.

Chatterjee, B. K.
 1975 Comment on "Ceramic Ecology of the Ayacucho Basin, Peru:
 Implications for Prehistory" by D. E. Arnold. *Current Anthropology*
 16:194–195.
Chávez, O.F.M. Fray Angélico
 1949 New Mexico Place-names from Spanish Proper Names, *El Palacio
 Magazine*, Vol. 56, Dec. 1949. Pp. 367-82. Museum of New Mexico
 Press, Santa Fe.
 1950 Neo-Mexicanisms in New Mexico Place-names, *El Palacio Magazine*,
 Vol. 57, March 1950. Pp. 67-79. Museum of New Mexico Press, Santa
 Fe.
 1955 Early settlements in the Mora Valley, *El Palacio Magazine*, Vol. 62, Nov.
 1955. Pp. 318-23. Museum of New Mexico Press, Santa Fe.
Cobos, Rubén
 1983 *A Dictionary of Northern New Mexico and Southern Colorado Spanish.*
 Museum of New Mexico Press, Santa Fe.
Cordell, Linda S., and Fred Plog
 1979 Escaping the Confines of Normative Thought: A Re-evaluation of
 Puebloan Prehistory. *American Antiquity* 44:405–429.
Córdova, Gilberto B.
 1979 *Missionization and Hispanicization of Santo Tomás Apostól de Abiquiú, 1750–
 1770.* Unpublished Ph.D. dissertation, Department of Education,
 University of New Mexico, Albuquerque.
Costin, Cathy Lynne
 1986 *From Chiefdom to Empire State: Ceramic Economy among the Prehistoric Wanka
 of Highland Perú.* Ph.D. Dissertation, University of California, Los
 Angeles. University Microfilms, Ann Arbor.
 1991 Craft Specialization: Issues in Defining, Documenting, and
 Explaining the Organization of Production. In *Archaeological Method
 and Theory*, Vol. 3, edited by Michael B. Schiffer. Pp. 1–56. University
 of Arizona Press, Tucson.
Crown, Patricia L., and W.H. Wills
 1995 The Origins of Southwestern Ceramic Containers: Women's Time
 Allocation and Economic Intensification, in *Journal of Anthropological
 Research*, Vol. 51, No. 2, Summer 1995, UNM Albuquerque.
Curtis, F.
 1962 The Utility Pottery Industry of Bailén, Southern Spain. *American
 Anthropologist* 64:486–503.
David, N., and H. Hennig
 1972 The Ethnography of Pottery: A Fulani Case Seen in Archaeological
 Perspective. *Addison Wesley Modular Publications* 21:1–29. Reading,
 Massachusetts.
Davis, W. W. H.
 1938 *El Gringo of New Mexico and Her People.* Rydal Press, Santa Fe.
Deal, Michael
 1985 Household Pottery Dispoal in the Maya Highlands: An
 Ethnoarchaeological Interpretation. *Journal of Anthropological
 Archaeology* 4:243–291.

DeAtley, Suzanne P.
 1973 A Preliminary Analysis of Patterns of Raw Material Use in Plainware Ceramics
 from Chevelon, Arizona. Unpublished M.A. Thesis, Department of
 Anthropology, University of California, Los Angeles.
DeBoer, Warren R.
 1974 Ceramic Longevity and Archaeological Interpretation: An Example
 from the Upper Ucayali Perú. American Antiquity 39:335–343.
 1979 The Making and Braking of Shipibo-Conibo Ceramics. In
 Ethnoarchaeology, edited by Carol Kramer. Pp. 102–138. Columbia
 University Press, New York.
Deetz, James
 1965 The Dynamics of Stylistic Change in Arikara Ceramics. University of Illinois
 Press, Urbana.
DeGarmo, Glen D.
 1975 A Methodological Study of a Prehistoric Pueblo Population. Unpublished
 Ph.D. Dissertation, Department of Anthropology, University of
 California at Los Angeles.
Díaz, M.
 1966 Tonalá: Conservatism, Responsibility and Authority in a Mexican Town.
 University of California Press, Berkeley.
Dick, Herbert
 1968 Six Historic Pottery Types from Spanish Sites in New Mexico. In
 Collected Papers in Honor of Lyndon Lane Hargrave, edited by Albert H.
 Schroeder. Pp. 77–94. Papers of the Archaeological Society of New
 Mexico 1. Museum of New Mexico Press, Santa Fe.
 n.d. "Background Information for the Study of Micaceous Pottery,"
 unpublished manuscript.

Dickey, Roland F.
 1949 New Mexico Village Arts. University of New Mexico Press,
 Albuquerque.
Earle, Timothy
 1981 Comment on P. Rice, "Evolution of Specialized Pottery Production: A
 Trial Model." Current Anthropology 22:230–231.
Ebright, Malcolm
 1994 Land Grants and Lawsuits in Northern New Mexico. New Mexico Land
 Grant Series, John R. Van Ness, series editor. UNM Press,
 Albuquerque.
Ehly, J.
 1973 Truchas Becomes a Weaving Center. Handweaver and Craftsman 24(4,
 July–August): 40.
Ellis, Florence H., and J. J. Brody
 1964 Ceramic Stratigraphy and Tribal History at Taos Pueblo. American
 Antiquity 29:316–327.
Ericson, J. E., D. W. Read, and C. Burke
 1971 Research Design: The Relationship between the Primary Functions and
 the Physical Properties of Ceramic Vessels and Their Implications from
 Distributions on an Archaeological Site. Anthropology UCLA 3(2):84–95.

Espinosa, Gilbert, Chávez, Tibo, J. Ward, Carter M.
 1967 *El Río Abajo*, Bishop Publishing Co., Portales.

Evans, Robert
 1978 Early Craft Specialization: An Example for the Balkan Chalcolithic. In *Social Archaeology: Beyond Subsistence and Dating*, edited by Charles Redman, Patty Jo Watson, and Steven LeBlanc. Pp. 113–129. Academic Press, New York.

Feinman, Gary
 1986 The Emergence of Specialized Ceramic Production in Formative Oaxaca. In *Economic Aspects of Prehistoric Highlands Mexico*, edited by B. L. Isaac. Pp. 347–373. Research in Economic Anthropology, supplement 2. JAI Press, Greenwich, Connecticut.

Feinman, Gary, Steadman Upham, and Kent Lightfoot
 1981 The Production Step Measure: An Ordinal Index of Labor Input in Ceramic Manufacture. *American Antiquity* 46:871–884.

Ferg, Alan
 1984 Historic Archaeology on the San Antonio de las Huertas Grant, Sandoval County, New Mexico. CASA Papers 3. Complete Archaeological Services Associates, Cortéz, Colorado.

Fergusson, Harvey
 1931 *Río Grande*. Alfred A. Knopf, New York.

Fisher, Nora, editor
 1979 *Spanish Textile Tradition of New Mexico and Colorado*. Museum of International Folk Art, Santa Fe.

Ford, Richard I., Albert H. Schroeder, and Stewart L. Peckham
 1972 Three Perspectives on Puebloan Prehistory. In *New Perspectives on the Pueblos*, edited by Alfonso Ortiz. Pp. 22–40. School of American Research and University of New Mexico Press, Santa Fe and Albuquerque.

Foster, G. M.
 1948 Some Implications of Modern Mexican Mold-Made Pottery. *Southwestern Journal of Anthropology* 4:356–370.
 1955 *Contemporary Pottery Techniques in Southern and Central Mexico*. Middle American Research Institute Publication No. 2. Tulane University, New Orleans.
 1962 *Traditional Cultures and the Impact of Technological Change*. Harper and Row, New York.
 1965 The Sociology of Pottery: Questions and Hypotheses Arising from Contemporary Mexican Work. In *Ceramics and Man*, edited by Frederick R. Matson. Pp. 43–61. Viking Fund Publications in Anthropology No. 41. Aldine, Chicago.
 1967 *Tzintzuntzán: Mexican Peasants in a Changing World*. Little, Brown, Boston.

Frank, Larry, and Frances H. Harlow
 1974 *Historic Pottery of the Pueblo Indians, 1600–1880*. New York Graphic Society, Boston. (second edition printed in 1991 by Schaffer, West Chester, Pennsylvania)

Frank, Ross H.
 1989 From Settler to Citizen: Economic Development and Cultural Change in Late
 Colonial New Mexico, 1750–1820. Dissertation Prospectus, Department of
 History, University of California, Berkeley.
 1992 From Settler to Citizen: Economic Development and Cultural Change in Late
 Colonial New Mexico, 1750–1820. Ph.D. Dissertation, University of
 California, Berkeley. University Microfilms, Ann Arbor.
 1993 The Changing Pueblo Indian Pottery Tradition: The Underside of
 Economic Development in Late Colonial New Mexico, 1750–1820.
 Journal of the Southwest 33:282–320.
Frazer, Robert W.
 1983 Forts and Supplies: The Role of the Army in the Economy of the Southwest,
 1846–1861. University of New Mexico Press, Albuquerque.
Gallegos C., José Ignacio
 1969 Historia de la Iglesia en Durango, Colección México Heróico. Vol. 100.
 Editorial Jus. México.
Gunnerson, James H.
 1969 Apache Archaeology in Northeastern New Mexico. American Antiquity
 34:23–39.
Gunnerson, James H., and Dolores A. Gunnerson
 1971 Apachean Culture: A Study in Unity and Diversity. In Apachean
 Culture History and Ethnology. Anthropological Papers of the University
 of Arizona, No. 21. University of Arizona Press, Tucson.
Gupta, S. P.
 1969 Sociology of Pottery: Chirag Dilli, A Case Study. In Potteries in Ancient
 India, edited by B. P. Sinha. Pp. 15–26. Department of Ancient Indian
 History and Archaeology, Patna University, Patna.
Hackett, Charles Wilson, ed.
 1923–1937 Historical Documents Relating to New Mexico, Nueva Viscaya, and Approaches
 Thereto, 3 vols. Carnegie Institution, Washington, D.C.
Hagstrum, M. B.
 1985 Measuring Prehistoric Ceramic Craft Specialization: A Test Case in
 the American Southwest. Journal of Field Archaeology 12:65–75.
Hammond, P. B.
 1966 Yatenga: Technology in the Culture of a West African Kingdom. Free Press,
 New York.
Harlow, Francis H.
 1973 Matte-Paint Pottery of the Tewa, Keres, and Zuni Pueblos. Museum of New
 Mexico Press, Santa Fe.
Harrington, J. P.
 1916 The Ethnogeography of the Tewa Indians. In Twenty-Ninth Annual
 Report of the Bureau of American Ethnology. Pp. 29–636. Washington, D.C.
Hill, Williard
 1940 Untitied. Unpublished ms. on Santa Clara Pueblo.
Hinshaw, R. E.
 1975 Panajachel: A Guatemalan Town in Thirty-Year Perspective. University of
 Pittsburgh Press, Pittsburgh.

Hogbin, H. I.
 1951 *Transformation Scene: The Changing Culture of a New Guinea Village.*
 Routledge and Kegan Paul, London.
Horvath, Steven M., Jr.
 1979 *The Social and Political Organization of the Genízaros of Plaza de Nuestra
 Señora de los Dolores de Belén, New Mexico, 1740–1812.* Ph.D. Dissertation,
 Department of Anthropology, Brown University, Providence.
Hurt, Wesley R.
 1989 *Manzano: A Study of Community Disorganization.* AMS Press, New York.
Hurt, Wesley R., and Herbert W. Dick
 1946 Spanish-American Pottery from New Mexico. *El Palacio* 53(10–
 11):280–288, 307–312.
Jaramillo-Lavadie, Juanita
 1977 Río Grande Weaving: A Continuing Tradition. In *Hispanic Crafts of the
 Southwest,* edited by William Wroth. Pp. 9–23. Taylor Museum,
 Colorado Springs.
Jones, Oakah L.
 1962 Pueblo Indian Auxiliaries in New Mexico, 1763–1821. *New Mexico
 Historical Review* 37(2):81–109.
 1979 *Los Paisanos: Spanish Settlers on the Northern Frontier of New Spain.*
 University of Oklahoma Press, Norman.
Kemper, R. V.
 1976 Contemporary Mexican Urbanization: A View from Tzintzuntzán,
 Michoacán. *Atti XL Congresso Internationale Delgi Americanisti* 4:53–65.
 Tilgher Genova, Genoa, Italy.
Kempton, W.
 1981 *The Folk Classification of Ceramics: A Study of Cognitive Prototypes.* Academic
 Press, New York.
Kendall, George Wilkens
 1935 *Narrative of the Texas–Santa Fe Expedition,* 2 vols. Reprinted. Steck, Austin.
 Originally published in 1844 by Wiley and Putnam, London.
Kessell, John L.
 1989 *Remote beyond Compare: Letters of don Diego de Vargas to His Family from New
 Spain and New Mexico, 1675–1706.* University of New Mexico Press,
 Albuquerque.
Kidder, Alfred Vincent, and Charles A. Amsden
 1931 *The Pottery of Pecos,* vol. 1. Dull Paint Wares. Papers of the Phillips
 Academy Southwestern Expedition 7. Yale University Press, New
 Haven.
Kidder, Alfred Vincent, and Anna O. Shepard
 1936 *The Pottery of Pecos,* vol. 2. The Glaze Paint, Culinary, and Other Wares.
 Papers of the Phillips Academy Southwestern Expedition 7. Yale
 University Press, New Haven.
King, Marsha K., and Edward Staski
 1984 Appendix A: "Local" Ceramics. In *Beneath the Border City: Urban
 Archaeology in Downtown El Paso,* by Edward Staski. University Museum
 Occasional Papers No. 12. New Mexico State University, Las Cruces.

Kolb, C. C.
 1976 The Methodology of Latin American Ceramic Ecology. *El Dorado:*
 Newsletter-Bulletin on South American Anthropology 1(2):44–82.
Kramer, Carol
 1985 Ceramic Ethnoarchaeology. *Annual Review of Anthropology* 14:77–102.
Lackey, Louana M.
 1982 *The Pottery of Acatlán: A Changing Mexican Tradition.* University of
 Oklahoma Press, Norman.
Lange, Charles H., ed.
 1982 *An Ethnography of Santa Clara Pueblo, New Mexico.* University of New
 Mexico Press, Albuquerque.
Lauer, P. K.
 1970 Amphlett Islands' Pottery Trade and the Kula. *Mankind* 7:165–176.
LeFree, B.
 1975 *Santa Clara Pottery Today.* School of American Research and University
 of New Mexico Press, Albuquerque.
Levine, Daisy F.
 1990 Tewa or Hispanic Manufacture? Pottery from Eighteenth- and
 Nineteenth-Century Spanish Sites near Abiquiú. In *Clues to the Past:*
 Papers in Honor of William M. Sundt, edited by Meliha S. Durán and
 David T. Kirkpatrick. Pp. 173–183. Papers of the Archaeological
 Society of New Mexico 16. Albuquerque.
 1996 Ceramic Analysis and Interpretation for Two Chama Valley Sites.
 Laboratory of Anthropology, Santa Fe, in preparation.
Longacre, William
 1970 *Archaeology as Anthropology: A Case Study.* Anthropological Papers of the
 University of Arizona No. 17. Tucson.
 1981 Kalinga Pottery: An Ethnoarchaeological Study. In *Pattern of the Past:*
 Studies in Honour of David Clarke, edited by Ian Hodder, Glenn Ll. Isaac,
 and Norman Hammond. Pp. 49–55. Cambridge University Press,
 Cambridge.
Longacre, William A., Kenneth L. Kvamme, and Masashi Kobayashi
 1988 Southwestern Pottery Standardization: An Ethnoarchaeological View
 from the Philippines. *The Kiva* 53(2).
Lucero, Helen
 1986 *Hispanic Weavers of North-Central New Mexico: Social/Historical and*
 Educational Dimensions of a Continuing Artistic Tradition. Unpublished Ph.D.
 Dissertation, Department of Education, University of New Mexico,
 Albuquerque.
Luna, Hilario
 1975 *San Joaquín del Nacimiento.* Private publishing. Limited edition.
 California.
Marshall, Michael P.
 1979 The Jornada del Muerto. In *Jornada Mogollon Archaeology: Proceedings of*
 the First Jornada Conference, edited by Pat Beckett and Regge Wiseman.
 Pp. 389–394. New Mexico State University, Las Cruces.
 1984 *Río Abajo: Prehistory and History of a Río Grande Province.* New Mexico
 Historic Preseravtion Program. Santa Fe.

1996 The Valle Bajo Ceramic Tradition, Chapter 7 in *The Presidio and River on the Borderlands: The Phase III Testing Program*, by Bradley J. Vierra. OCA-UNM Report No. 185-545A. Draft. Office of Contract Archaeology, University of New Mexico, Albuquerque.

1996 The Ceramics of Old Socorro: An Analysis of Valle Bajo Brownware Ceramics from the Old Socorro Mission and Other Tested in Sites in Socorro del Sur, El Paso County, Texas. Chapter 7 in *Searching for Piros Near the Old Socorro Mission: Phase IIB Excavation at 41EP2986*, ed. by Bradley J. Vierra, June-el Piper and Richard C. Chapman. OCA-UNM Report No. 185-549. Draft. Office of Contract Archaeology, University of New Mexico, Albuquerque.

Marshall, Michael P., and Christina L. Marshall
1992 *Investigations in the Middle Río Grande Conservancy District: A Cultural Resource Survey of Irrigation and Drainage Canals in the Isleta-South to La Joya Area. The 1991–1992 Bureau of Reclamation Phase II Survey*. Submitted by Laurens C. Hammack, Complete Archaeological Services Associates (CASA), Cortéz, Colorado.

Marshall, Michael P., and Walt, Henry J. Walt
1984 *Río Abajo: Prehistory and History of a Río Grande Province*. Historic Preservation Division, Santa Fe.

Matson, F. R.
1965 Ceramic Ecology: An Approach to the Study of the Early Cultures of the Near East. In *Ceramics and Man*, edited by Frederick R. Matson. Pp. 202–217. Viking Fund Publications in Anthropology No. 41. Aldine, Chicago.

1973 The Potters of Chalkis. In *Classics and the Classical Tradition*, edited by E. N. Borza and R. W. Carruba. Pp. 117–142. Pennsylvania State University Press, State College.

1974 The Archaeological Present: Near Eastern Village Potters at Work. *American Journal of Archaeology* 78:345–347.

1981 Archaeological Ceramics and the Physical Sciences: Problem Definition and Results. *Journal of Field Archaeology* 8:448–456.

McIntyre, Kellen Kee
1990 *Transitional Period Río Grande Weaving: Catalogue of the Will and Liz Doty Textile Collection*. M.A. Thesis, Department of Art History, University of New Mexico, Albuquerque.

Meinig, David Ward
1970 *Southwest: Three Peoples in Geographical Change, 1600–1970*. Oxford University Press, New York.

Mera, Henry P.
1935 Ceramic Clues to the Prehistory of North-Central New Mexico. Laboratory of Anthropology Technical Series Bulletin 8. Santa Fe.

1939 Style Trends in Pueblo Pottery in the Río Grande and Little Colorado Cultural Areas from the Sixteenth to the Nineteenth Century. Laboratory of Anthropology Memoir No. 3. Santa Fe.

Mills, Barbara J.
1984 A Functional Analysis of Ceramics from the Anderson Site. In *The Ladder Ranch Research Project: A Report of the First Season*, edited by

Margaret C. Nelson. Maxwell Museum Occasional Papers No. 2.
Albuquerque.

Mills, Barbara J. and Patricia L. Crown (eds.)
1995 *Ceramic Production in the American Southwest,* University of Arizona Press,
 Tucson.

Minton, Charles Ethrige
1973 *Juan of Santo Niño, an Authentic Account of Pioneer Life in New Mexico,
 1863-1864.* Sunstone Press, Santa Fe.

Montgomery, A.
1963 The Source of Fibrolite Axes. *El Palacio* 70(1-2):34-48.

Moore, James L.
1996 *Spanish Adaptations to the New Mexican Frontier.* LA65005. Laboratory of
 Anthropology, Santa Fe, in preparation.

Moorhead, Max L.
1968 *The Apache Frontier.* Civilization of the American Indian Series, Vol. 90.
 University of Oklahoma Press, Norman.

Morales, Thomas M.
1988 *Specialized Pottery Production as a Subsistence Buffering Strategy among Pueblos
 in the Tano District of New Mexico.* Dissertation Prospectus, Department of
 Anthropology, University of New Mexico, Albuquerque.

Murray, K. C.
1972 Pottery of the Ibo of Ohuhu-Ngwa. *The Nigerian Field* 37:148-175.

Netting, R. M.
1969 Ecosystems in Process: A Comparative Study of Change in Two West
 African Societies. *Ecological Essays* 8:109-112. National Museums of
 Canada Bulletin 230, Contributions to Anthropology.

1990 Population, Permanent Agriculture, and Politics: Unpacking the
 Evolutionary Portmanteau. In *The Evolution of Political Systems,* edited by
 Steadman Upham. Pp. 21-61. Cambridge University Press,
 Cambridge.

New Mexico Archives
 New Mexico Archives, Documents 1803-04. ff. 1501. Center for Southwest
 Research, University of New Mexico, Albuquerque

Olinger, Bart
1988 Pottery Studies Using X-Ray Fluorescence, Part 3: The Historic
 Pottery of the Northern Tewa. *Pottery Southwest* 15(4).

Ortiz, Roxanne Dunbar
1980 *Roots of Resistance: Land Tenure in New Mexico, 1680-1980.* University of
 California Press, Los Angeles.

Papousek, D. A.
1984 Pots and People in Los Pueblos: The Social and Economic
 Organization of Pottery. In *The Many Dimensions of Pottery,* edited by
 Sander E. van der Leeuw and Alison C. Pritchard. Pp. 476-521. Albert
 Egges Van Giffen Instituut voor Prae- en Protohistorie, Cingula VII.
 Universiteit van Amsterdam.

Payne, Stanley G
1973 *A History of Spain and Portugal, Vol. II.* The University of Wisconsin
 Press, Madison.

Peacock, D. P. S.
1970 The Scientific Analysis of Ancient Ceramics: A Review. *World Archaeology* 1:375–389.
1981 Archaeology, Ethnology and Ceramic Production. In *Production and Distribution: A Ceramic Viewpoint*, edited by H. Howard and E. L. Morris. Pp. 187–194. BAR International Series 120. Oxford.
Pearce, T. M.
1965 *New Mexico Place Names.* University of New Mexico Press, Albuquerque.
Pike, Zebulon
1966 *The Journals of Zebulon Montgomery Pike*, 2 vols, edited by Donald Jackson. University of Oklahoma Press, Norman.
"Plan de Iguala"
1995 *Diccionario Porrúa de historia, biografía y geografía de México.* Pp. 2745-2747. Editorial Porrúa, S.A. México, D.F.
Plog, Stephen
1980 *Stylistic Variation in Prehistoric Ceramics: Design Analysis in the American Southwest.* Cambridge University Press, New York.
1987 The Sociopolotics of Exchange (and Archaeological Research) in the Northern Southwest. In *The Evolution of Political Systems: Sociopolitics in Small-Scale Sedentary Societies*, edited by S. Upham and K. G. Lightfoot. Cambridge University Press, Cambridge.
Raab, L. Mark
1973 AZ AA:5:2, A Prehistoric Cactus Camp in Papagueria. *Journal of Arizona Academy of Science* 8:116–118.
Rathje, William
1975 The Last Tango in Mayapán: A Tentative Trajectory of Production-Distribution Systems. In *Ancient Civilization and Trade*, edited by Jeremy A. Sabloff and C. C. Lamborg-Karlovsky. Pp. 409–448. University of New Mexico Press, Albuquerque.
Reina, Ruben E.
1959 Continuidad de la cultura indigena en una communidad Guatemalteca. *Cuadernos del Seminario de Integración Social Guatemalteca*, Primer Serie, No. 4.
1960 Chinautla, a Guatemalan Indian Community: A Study in the Relationship of Community Culture and National Change. *Middle American Research Institute Publication* 24:55–130. Tulane University, New Orleans.
1963 The Potter and the Farmer: The Fate of Two Innovators in a Maya Village. *Expedition* 5(4):18–30.
1966 *The Law of the Saints: A Pokomam Pueblo and Its Community Culture.* Bobbs-Merrill, New York.
1969 Eastern Guatemala Highlands: The Pokomames and Chorti. *Handbook of Middle American Indians* 7:101–132. University of Texas Press, Austin.
Reina, Ruben E., and R. M. Hill
1978 *The Traditional Pottery of Guatemala.* University of Texas Press, Austin.
Rice, Prudence
1981 Evolution of Specialized Pottery Production: A Trial Model. *Current Anthropology* 22:219–240.

Rock, Michael J.
　1980　　Antón Chico and Its Patent, *Spanish and Mexican Land Grants in New Mexico and Colorado*. Pp. 86-91. Sunflower University Press, Manhattan.
Rudecoff, Christine A., and Charles Carrillo
　1987　　Test Excavations at San Antonio de los Poblanos: A Spanish Colonial Community on the Middle Río Grande. In *Secrets of a City: Papers on Albuquerque Area Archaeology in Honor of Richard A. Bice*, edited by Anne V. Poore and John Lawrence Montgomery. Pp. 48–56. Papers of the Archaeological Society of New Mexico 13.
Rye, Owen S.
　1976　　Keeping Your Temper under Control: Materials and the Manufacture of Papuan Pottery. *Archaeology and Physical Anthropology in Oceania* 11:106–137.
　1978　　*Pottery Technology*. Taraxcum Manuals in Archaeology 4. Taraxcum, Washington, D.C.
Sabloff, J.A., T.W. Beale, and A.M. Kurland, Jr.
　1973　　Recent Developments in Archaeology. *Annals of the American Academy of Political and Social Science*. 408:103-118.
Salazar, J. Richard
　1976　　"Santa Rosa de Lima," *New Mexico Architecture*, Sept./Oct. 1976, Volume 18, No. 5, pp 13-20
Santley, R. S.
　n.d.　　Specialized Production and Exchange within a Late Formative Community in the Basin of México: Implications for the Study of Exchange Systems in Prehistory. Unpublished ms. in the author's possession. Department of Anthropology, University of New Mexico, Albuquerque.
Sargeant, Kathryn, ed.
　1985　　*An Archaeological & Historical Survey of the Villages of Los Ranchos*, State Historic Preservation Office, Santa Fe.
Sargeant, Kathryn, and Mary Davis
　1986　　*Shining River, Precious Land: An Oral History of Albuquerque's North Valley*. Albuquerque Museum, Albuquerque
Scheans, D. J.
　1965　　The Pottery Industry of San Nicolás, Ilocos Norte. *Journal of East Asiatic Studies* 9:1–28.
Schroeder, Albert H.
　1972　　Río Grande Ethnohistory. *New Perspectives on the Pueblos*, edited by Alfonso Ortiz. Pp. 41–70. University of New Mexico Press, Albuquerque.
Schroeder, Gail D.
　1964　　San Juan Pottery: Methods and Incentives. *El Palacio* 71:45–51.
Shepard, Anna O.
　1942　　*Río Grande Glaze Paint Ware: A Study Illustrating the Place of Ceramic Technological Analysis in Archaeological Research*. Carnegie Institution of Washington, Publication 528, Contribution No. 39. Washington, D.C.
　1956　　*Ceramics for the Archaeologist*. Carnegie Institution of Washington, Publication 609. Washington, D.C.

Simmons, Marc
 1966 New Mexico's Smallpox Epidemic of 1780–81. *New Mexico Historical Review* 41(4):319–326.
 1991 *Coronado's Land: Essays on Daily Life in Colonial New Mexico*. University of New Mexico Press, Albuquerque.
 1992 Hygiene, Sanitation and Public Health in Hispanic New Mexico. *New Mexico Historical Review* 67(3).
Simmons, Marc, translator
 1977 *Account of Disorders in New Mexico, 1778*, by Fray Juan Augustín de Morfí. Historical Society of New Mexico, Isleta Pueblo.
Sinopoli, Carla M.
 1988 The Organization of Craft Production at Vijayanagara, South India. *American Anthropologist* 90:580-597.
Snow, David H.
 1984 Spanish American Pottery Manufacture in New Mexico: A Critical Review. *Ethnohistory* 31(2):93–113.
Stanley, F.
 1962 *The Manzano, New Mexico Story*. Private publishing, New Mexico.
Staski, Edward
 1984 *Beneath the Border City: Urban Archaeology in Downtown El Paso*. Prepared for the City of El Paso. Submitted by Steadman Upham and David Batcho, Cultural Resources Management Division, New Mexico State University, Las Cruces. University Museum Occasional Paper No. 12.
 1990 Site Formation Processes at Fort Fillmore, New Mexico: First Interpretations. *Historical Archaeology* 24(3):79–90.
Steponaitis, V.
 1980 Some Preliminary Chronological and Technological Notes on Moundville Pottery. *Southeastern Archaeological Conference Bulletin* 22:46–50.
Steward, Julian
 1955 *Theory of Culture Change*. University of Illinois Press, Urbana.
Stoller, Marianne L.
 1979 *A Study of Nineteenth-Century Hispanic Arts and Crafts in the American Southwest: Appearances and Processes*. Ph.D. Dissertation, University of Pennsylvania, University Park. University Microfilms, Ann Arbor.
Stone, Tammy
 1984 An Examination of Mogollón Corrugated Pottery. Paper presented at the Third Mogollón Conference, Las Cruces, New Mexico.
Swadesh, Frances León
 1974 *Los Primeros Pobladores: Hispanic Americans of the Ute Frontier*. University of Notre Dame Press, South Bend.
de Tamarón y Romeral, Pedro
 1937 Demonstración del vastísimo obispado de la Nueva Viscaya, 1765, *Biblioteca história mexicana de obras inéditas*. Vol. 7. Antigua Libreria Robredo, de José Porrúa e Hijos, México.
Thomas, Alfred Barnaby
 1932 *Forgotten Frontiers: A Study of the Spanish-Indian Policy of Don Juan Bautista de Anza, 1777-1787*. University of Oklahoma Press, Norman.

Thomas, Alfred Barnaby, translator and editor
1935 *After Coronado: Spanish Exploration Northeast of New Mexico, 1696–1727.*
University of Oklahoma Press, Norman.
Thomas, William, Nathan W. Bower, John W. Kantner, Marianne L. Stoller, and David H.
Snow
1992 An X-Ray Florescence Pattern-Recognition Analysis of Pottery from
an Early Historic Hispanic Settlement near Santa Fe, New Mexico.
Historical Archaeology 26:25–36.
Tjarks, Alicia V.
1978 Demographic, Ethnic, and Occupational Structure of New Mexico,
1790. *The Americas* 35(1):45–88.
Torrence, Robin
1986 *Production and Exchange of Stone Tools: Prehistoric Obsidian in the Aegean.*
Cambridge University Press, Cambridge.
Tosi, Maurizio
1984 The Notion of Craft Specialization and Its Representations in the
Archaeological Record of Early States in the Turanian Basin. In
Marxist Perspectives in Archaeology, edited by M. Spriggs. Pp. 22–52.
Cambridge University Press, Cambridge.
Toulouse, J. H., Jr.
1949 *The Mission of San Gregorio de Abó.* Monographs of the School of
American Research No. 13. University of New Mexico Press,
Albuquerque.
Turner, P. R.
1977 Intensive Agriculture among the Highland Tzeltal. *Ethnology* 16:167–
174.
Tyler, Daniel
1989 Ejido Lands in New Mexico. In *Spanish and Mexican Land Grants and the
Law,* edited by Malcolm Ebright. Sunflower University Press,
Manhattan, Kansas.
Upham, Steadman
1982 *Politics and Power: An Economic and Political History of the Western Pueblo.*
Academic Press, New York.
Upham, Steadman, Kent Lightfoot, and Gary Feinman
1981 Explaining Socially Determined Ceramic Distributions in the
Prehistoric Plateau Southwest. *American Antiquity* 46:822–833.
U.S. Bureau of the Census
1860 General Census. *Eighth Census of the United States,* Vol. 1. Pp. 566–573.
Washington, D.C.
van der Leeuw, Sander E.
1976 *Studies in the Technology of Ancient Pottery,* 2 vols. Ph.D. Dissertation,
University of Amsterdam.
van der Leeuw, Sander E., and Alison C. Pritchard
1984 Modeling Ceramic Production. In *The Many Dimensions of Pottery,* edited
by Sander E. van der Leeuw and Alison C. Pritchard. Albert Egges
Van Giffen Instituut voor Prae-en Protohistorie, Cingula VII.
Universiteit van Amsterdam.

Van Ness, John R., and Christine M. Van Ness
 1980 Introduction, *Spanish and Mexican Land Grants in New Mexico and
 Colorado. Pp. 3-11. Sunflower University Press, Manhattan.
de Villaseñor y Sánchez, José Antonio
 1748 *Teatro Americano.* Madrid.
Warren, A. Helene
 1979 Historic Pottery of the Cochití Reservoir. In *Adaptive Change in the
 Northern Río Grande,* edited by Jan V. Biella and Richard C. Chapman.
 Pp. 235–245. Archaeological Investigations in Cochití Reservoir, Vol.
 4. Office of Contract Archeology, University of New Mexico,
 Albuquerque.
 1981 The Micaceous Pottery of the Río Grande. In *Colected Papers in Honor of
 Eric Kellerman Reed,* edited by Albert H. Schroeder and David
 Breternitz. Pp. 149–164. Papers of the Archaeological Society of New
 Mexico 6.
 1985 In *An Archaeological & Historical Survey of the Villages of Los Ranchos,* ed. by
 Kathryn Sargeant. State Historic Preservation Office, Santa Fe.
Weber, David J.
 1982 *The Mexican Frontier, 1821–1846: The American Southwest under Mexico.*
 University of New Mexico Press, Albuquerque.
Wedel, Waldo R.
 1959 *An Introduction to Kansas Archaeology.* Bureau of American Ethnology
 Bulletin 174. Washington, D.C.
Weigle, Marta
 1975 *Hispanic Villages of Northern New Mexico.* A Reprint of Volume II of the
 1935 Tewa Basin Study with Supplementary Materials. Lightning Tree, Santa
 Fe.
Weigle, Marta, Claudia Larcombe, and Samuel Larcombe, editors
 1983 *Hispanic Arts and Ethnohistory in the Southwest: New Papers Inspired by the
 Work of E. Boyd.* Ancient City Press, Santa Fe.
Wendorf, Fred, and Eric K. Reed
 1955 An Alternative Reconstruction of Northern Río Grande Prehistory. *El
 Palacio* 62(5–6):131–173.
Westphall, Victor
 1983 *Mercedes Reales: Hispanic Land Grants of the Upper Río Grande Region.*
 University of New Mexico Press, Albuquerque.
 1988 Thomas Benton Catron: A Historical Defense. *New Mexico Historical
 Review* 63(January):43–57.
Wheat, Joe Ben
 1979 Río Grande, Pueblo, and Navajo Weavers: Cross-Cultural Influence.
 In *Spanish Textile Tradition of New Mexico and Colorado,* edited by Nora
 Fisher. Pp. 29–36. Museum of International Folk Art, Santa Fe.
Wislizenus, A.
 1969 *Memior of a Tour to Northern Mexico Connected with Colonel Doniphan's
 Expedition in 1846 and 1847.* Reprinted. Calvin Horn, Albuquerque.
 Orginally published 1848, Senate Miscellaneous Documents No. 26,
 30th Congress, 1st Session. Washington D.C.
Wroth, William
 1973 Traditional Ways in New Mexico Villages. *The Journal of the New
 Alchemists* 1:61–64.

Index

Publications by the Author

"Abiquiú Reservoir Project," The Ethno-history of the Abiquiú Reservoir Region, Corps of Engineers, Albuquerque, NM 1985.

"The Acequias of El Llano, NM" Report to the Office of the Governor, New Mexico Bureau of Mines and Mineral Resources, Socorro, NM March 1985.

"Archaelogical Survey of 12.5 miles of the Pecos River Road," Final Report: The Historic Artifacts of QRA-NM SM 84 (4, 5, 6, 7), Quivira Research Center, University of New Mexico, Albuquerque, NM.

"Bone Carving by Hispanic New Mexican Pastoralists: A 400 Year-Old Tradition," Tradición Revista, December 1995.

"Colored Earth: the Tradition," Traditional Southwest: The Adobe and Folk Art Magazine, Fall 1989.

"A Grassroots Adventure in Archaeology," La Comunidad: Design, Development, and Self Determination in Hispanic Communities, 1982, National Endowment for the Arts, Design Arts Program, Partners for Livable Places, Washington, D.C.

En Divina Luz: The Penitente Moradas of New Mexico, by Varjabedian, Craig and Michael Wallis. Afterward by Charlie Carrillo. University of New Mexico Press, Albuquerque, 1994.

"Frank Brito, Master Santero," Tradición Revista, Vol. 1 #3, October, 1996.

"Hispanic and Native American Ceramic Assemblages from LA288," Archaeological Testing and Analysis Along a Mountain Bell Cable Near Two Sites in Corrales, NM, UNM Office of Contract Archaeology, Albuquerque. 1985.

"Hispanic Sources" in Sources and Inspirations: Paintings by Paul Pletka Exhibition Catalogue, Museum of Fine Arts, Santa Fe. 1990.

"Historic Hispanic NM Pottery: Some Revealing New Research," Tradición Revista, Vol.2 #1, April 1997.

"My Tio Floyd," Ghost Ranch Journal, 1991, an article on Debbie Carrillo's uncle Floyd and his knowledge of Hispanic verbal history.

"Pottery of the Abiquiú Reservoir Area," Archaeological and Historical Research at Abiquiú Reservoir, Corps of Engineers, Albuquerque. 1987.

Ramilletes de Papel (Paper Ramilletes), Manuscript written for the Spanish Colonial Arts Society, Santa Fe. 1991.

"Test Exacavations at San Antonio de los Poblanos: A Spanish Colonial Community on the Middle Río Grande," Archeological Society of New Mexico, Ancient City Press, Santa Fe. 1987. Co-authored with Christine A. Rudecoff.

"Traditional New Mexican Hispanic Crafts: Ayer y Hoy - Yesterday and Today," 1991-92 The Wingspread Collector's Guide.

"Where Were the Sheep? The Piedra Lumbre Phases Revisited," 1993, New Mexico Archeological Society, Brad Viera, editor.

About the Author

Charles M. Carrillo received his Doctorate from the University of New Mexico in Albuquerque in May of 1996 in Anthropology with a specialty in Archaeology. He has participated in the excavation of a number of historic sites in New Mexico, most notably the site of Santa Rosa de Lima de Abiquiú in the Chama Valley.

In addition to his work as an archaeologist, Carrillo is known for his research on the historic santos of Northern New Mexico. He has studied the techniques, iconography, and styles of the santeros that lived from the 1700's to the present.

Carrillo is best known as an award-winning santero who has received First Place and Best of Show Awards in Spanish Market held each year in Santa Fe the last weekend in July. Carrillo is a popular speaker on the Hispanic traditions of New Mexico and gives many demonstrations on the techniques of the santeros.

He is the subject of the book *Charlie Carrillo: Tradition & Soul* (LPD Press 1994). He received the Governor of New Mexico's Award for Excellence in the Arts, as well as the Santa Fe Mayor's Award and the University of New Mexico Alumni Award for contributions to the arts. Carrillo lives in Santa Fe with his wife Debbie and two children, Estrellita and Roán.

From LPD Press

Charlie Carrillo: Tradition & Soul, Barbe Awalt & Paul Rhetts,1995

Hispanic New Mexican Pottery: Evidence of Craft Specialization 1790-1890, Charles M. Carrillo, 1997

Our Saints Among Us/Nuestros Santos Entre Nosotros: 400 Years of Devotional Art in New Mexico, Paul Rhetts & Barbe Awalt, 1997

Santos: Sacred Art of Colorado, Thomas J. Steele, S.J., 1997

The Regis Santos: Thirty Years of Collecting 1966-1996, Thomas J. Steele, S.J., 1997

Tradición Revista: The Journal of Contemporary & Traditional Spanish Colonial Art & Culture, a quarterly magazine

LPD Press
2400 Río Grande Blvd. NW #1213
Albuquerque, New Mexico 87104-3222
(505) 344-9382
FAX (505) 345-5129